GARDENS OF GEORGIA

Gordonia lasianthus in the Jones garden, Bishop.

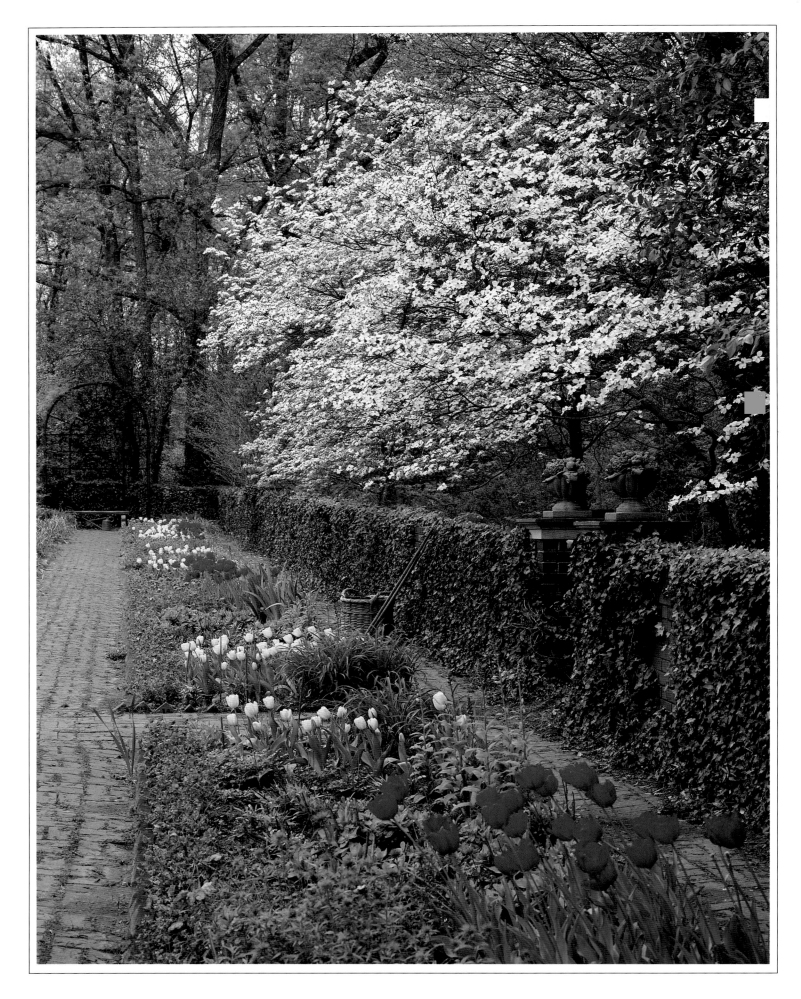

Formal walled garden, Bankshaven, Newnan.

GARDENS
OF
GEORGIA

Text by William Mitchell
Photography by Richard Moore

A Book by The Garden Club of Georgia, Inc.

PEACHTREE PUBLISHERS, LTD., ATLANTA

We have always the old and timeless elements of light and shade,
earth, stone, and water, foliage, and flowers.
Add houses for living, paths for walking, lawns for games,
terraces and loggias for sun and shelter,
water for swimming, for plants, or for fountains.
Using these, we can make gardens if we understand the essential
nature of the place, the principles underlying the patterns,
and the cultural needs that make our plantings flourish.

Russell Page, The Education of a Gardener, 1983

Peachtree Publishers, Ltd.
494 Armour Circle, NE
Atlanta, Georgia 30324

Peachtree books are available for bulk purchases at special
discounts for sales promotions, premiums, fund-raising, or
educational purposes. For details, contact our Special Sales
Manager at the address above or phone (404) 876-8761.

ISBN 0-934601-76-3
(Special Limited Edition. ISBN 0-934601-77-1)

Manufactured in the United States of America
10 9 8 7 6 5 4 3 2 1

Credits:
Directed and edited by Van Jones Martin
Designed and produced by Lisa Lytton-Smith
Copyedited by Kathleen Bergen Durham
Proofread by Rusty Smith
Color Separations by Savannah Color Separations,
 Savannah, and Color Response, Charlotte
Typography by DG&F Typography, Columbia
Printed by Miller Press, Jacksonville
Bound by Nicholstone Book Bindery, Nashville

Photographic credits:
All photographs by Richard Moore, except as noted below.
Editor's collection, 4, 8, 9, 13, 14 (both), 16, 19, 20, 21,
 23 (top), 25, 36, 66 (bottom), 77 (top), 79 (top), 102,
 104 (top), 105 (bottom), 126, 136, 188
Deloye Burrell, 156
Tom Woodham, 162 (bottom), 163 (top), 164 (both)
James Valentine, 96 (bottom)
Paul G. Beswick, 96 (top), 97 (both)
Michael Portman, 44, 45

Cover photograph: Walled boxwood parterre, Swan
 House, Atlanta Historical Society. (As a background,
 ivy adorns the stucco garden wall at the Richardson-
 Owens-Thomas House, Savannah.)

Title page : Gloriosa lily, Hills and Dales, LaGrange.

Library of Congress Cataloging-in-Publication Data:
Mitchell, William R.
 Gardens of Georgia/text by William Robert Mitchell, Jr.:
 photographs by Richard Moore.
 p. cm.
ISBN 0-934601-76-3 : $50.00
 1. Gardens—Georgia
 2. Gardens—Georgia—Pictorial works.
I. Moore, Richard, 1955- . II. Title.
SB466.U65G46 1989
712: 09758—dc20 89-16100
 CIP

The Garden Club of Georgia, Inc., gratefully acknowledges
the generous support of the following patrons and benefactors.

Mr. and Mrs. J. B. Fuqua
Mr. and Mrs. Charles O. Smith, Jr.

William Nathaniel Banks
Mrs. Fuller E. Callaway, Jr.
Mrs. Thomas C. Chubb
Citizens and Southern National Bank
Mrs. Emory Cocke
Mr. and Mrs. J. Yates Green
J. Robin Harris
Sara G. Moore
Mr. and Mrs. Guy H. Northcutt, Jr.
Mr. and Mrs. G. Harold Northrop
H. J. Russell and Company
Mr. and Mrs. Carl E. Sanders
Dr. and Mrs. William M. Suttles
Trust Company Bank
Gloria S. Williams
Mrs. Thomas Lyle Williams, Jr.

Anonymous
Brenda Agee
Mrs. Ivan Allen, Jr.
Dr. and Mrs. Crawford F. Barnett, Jr.
Dr. Needham Bryan Bateman
Ann Blair Brown
Mr. and Mrs. Philip A. Browning, Jr.
David Richmond Byers III

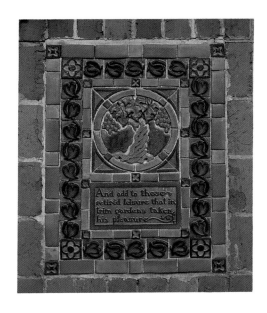

Jimmy and Rosalynn Carter
Ann Lyon Crammond
Dr. and Mrs. William V. Crosby
Days Inns of America
Mr. and Mrs. Jack C. Deady
Mrs. Julius B. Dodd, Jr.
Mr. and Mrs. Clarence Dodson
Mr. and Mrs. William W. Epstein
Ernst and Whinney
Mr. and Mrs. Robert H. Ferst
Mr. and Mrs. William A. Fickling, Jr.

Tom and Dot Fuqua, Sr.
Robert J. George
Mr. and Mrs. Robert E. Gibson
Mrs. Louis M. Givens
Donald M. Hastings and Family
Mr. and Mrs. W. Ray Houston
Mrs. Virginia H. Illges
Mr. and Mrs. C. Dexter Jordan, Jr.
Mrs. Raymond C. Kelly (in honor of)
Cindy R. Moore
John and Kathryn Myers
Mr. and Mrs. Bernard N. Neal
Mrs. Lawson Neel
Barry Phillips
Ms. Doris Tindal Robinson
Mr. and Mrs. J. Mitchael Rogers
Rome Federated Garden Clubs, Inc.
Mr. and Mrs. J. Clyde Rushin
Alana Shepherd
Mr. and Mrs. Val Sheridan
Mrs. Edward D. Smith
Dr. and Mrs. Richard Loring Stapleton
Dr. and Mrs. William H. Stuart
Mrs. Roy M. Sullivan, Jr.
Mrs. E. Carl White
Mr. and Mrs. Edward L. White, Jr.
Tom Woodham
Mrs. Dorothy M. Yates

Terra-cotta tile plaque in the garden of the president's home, Medical College of Georgia, Augusta.
From Milton's "Il Penseroso," the motto reads, "And add to these retired leisure that in trim gardens takes his pleasure."

ACKNOWLEDGMENTS

IN 1972 I PURCHASED the late Ellen Shipman's copy of *Garden History of Georgia, 1733-1933* from a New York book dealer—"Ellen Shipman Her Book," reads the bookplate. Shipman, born in 1869, was one of a small group of the first women landscape architects in America. In 1976 The Garden Club of Georgia, Inc., reprinted the *Garden History*, and I bought a working copy to replace my original, which I retired to the rare book shelf. Little did I know I would be needing both copies as editor/author of *Gardens of Georgia*—as well as needing all other garden source materials I could lay my hands on.

Those sources—other than the gardens themselves—are listed in the bibliography, but here I want to acknowledge some of the people, influences, and gardens which have guided and inspired me in this work.

Late in May 1988, Deen Day Smith (Mrs. Charles O. Smith, Jr.), president of The Garden Club of Georgia, Inc., 1987-1989, asked me to take on this project. Coincidentally her request came only a few weeks after I had heard about it from Richard Moore, who had already begun the long process of photographing the more than 150 gardens that would appear on these pages. Soon Richard and I were traveling together around the state, I with notebook and pen, and he with a new camera worthy of Matthew Brady.

Friends around the state were a great help: Jean Hogan and Val and Mary Sheridan in Macon; Bryan and Harriet Haltermann in Augusta; Clason Kyle in Columbus; Ben Grace in Thomasville; Robert Tucker in southwest Georgia; and Dan Franklin, Edith Henderson, and David Byers in Atlanta.

Others I want to thank are Laura Ellis, Clermont Lee, Tom Woodham, Ed Daugherty, Jim Gibbs, Ryan Gainey, Doug Dorough, Patricia Ray, Robert J. Hill, Emily Harris, Louise Allen, Henry Howell, Mrs. Michael McDowell, Louisa McIntosh, Martha Bateman, Ken Thomas, Jane Boyd, Julia Orme Martin, Michael Portman, Carl Cofer, Barbara Stegall, Roy Mann, Eugene and Margarita Cline, Sam W. Mangham, B. G. McElwee, Prince Fugger (who now owns Barnsley Gardens), Judy Russell of Callaway Gardens, Ed Weldon and Tony Dees of the Georgia Department of Archives and History, the staff of the Emory University Library, and the staff of the Atlanta Historical Society and its Cherokee Garden Library.

Garden owners uniformly cooperated with us. I especially want to thank them for returning the questionnaires and release forms. These "green sheets" have proved to be very useful in writing about the gardens, and I have quoted directly from many of the owners' comments.

The people of Peachtree Publishers, Ltd., whom I introduced to The Garden Club of Georgia, Inc., have been working diligently, led by Wayne Elliott and Margaret Quinlin, to ensure that *Gardens of Georgia* will be in bookstores, gift shops, libraries, and homes all over the country.

Van Jones Martin, Lisa Lytton-Smith, Rusty Smith, Kathleen Durham, Jennifer Ellison, and David Kaminsky have worked tirelessly to design, edit, and coordinate this sometimes overwhelming project. Without Van and Lisa we could not have produced this book.

I have not yet specifically acknowledged committee members of The Garden Club of Georgia, Inc. A complete listing of garden club people who have formed a network of assistance is listed with the dedication, but I must single out Pat Setzer, Ruth Sullivan, Carolyn Waters, Mary Helen Ray, Ann Venard, Marvina Northcutt, and Peggy White (president of The Garden Club of Georgia, Inc., 1989-1991). In addition, Deen Day Smith's staff, her executive secretary Jo Dollar, and Elizabeth Stone, who typed much of my manuscript, have been valuable and cheerful members of our team. Finally, I want to thank Deen Day Smith for her great generosity and sustaining strength of purpose.

During the course of our work, we lost two dear friends of Georgia gardening: Dean Hubert Bond Owens (1905-1989) of Athens and Rebecca Wight Cherry Sims (1921-1989) of Atlanta. Hubert Owens had been a friend for many years, and I was an editorial consultant on his *Personal History of Landscape Architecture.* "Beck" Sims's very special garden is one of the features of this book.

Over the years, acquaintances with such remarkable people have had an incalculable effect on my growth as a scholar and writer. My appreciation of gardens and landscape architecture was similarly enhanced by the beautiful surroundings of some of the places I have studied: Duke University, Emory University, the Winterthur Museum and the University of Delaware, Williamsburg, and the Attingham English country-house study program.

My early memories are of the gardens of my maternal grandparents, Miriam Graves and William Calvin Hays, and my parents, Miriam Hays and William Robert Mitchell—and their flowers, herbs, shrubs, trees (my mother's specialty), and vegetables (my late father's). Later memories were of my mother's Ansley Park terrace and woodland gardens, and then of her lovely walled garden in Savannah, which I helped maintain and in which I spent many happy hours. Thanks go without saying, almost, to Miriam Hays Mitchell, but it never hurts to remind someone of how much she means to you.

WILLIAM R. MITCHELL, JR.
Atlanta, July 9, 1989

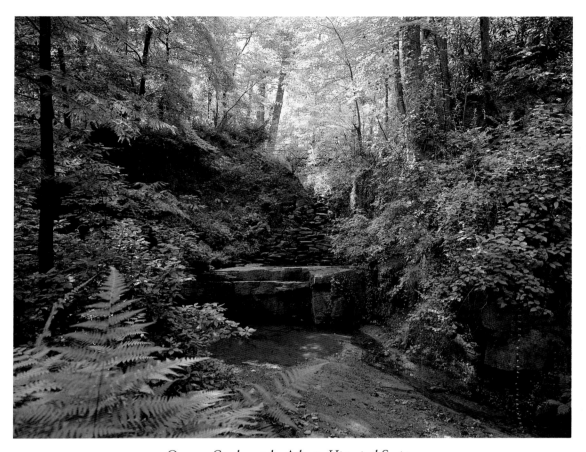

Quarry Garden at the Atlanta Historical Society.

I LEFT MY NEW ENGLAND HERITAGE in 1985 to venture south, where I could pursue my career as an environmental portrait photographer. I chose Georgia for several reasons. I loved the temperate climate, the rolling hills, the lush green vegetation, and especially the four distinct seasons which would provide more time for photography.

Through slide lectures compiled from the many wonderful winter months spent at Kauai, Hawaii, I made the acquaintance of The Garden Club of Georgia, Inc. I am indeed grateful to Deen Day Smith for giving me the opportunity to serve as photographer for *Gardens of Georgia*. Her constant selflessness was the greatest inspiration of all for me in my effort to document these beautiful Georgia gardens.

Long before my association with The Garden Club of Georgia, I was privileged to have had a family that instilled in me an appreciation of flowers and gardening. My great-grandmother, Josephine Killion, and my grandfather, Edward Killion, were noted florists and horticulturists. My mother, Ellen Killion Moore, is a lover of gar-

dening as well. I am so fortunate to know Paul Turnbull, president and director of the Hallmark Institute of Photography, who inspired me to recognize the beauty in this world and taught me the skills to capture such beauty and share it with others.

To Adam Patterson, my assistant and office manager for my Atlanta-based company, Richard J. Moore Photography, I express my deepest appreciation for "holding down the fort" and juggling my portrait appointments and other commitments, while I spent the year roaming the state photographing the gardens.

This experience has truly enriched my life, and I feel very "Georgian" as a result of my endeavors. I salute The Garden Club of Georgia, Inc., for its dedication to this project, and I am indebted to all who helped make this book a reality.

RICHARD J. MOORE
Atlanta, July 18, 1989

DEDICATED

*To the continuing work of gardeners and garden clubs
in making the world more beautiful and livable.*

THE GARDEN CLUB OF GEORGIA, INC.
1928-1988

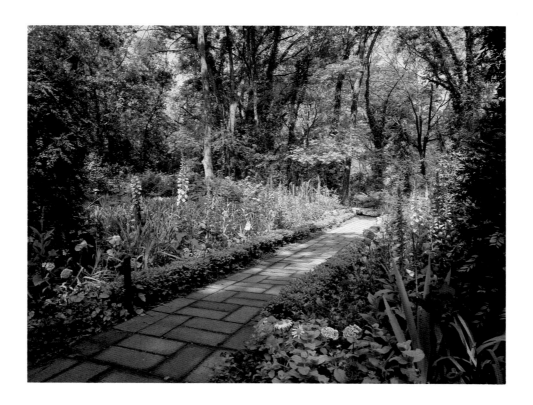

EXECUTIVE COMMITTEE:
Mrs. Charles O. Smith, Jr., President
Mrs. E. Carl White, First Vice-President
Mrs. Robert Gibson, Second Vice-President
Mrs. Wayne Wiseman, Third Vice-President
Mrs. C. Max Miller, Fourth Vice-President
Mrs. Ben T. Ambrose, Recording Secretary
Mrs. H. Richard Payne, Corresponding Secretary
Mrs. George E. Waters, Treasurer
Mrs. Paul W. Miller, Assistant Treasurer
Mrs. Haskell Venard, Parliamentarian

PUBLICATIONS COMMITTEE:
Mrs. Hugh Setzer, Chairman
Mrs. Roy M. Sullivan, Vice-Chairman
Mrs. George E. Waters, Treasurer

ADVISORY COMMITTEE:
Mrs. Van B. Bennett
Mrs. T. Edward Clyatt
Mrs. Clarke W. Duncan
Mrs. Lawson Neel
Mrs. Guy H. Northcutt, Jr.
Mrs. George W. Ray
Mrs. Ben Sims
Mrs. Haskell Venard

DISTRICT DIRECTORS:
Mrs. J. T. Row, Laurel
Mrs. William H. Wiseman, Azalea
Mrs. Dorsey Flanders, Oleander
Mrs. T. R. Nisbet, Jr., Camellia
Mrs. Bill Maxwell, Magnolia
Mrs. Thorne Winter, Jr., Dogwood
Mrs. John D. Stephens, Redbud

DISTRICT CHAIRMEN:
Mrs. Douglas Milner, Laurel
Mrs. Clarence Jones, Azalea
Mrs. George W. Ray, Oleander
Mrs. Harry Lamon, Camellia
Mrs. M. U. Chambless, Magnolia
Mrs. Ben Sims, Dogwood
Mrs. Louis Givens, Redbud
Ms. Rebecca Reeves Carter, Redbud

AND:
Mrs. Robert S. Brown
Mrs. Clyde Dekle, Jr.
Mrs. Edward DeZurko
Mrs. Clarence Dodson
Mrs. W. C. Graham
Mrs. Raymond F. Kelly
Mrs. Leon Neel
Mrs. Warren Robertson
Mrs. M. M. Scarborough
Mrs. Jo Stegall, Jr.
Mrs. Dan Sweat

Garden of Dean Hubert Bond Owens (1905-1989), Athens.

FOREWORD

The publication of *Gardens of Georgia* is a project of The Garden Club of Georgia, Inc., to commemorate the Diamond Jubilee (1928-1988) of the founding of the state federation.

On June 8, 1928, at the Biltmore Hotel in Atlanta, the organizational chairman, Mrs. Robert L. Cooney, president of the Peachtree Garden Club of Atlanta, conducted the meeting where Mrs. F. Phinizy Calhoun of Atlanta was elected the first president of the state federation. Thirty clubs were listed as charter members. Of special interest, the minutes of this meeting reflect a request made for the members to send information on gardens in Georgia established before 1840. Gardens are a part of the heritage of this state.

Mrs. Cooney later spearheaded the effort to publish the classic *Garden History of Georgia, 1733-1933*, which was reprinted in 1976 as a bicentennial project of The Garden Club of Georgia, Inc.

Gardens of Georgia is an effort to continue this proud garden history. It contains gardens large and small, formal and informal, old and new, and suburban, urban, and rural, and it gives the reader ideas for creative gardening.

Proceeds from the sale of the book will be used to establish a fund that will be administered by The Garden Club of Georgia, Inc., for the following projects:

- ❦ a garden project at the Atlanta Botanical Garden

- ❦ a garden project at the State Botanical Garden

- ❦ an educational project at Callaway Gardens

- ❦ other garden related projects of The Garden Club of Georgia, Inc.

May this book enrich the life of each reader as it brings visual pleasure for the senses and contentment to the spirit. It is hoped that this volume will inspire Georgians to keep accurate records of gardens in the state, because preservation is important for future reference.

THE GARDEN CLUB OF GEORGIA, INC.

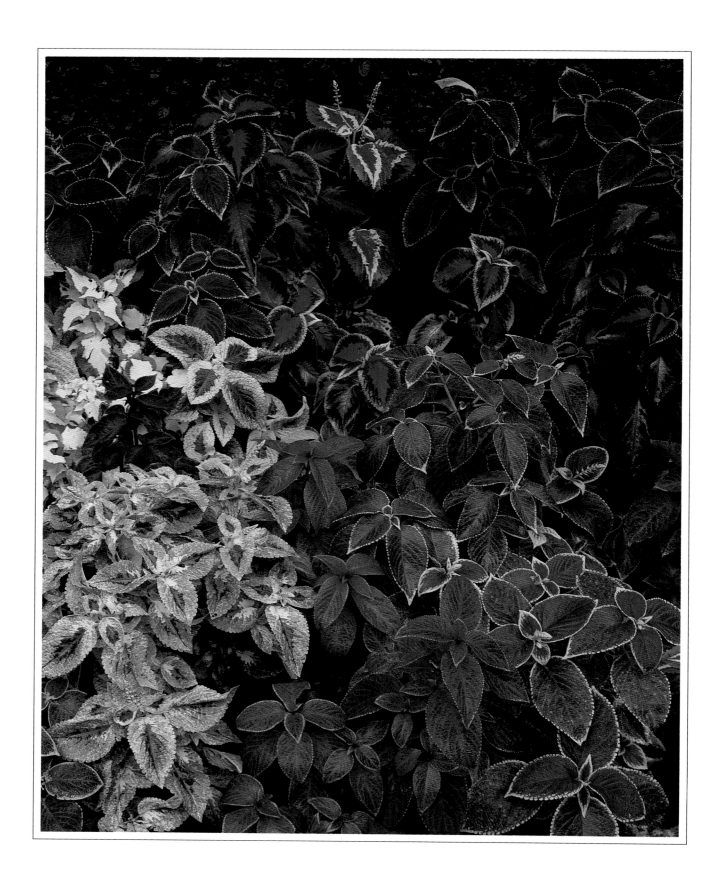

Coleus border at the Founders' Memorial Garden, Athens.

CONTENTS

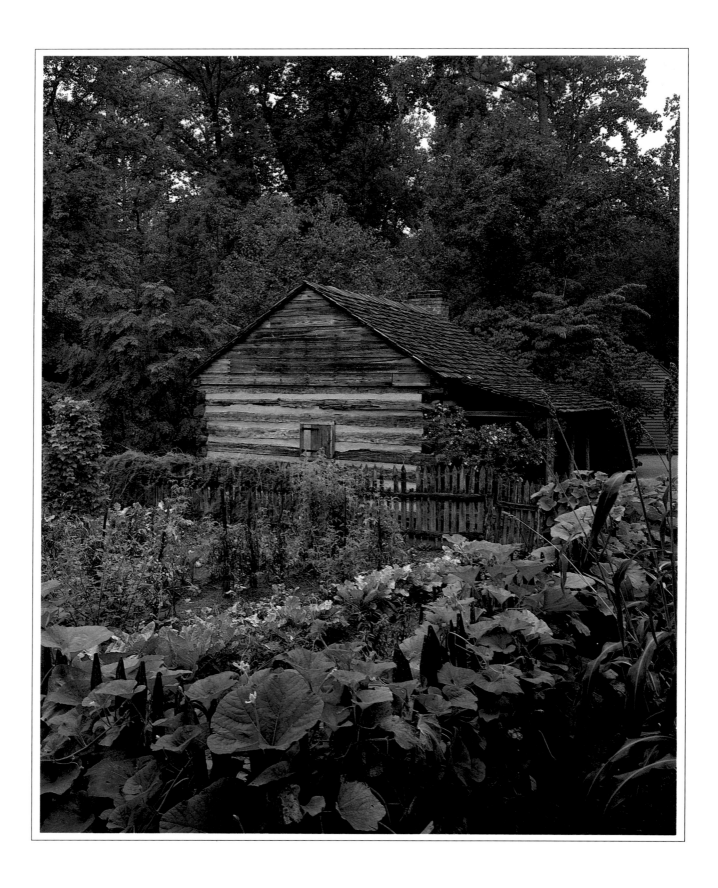

Vegetable garden, Tullie Smith House, Atlanta Historical Society.

INTRODUCTION

*J*ULIUS CAESAR, as every high school Latin student learned, divided Gaul into three parts, "Gallia est omnis divisa in partes tres." We divide Georgia into four: Savannah and the sea island coast; the piedmont plateau and fall-line cities; south Georgia; and Atlanta and north Georgia. These sections reflect traditional divisions of this large Deep South state, the largest east of the Mississippi River. Caesar's "Gallia est omnis," however, will be, with few exceptions, the only Latin the reader will encounter. Plants are generally referred to in the text by their popular names: dogwood, for example, instead of *Cornus florida*.

The regional divisions adopted for *Gardens of Georgia* roughly parallel the historic settlement and cultural patterns of Georgia, as well as the physical makeup of the state—its geography, climate, rainfall, soil, topography, and native vegetation. Historically, just saying the name of the state has seldom been enough; Georgians have modified the name by direction and section—north and south Georgia, or middle Georgia—or by the lay of the land—up-country, low country, the piedmont, or coastal Georgia.

The combinations have been many, for Georgia represents a varied and increasingly vulnerable environment that every gardener starts to understand in relation to his own "yard," as Georgians have traditionally called their home grounds. (Yard:

Franklinia alatamaha, the rare plant discovered by John and William Bartram, has not been documented in the wild since 1790.

Middle English, from Old English *geard*, enclosure; akin to Old High German *gart*, enclosure; Latin *hortus*, garden. Garden: Middle English *gardin*, from Old High German *gart*, enclosure.) Georgians, with their roots in the land, have clung to that old usage, and one commonly hears references to front, back, and side yards. The conservative Georgian knows instinctively that yard and garden are linguistically related. Starting with their own yards—"cultivating their own gardens"—Georgians learn to appreciate the beauty and problems of the whole, and their gardens come to represent a world.

Indeed, the state of Georgia is large enough to constitute a world—some 58,876 square miles—and it seems to be a microcosm of the entire country. In fact, when George II granted the charter for Georgia in 1732, the territory of the new colony stretched theoretically from the Atlantic coast between the Savannah and Altamaha rivers across the entire continent to the "South Seas." Today, although the western boundary is the Chattahoochee River and not the Pacific Ocean, "from the mountains to the Sea" and "from Rabun Gap to Tybee Light" are but two expressions that reflect the extent—the length, breadth, and variety—of a state that sometimes seems a nation unto itself—"the Empire State of the South."

Whether one's yard is near Rabun Gap in the north Georgia mountains (2,500 feet elevation, with average lowest temperatures between 0 and 10 degrees Fahrenheit [Zone 7]), or near the fall line in the piedmont of middle Georgia (600 feet elevation, with average lowest temperatures between 10 and 20 degrees [Zone 8]), or near Savannah on the coastal plain (25 feet elevation, with average lowest temperatures between 20 and 30 degrees [Zone 9]), a Georgia gardener must know the relative constants of the natural environment. These facts historically have shaped the character of gardening in Georgia, especially in the choice of plants for effects and efforts in a private yard.

Planted squares and streets, such as this carefully maintained median on Oglethorpe Avenue, have earned Savannah the sobriquet, "The Forest City."

Gardens of Georgia reflects natural and historical realities, beginning with the low country coastal plain, where the first gardens were laid out in the colonial and early federal periods. Savannah gardens today still honor their historic British origins with a gracious geometry of walled parterres and landscaped city squares — a series of twenty-one small public gardens — which prompted nineteenth-century Savannah to be called "a little London in the southern forest."

From Savannah and the sea islands, colonized in the 1730s, we proceed chronologically and up-country into the piedmont, first settled in the 1770s. Cities featured include Athens, where the American garden club movement began, and three on the fall line — Augusta on the Savannah River, created, like Savannah, by James Oglethorpe in the 1730s, and Columbus on the Chattahoochee and Macon on the Ocmulgee, both settled in the 1820s. After admiring gardens in the gently rolling south Georgia country west of the coast, settled in the 1820s and 1830s, we continue to Atlanta and into north Georgia, which was opened to white settlement in the 1830s after the Cherokee land cessions. Atlanta, though technically in the northern piedmont, is considered more a part of north Georgia, since its metropolitan area now extends into the foothills of the Blue Ridge Mountains.

Starting with Savannah, the original town and first capital, we end with Atlanta, the state capital since 1868. The largest city in the state, Atlanta has long been a major center of gardening interest. This interest, magnified and intensified in the 1970s and 1980s by one of the fastest-growing metropolitan populations in the nation, led to the creation of a major public botanical garden. Situated in the heart of midtown, the Atlanta Botanical Garden thrives in the fine nineteenth-century Piedmont Park, a 185-acre oasis planned with direct influences from Frederick Law Olmsted, the first landscape architect in America.

The essentially mild climate of Georgia "from the mountains to the sea" has encouraged traditions of gardens and gardening as rich and interesting as any in the United States. The Georgia gardener today adds to a heritage unequalled in North America, with origins in the eighteenth century, continued into the antebellum period, revived in the latter part of the nineteenth century, and continued into our own century. It has been said gardening involves bringing order to nature, and one Georgia garden tradition, which has origins in British colonial taste, is that of enclosed, formal parterres — or beds — designed to be appreciated from above, as well as from within and without. The parterres are often edged with boxwood and are symmetrical and separated by swept paths, a tradition as old as Tudor-period England. (Front lawns — or any lawns — in any part of Georgia were rare prior to the twentieth century.) Sometimes, as at Boxwood in the piedmont town of Madison, gardeners planted front, rear, and side yards with these formal parterres of boxwood, but more usually they planted the front yard alone, as at Valley View in north Georgia and at the president's home at the University of Georgia in Athens.

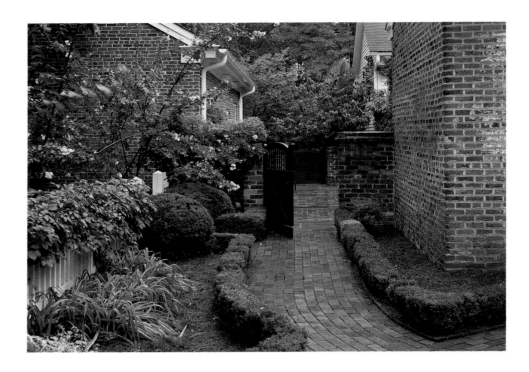

Few places in America can claim the gardening traditions of Athens, where the Ladies Garden Club founded the American garden club movement in the 1890s. (Professor Hubert Bond Owens stated: "The Garden Club movement is a phenomenon peculiar to the United States of America. The first garden club in the world was organized in Athens, Georgia, in 1891.")

In 1928, in the rich gardening environment of Athens, the department of landscape design began to evolve at the University of Georgia largely through the efforts of Professor Hubert Bond Owens (1906-1989), a Georgia native and University of Georgia alumnus. Professor Owens headed the program he established until his retirement as emeritus professor in 1973. Coincidentally, 1928 also marked the incorporation of the statewide Garden Club of Georgia, and these two entities, one lay and the other academic, have been extraordinary forces in the garden movement of this state ever since.

The on-campus location of the headquarters of The Garden Club of Georgia, Inc., represents the close association of the two entities. Situated on the historic North Campus, the headquarters complex consists of a brick, 1856 former faculty residence with its outside kitchen and smokehouse surrounded by the Founders' Memorial Garden, which comprises two and one-half acres of gardens and landscaped grounds. In his *Personal History of Landscape Architecture, 1922-1982*, Professor Owens wrote: "The Founders' Memorial Garden stands as both a fitting memorial to the founders of the Ladies Garden Club of Athens and a living laboratory for students of plant sciences and outdoor design."

In 1933, as a contribution to the bicentennial celebration of the founding of Georgia, the distinguished Peachtree Garden Club of Atlanta published the *Garden History of Georgia, 1733-1933*, an exceptional resource that we regard as primary to understanding

Courtyard gate, Founders' Memorial Garden, Athens.

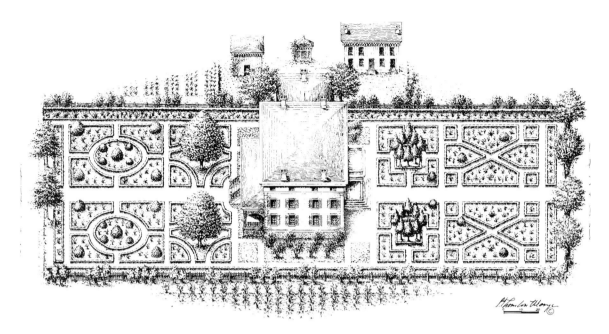

and appreciating the traditions of gardens in Georgia. Appearing before our day of color photography, this black-and-white masterpiece of information has an importance all its own, especially due to the classic pen-and-ink bird's-eye views of significant Georgia gardens drawn specifically for the publication by the Atlanta architect P. Thornton Marye (1872-1935). Marye's wife, Florence Nesbit Marye (1877-1963), composed "Georgia's Early Gardens," the first portion of the informative text. A selection of Marye's drawings help illustrate *Gardens of Georgia*, uniting the two books into a continuing tradition. (In 1976, the Garden Club of Georgia, Inc., with permission of the Peachtree Garden Club, reprinted the *Garden History* as its United States bicentennial project.) *Gardens of Georgia*, therefore, stands in a distinctive heritage of many labors of love for the traditions of gardens and gardening in Georgia.

Blessed with what James Edward Oglethorpe called "this happy Climate," Georgia has persevered to fulfill the promise of the early dreamers who envisioned it as a New World paradise—from the eighteenth-century efforts of botanists John and William Bartram, who came to Georgia to collect plant species and identify and document the special flora; to the nineteenth-century days of Louis LeConte's internationally renowned floral and botanical garden at Woodmanston Plantation; and now to the twentieth-century commitment of Virginia and Cason Callaway's 2,500-acre public garden and botanical preserve for the rare plumleaf azalea, *Rhododendron prunifolium*, on the southern slope of Pine Mountain near LaGrange.

To preserve and protect an always vulnerable natural environment and help nature bring forth its green and glowing cycles of rebirth is each generation's richest legacy to the next. By recording representative, as well as outstanding, Georgia gardens as they appear in the twilight of the twentieth century, *Gardens of Georgia* shares in that ongoing dream of a new Eden—even if the paradise is only a small plot of perennials in a Georgia yard, "far from the madding crowd's ignoble strife" (Thomas Gray, "Elegy Written in a Country Churchyard," 1750).

Boxwood, the Kolb-Newton House in Madison, c. 1852, retains the original boxwood parterre gardens in front and rear. The drawing by P. Thornton Marye is on page 87 of the <u>Garden History of Georgia, 1733-1933</u>.

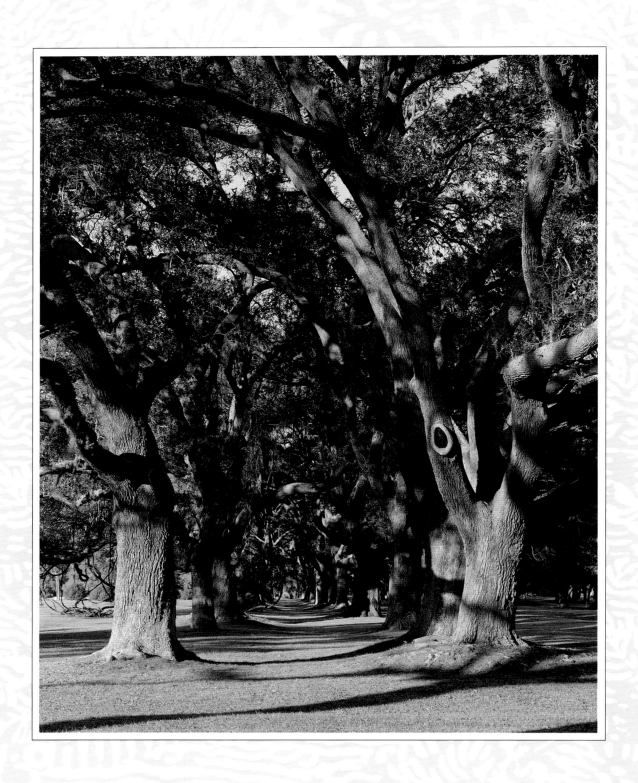

Oak alley, ca. 1848, Retreat Plantation, St. Simons Island.

SAVANNAH AND THE COAST

THE LAND we call "coastal Georgia"—the islands, marshes, and piney plains along the Atlantic coast south of the Savannah River—was once known in London as a "future Eden," situated in the "Most Delightful Country of the Universe." Accounts by early European explorers, renowned botanists and horticulturists, and serious gardeners through the years describe the land as an unusually verdant, gardener-friendly corner of the world—"delightful," certainly, and a southern frontier that promised to become an Eden for those willing to work to realize their dreams.

This area between the British Carolinas and Spanish Florida had been a source of wonder and contention for several centuries before it was included in the charter for the thirteenth British colony in 1732. When George II formalized the grant to establish the colony in his name, this botanically rich region became the coast of *Georgia*.

Regardless of the name this wild, exotic landscape had inspired rapturous accounts of its beauty by Europeans since the sixteenth century. In 1562, French explorer Jean Ribault sailed the warm waters, and he filled his journal with descriptions of a wondrous garden land: "It is a thing unspeakable to consider the things that bee seene there, and shal be founde more and more in this incomperable lande, which, never yet broken with plough yrons, bringeth forth al things according to his first nature wherewith the eternall God imbued it."

Camellia in the garden of Mrs. Arthur Solomon, Isle of Hope, Savannah.

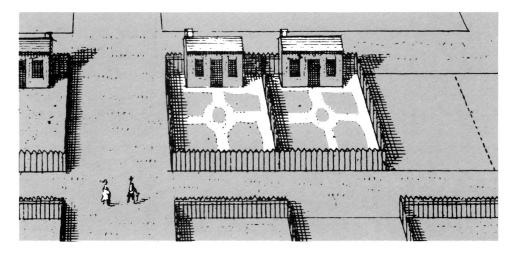

The French visited the coast and formed early alliances with the Indians to the west, but the Spanish were the first Europeans to inhabit the islands for any length of time. Intent on extending their influence north of St. Augustine, the Spanish established missions in the region in the sixteenth century. They called the coast Guale (pronounced "wally") for the tribe of Muskogean-speaking Indians who inhabited several of the islands.

Although they made concerted efforts to introduce cultivation techniques to the nomadic tribes and are generally credited with first importing the peach, orange, lemon, fig, pomegranate, and olive to the region, neither the Jesuits nor the Franciscans who followed were able to maintain a lasting Spanish presence. But, while the missions themselves did not take root, several varieties of Old World and Far East plants found the area hospitable and thrived in their new home.

In 1717, in an effort to secure their southern border against the French, Indians, and Spanish, the Lord's Proprietors of South Carolina granted to Sir Robert Montgomery, a Scottish baronet, a strip of land across the Savannah River, contingent on his settling it within a three-year period. To attract settlers to this "future Eden," Sir Robert published *A Discourse Concerning the Establishment of a New Colony to the South of Carolina in the Most Delightful Country of the Universe.*

In a similar vein, he published his *Description of the Golden Islands* in 1721. Prior to the eighteenth century, explorers had referred to these islands as golden, but Montgomery's work popularized the usage, and today they are still known as the Golden Isles. Sir Robert expressed many familiar themes that have been used through the centuries, and, in the eighteenth-century tradition of promotional literature, he warmed to his subject the more he wrote:

> Paradise with all her Virgin Beauties, may be modestly suppos'd at most
> but equal to its Native Excellencies. . . . It lies in the same Latitude with
> Palestine Herself, That promis'd Cannan. . . . 'Tis beautified with odorif-
> erous Plants, green all the Year. . . . The Air is healthy and the Soil in
> general fruitful, and of infinite Variety. . . . They have every Growth,

A detail from the prospect of Savannah James Edward Oglethorpe commissioned in 1734 shows the outlines of parterre gardens — an early attempt to bring English order to the wild nature of coastal Georgia.

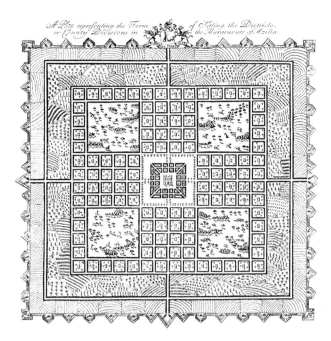

which we possess in England, and almost every Thing that England wants besides. . . . The River Banks are cover'd with a strange kind of lovely Trees, which being always Green present a Thousand Landskips to the Eye.

Montgomery called his territory Azilia, a fanciful name redolent of the wild azalea plant that abounds in the area, and, although his rhetoric, spelling, and geography are somewhat different from ours, there is truth in what he wrote, as anyone who has spent time on the Georgia coast knows.

Sir Robert never realized his vision, however, and, as South Carolinians continued to demand help from England to stabilize the area, it fell to James Edward Oglethorpe and the Georgia Trustees to create an English colony along the coast.

As part of his well-considered plan to settle the colony successfully, Oglethorpe published a pamphlet before leaving for America. He wrote in 1732: "It lies about the 30th and 31st Degree North Latitude, in the same Climate with the most temperate Parts of Persia and China. All things will undoubtedly thrive in this Country that are to be found in the happiest Places under the same Latitude. . . . Such an Air and Soil can only be fitly described by a Poetical pen, because there's but little Danger of exceeding the Truth . . . of this happy Climate."

As if Oglethorpe's own pen were not poetical enough, he even quoted lines of doggerel verse composed about South Carolina, which he said applied even more to Georgia:

Ripe Fruits and Blossoms on the same trees live,
At once they promise, what at once they give
So sweet the air, so moderate the Clime,
None sickly lives, or dies before his Time
Heav'n sure has kept this Spot of Earth uncurst,
To shew how all Things were created first.

Sir Robert Montgomery's 1717 design for the Margravate of Azilia,
his unrealized dream of a feudal colony south of the Savannah River.

By using a recurring reference to coastal Georgia sharing the same latitude as the Garden of Eden (where "all Things were created first"), Oglethorpe hoped to attract prospective settlers, and he set a tone of reverence which has often been repeated and exists even to this day.

An army officer and member of Parliament, Oglethorpe was the only Trustee who came to America. With 115 colonists, he sailed from England aboard the *Anne* in November 1732. Three months later, in early February 1733, he pitched a tent at Yamacraw Bluff above the Savannah River and began to stake out his design for the new town, which he and the other Trustees had decided to name Savannah, for the river that gave it access to the sea.

To acquaint the English with his colonial undertaking, Oglethorpe returned to London after little more than a year and had an engraving prepared of how Savannah had looked when he left. It showed an embryo town at the edge of a tall pine forest and a series of London-like squares, waiting to be developed, with a grid of sixty-by-ninety-foot town lots. On these a number of sixteen-by-twenty-four-foot cottages had been built, each with a rear garden plot. Even under frontier conditions, these modest plots had the lines of the formal, walled parterre gardens that were to become the most honored way of gardening in the Savannah historic district.

Today there are twenty-one tree-shaded squares, the descendants of Oglethorpe's plan. Georgian-style houses still surround some squares, and their rectangular lots have the original sixty-by-ninety-foot configuration, or some proportion thereof. The landscaped squares are garden oases that continue to prove the nineteenth-century sobriquet of Savannah, "The Forest City."

As part of the Trustees' design for the new colony, a ten-acre experimental nursery was planted in Savannah on the eastern edge of Yamacraw Bluff. Around 1740 Francis Moore, the keeper of the stores for the city, described the first planned Georgia garden:

> The Garden is laid out with Cross-walks planted with Orange-trees, but the last Winter a good deal of Snow having fallen, had killed these. . . . In the Squares between the Walks were vast Quantities of Mulberry-trees . . . there are in some of the Quarters in the coldest part of the Garden, all kinds of Fruit-trees usual in England such as Apples, Pears, etc. In another Quarter are Olives, Figs, Vines, Pomegranates and such Fruits as are natural to the warmest Parts of Europe . . . and in the warmest part of the Garden, there was a Collection of West-India Plants . . . some Coffee, some Cocoa-Nuts, Cotton, Palma-christi, and several West-Indian physical Plants. . . . There is a plant of Bamboo Cane brought from the East Indies . . . which thrives well. There was also some Tea seeds which came from the same Place; but the latter, though great Care was taken, did not grow.

Unfortunately, the garden fell to ruin about a decade after its creation, but the historic site on the eastern edge of downtown Savannah is still referred to as "Trustees' Garden" almost 250 years later.

Surviving old gardens are rare in twentieth-century Savannah, but the tradition of formal, enclosed gardens, with origins as far back as Oglethorpe's era, remains. The following gardens in the downtown Savannah historic district continue and restate this tradition; each is a harmonious variation on the theme of beauty derived from order and repetition among limited plots of urban green space.

Several of the suburban gardens illustrated are also firmly in the walled-garden tradition. The stately Wormsloe gardens owe much to their English heritage, and the wild setting on the broad and beautiful marsh along the Skidaway Narrows reminds us that this still-glorious landscape was once called "our future Eden."

In 1733, long before the town squares and avenues of Savannah would be dressed in the myriad blooms of camellia, azalea, and dogwood, a poet wrote these lines of verse about Georgia in the *South Carolina Gazette*: "Fair in the garden shall the Lemon grow/ And every Grove Hesperian Apples show."

Hesperian apples are apples of pure gold, and it was a golden and perhaps carefree paradise some people envisioned. But as the early settlers were to discover, and as all gardeners know, a successful garden is gained by careful planning and the sweat of one's brow — even in the paradise of coastal Georgia.

Johnson Square, at the intersection of Bull and St. Julian streets,
is typical of the twenty-one remaining Savannah squares — downtown outdoor living rooms decorated
with shade trees, ornamental shrubs, and monuments to heroes and ideals.

East Charlton Street
BATTERSBY-HARTRIDGE GARDEN

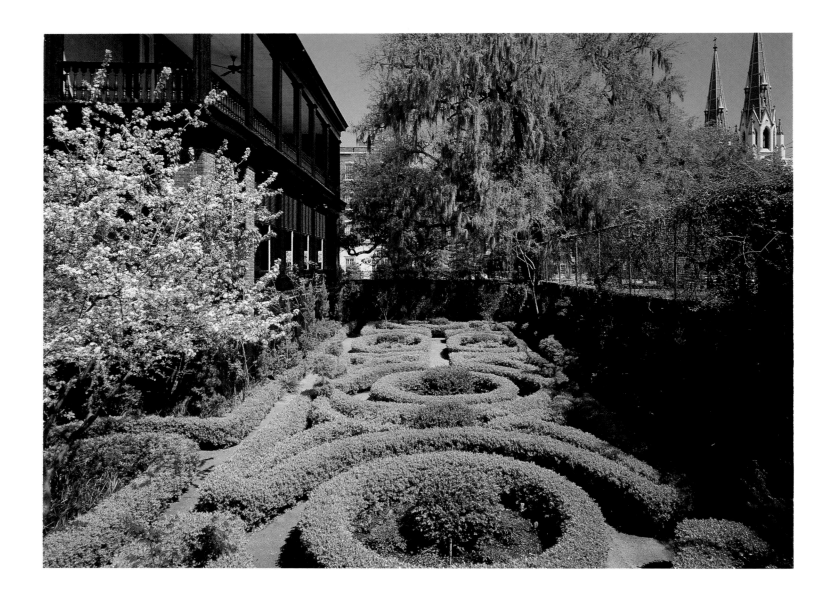

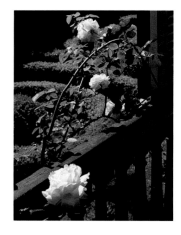

In 1852 William Battersby, an English cotton merchant residing in Savannah, built this house and walled garden facing Lafayette Square on the southwest corner of Lafayette Ward. One of only a few surviving antebellum parterre gardens in Savannah, it is the only one that is viewed from a side entrance porch of the Barbadian or Charleston style. A descendant of Mrs. Battersby's brother lives here with his family, more than 125 years after this exceptional house and garden were constructed. He and his wife preserve the tile-edged, box-bordered parterre garden, in plan essentially as it was originally conceived. Several plants that may date from the antebellum period thrive here, among these are a Cherokee rose and a white Banksia rose, both a full three stories high.

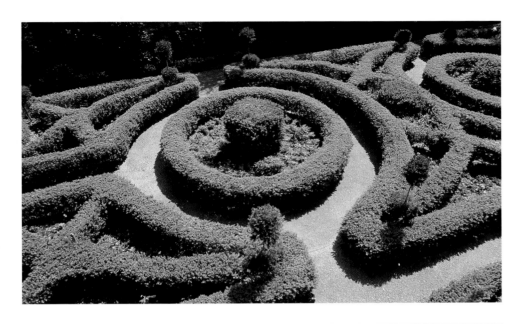

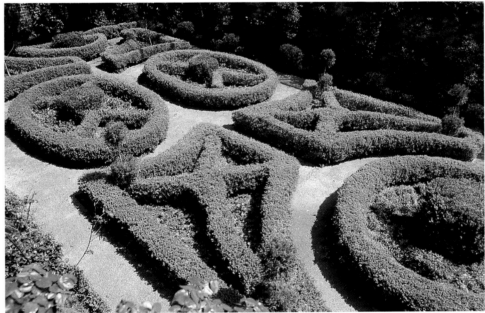

Parterre designs as viewed from the porch level.

Colonial Dames House
Abercorn Street at Lafayette Square

ANDREW LOW GARDEN

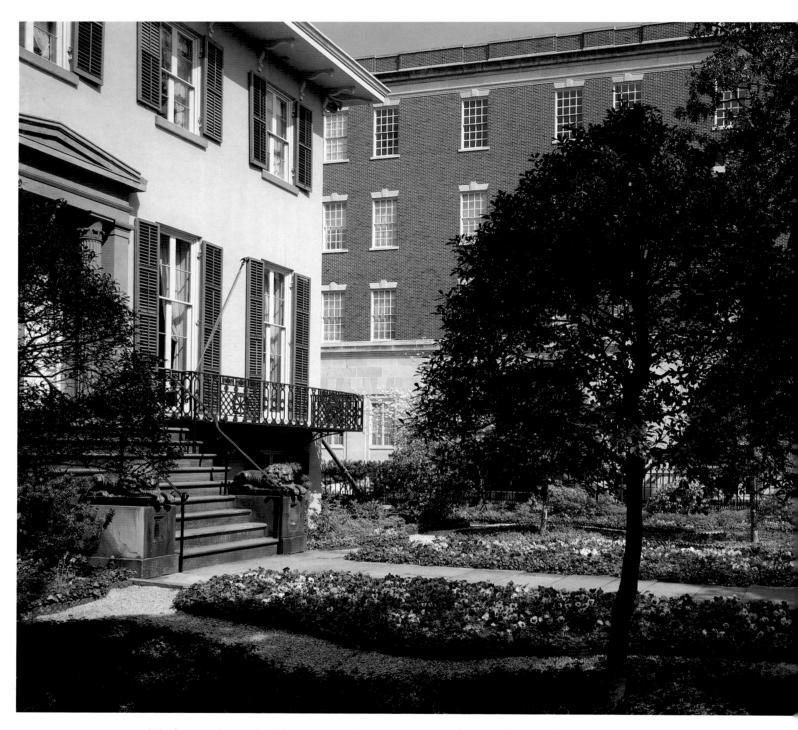

The front garden, enclosed by a cast-iron fence, preserves its mid-nineteenth-century hourglass design
(bird's-eye rendering on opposite page by P. Thornton Marye), and it is one of four parterre gardens in Savannah
to retain its original tile-edged pattern. The beds feature seasonal flowering annuals that can be viewed from the
sidewalk. Facing Lafayette Square since it was built in the late 1840s, the Andrew Low House was
Juliette Gordon Low's home when she founded the Girl Scouts of the U.S.A. March 12, 1912.
She died here in 1927, and the next year her heirs sold the property to the
Georgia chapter of the National Society of Colonial Dames as its headquarters and house museum.

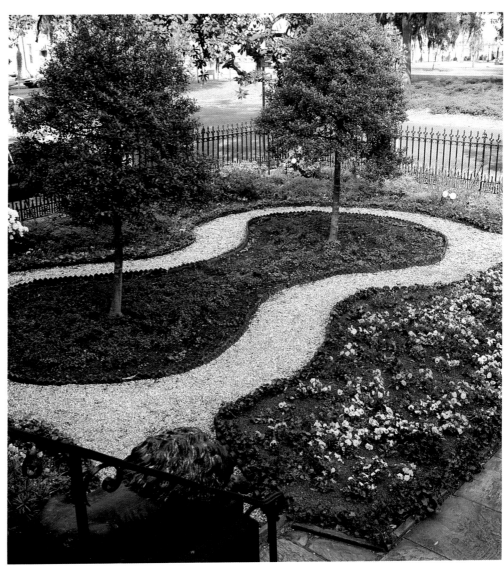

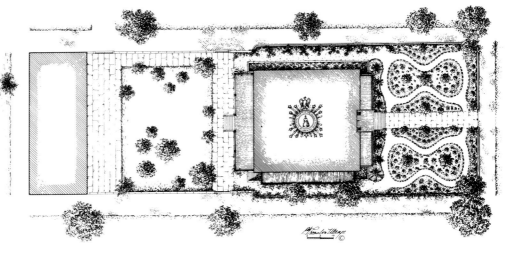

West Macon Street

GREEN-MELDRIM GARDEN

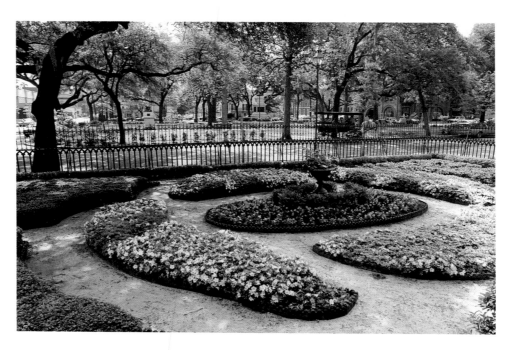

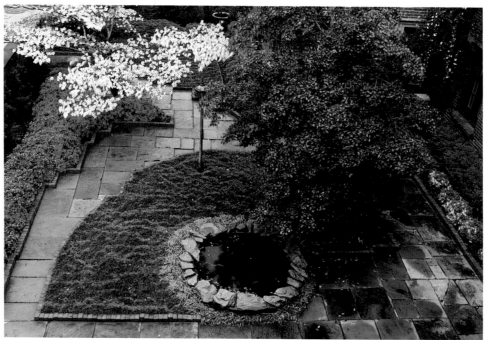

*Enclosed by the original iron fence, this garden retains its parterre design from the 1850s. On the east side of
the magnificent Gothic Revival Green-Meldrim House (now the parish house of St. John's Episcopal Church),
this garden (top) can be appreciated by passersby on Bull Street while serving as a buffer between the
side veranda and Madison Square. The house was designed by the New York architect John S. Norris for
Charles Green and was used by General William T. Sherman as his headquarters in December 1864.
The rector's private parish house garden (above) offers a quiet sanctuary from the city streets.
A National Historic Landmark, the house and garden are open to the public at specified hours.*

Juliette Gordon Low Birthplace and Center
Oglethorpe Avenue and Bull Street
GARDEN AT JAMES MOORE WAYNE HOUSE

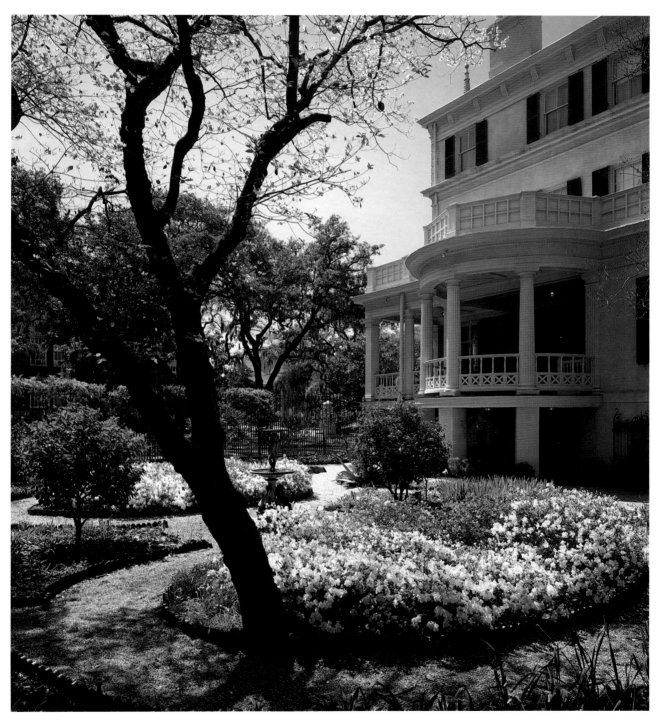

The founder of the Girl Scouts of the U.S.A., Juliette Magill ("Daisy") Gordon, was born in this house in 1860,
and here, in 1886, she was married to Andrew Low's son, William Mackay Low of Savannah and London.
For her wedding, the house, which had been built in 1820 and enlarged several times, was again renovated
and a curved piazza was added overlooking the side garden. The Girl Scouts purchased the property from
the Gordon family in 1953 to use as a center for scouting activities and as a memorial to their founder. In 1954,
Miss Clermont H. Lee, a distinguished landscape architect and historian, designed the present space to re-create
an authentic parterre garden of the Victorian period in Savannah. The house and garden are open regularly.

Abercorn Street at Oglethorpe Square

GARDEN AT RICHARDSON-OWENS-THOMAS HOUSE

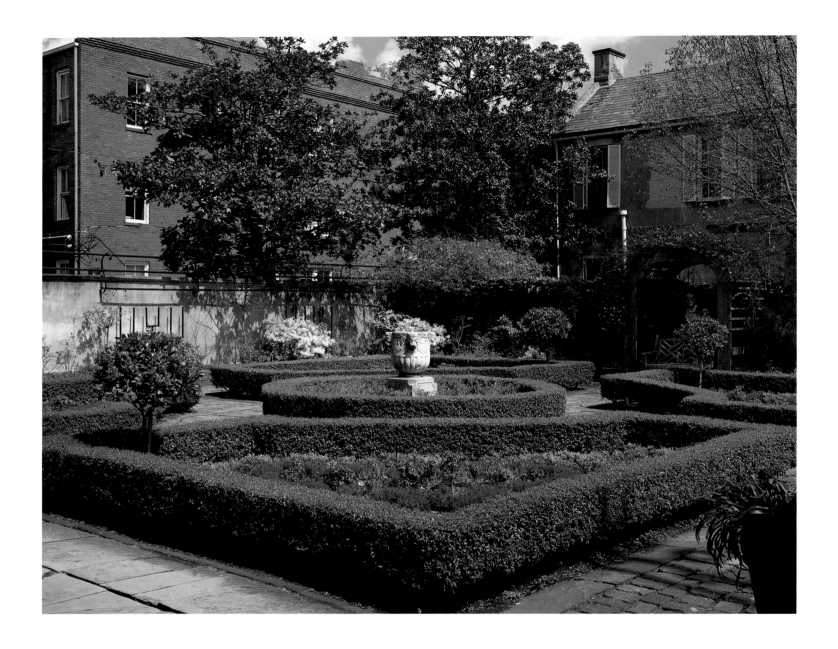

Miss Clermont Lee, who designed this garden, described it for Gardens of Georgia: *"The former back service courtyard was designed in 1954 for Telfair Academy of Arts and Sciences to be a period (1820) setting for a restored house. It is a five bed scheme, an American adaptation of a small, formal English Regency garden. The garden walls are of tabby and brick; the walks are of imported ballast stones. A simple grape arbor of cypress is based on one at Salem, Massachusetts. An old Italian marble urn is used in the central bed and is a central feature of the garden."*

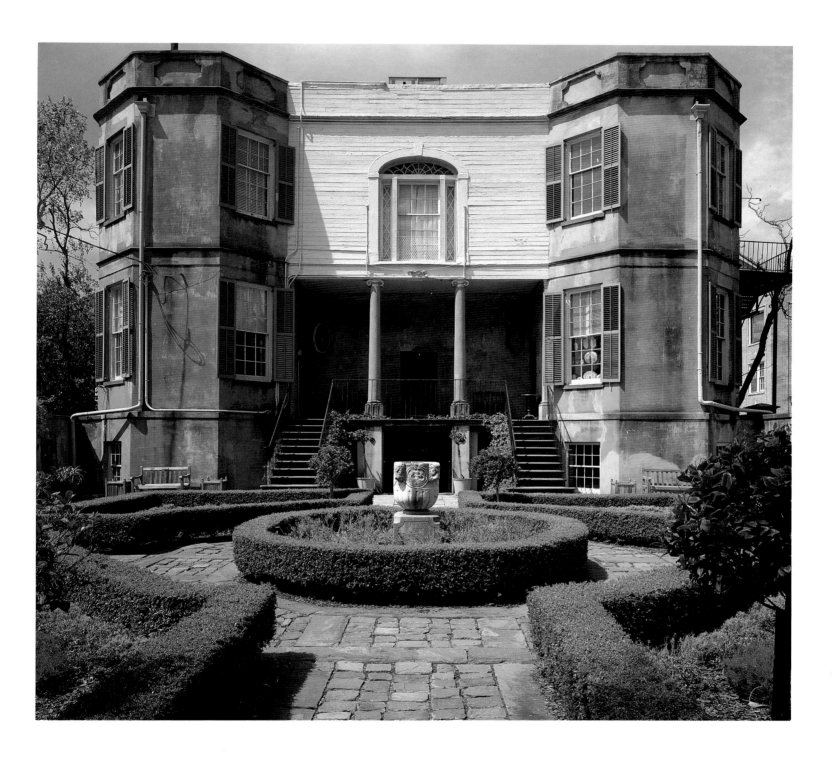

Louisa Farrand Wood revised Miss Lee's period planting scheme and selected modern cultivars for easy maintenance.
Located on a trust lot facing Oglethorpe Square, the Owens-Thomas House was designed by William Jay,
an English architect, and built for Richard Richardson, a Savannah banker, between 1816 and 1819.
The house and garden are open to the public.

West Broad Street

GARDEN AT WILLIAM SCARBROUGH HOUSE

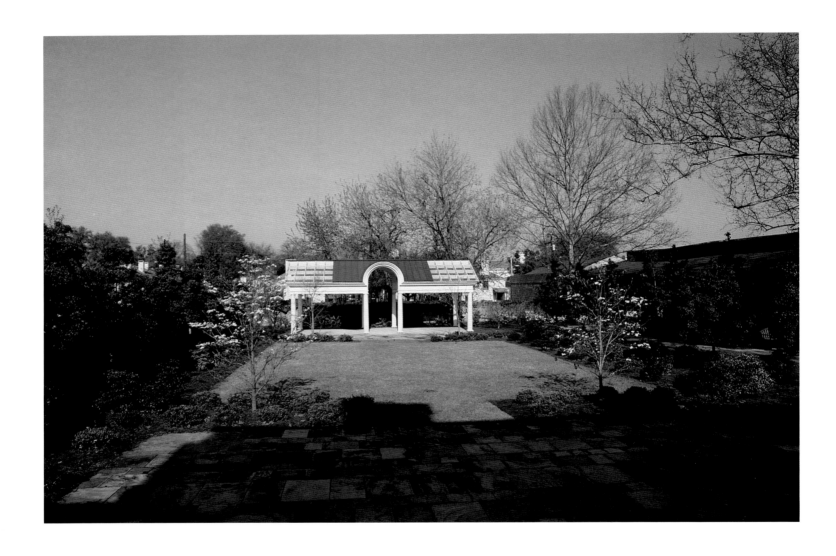

The garden that may have existed when the William Scarbrough House was built in *1819* is unknown. In May of that year, William and Julia Scarbrough, for whom William Jay designed the house, received President James Monroe here while he was in Savannah on his southern tour. Now the headquarters of the Historic Savannah Foundation, Inc., the house was restored and opened to the public in *1977*. In *1982* the present garden (top)—a modern interpretation of traditional Savannah gardens—was created as an ongoing project of the Trustees' Garden Club. All flowering plants used are white, with the exception of six pink camellias near the pavilion. Carolina jasmine (at left) blooms on the curving handrail leading to the house from the rear garden.

Habersham Street

CARSWELL GARDEN

The John Mongin House, built in 1797 facing the square in Warren Ward, is one of only a few buildings in Savannah which survives from the eighteenth century. This area of Savannah was renovated in the 1960s largely through the efforts of the Mills Bee Lanes. One of their finest restorations was this two-story Federal-style frame house, which they had moved across Warren Square and restored on this site. The present owner had the rear garden redesigned several years ago, changing the central bed of the parterre into a reflecting pool. The perimeter beds contain dogwoods, azaleas, and crape myrtles, and the central beds are planted with annuals and changed with the seasons. Whether glimpsed from the side gate or enjoyed from the comfort of the porch, this tranquil spot captures the spirit of the historic gardens of downtown Savannah.

East Jones Street

KOGER GARDEN

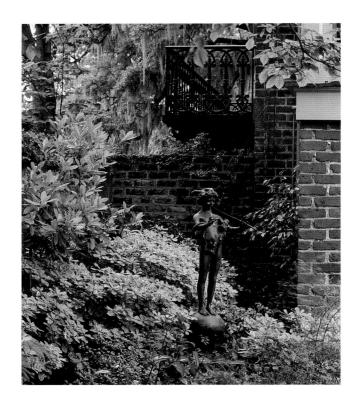

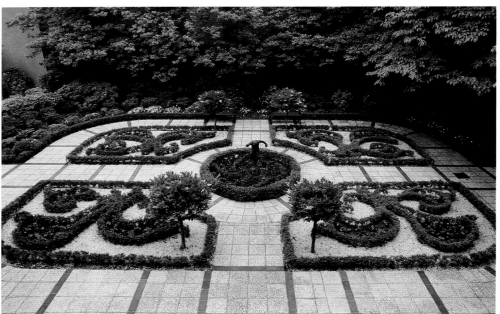

A major garden laid out in recent years with a respect for Savannah precedents, this is more spacious than any
other in the historic district, and even includes a swimming pool at the rear wall. A side instead of a back garden,
it has evolved over a decade with the help of several designers: among them the Kogers' Jones Street neighbors,
James Morton and Louisa Farrand Wood. Their additions include the fleur-de-lis patterns set in gravel and four
topiary trees of ligustrum. These elements complement the superb Italianate house built by Abraham Minis II
in 1860. The bronze statue of Pan (top) is by Frederick MacMonnies.

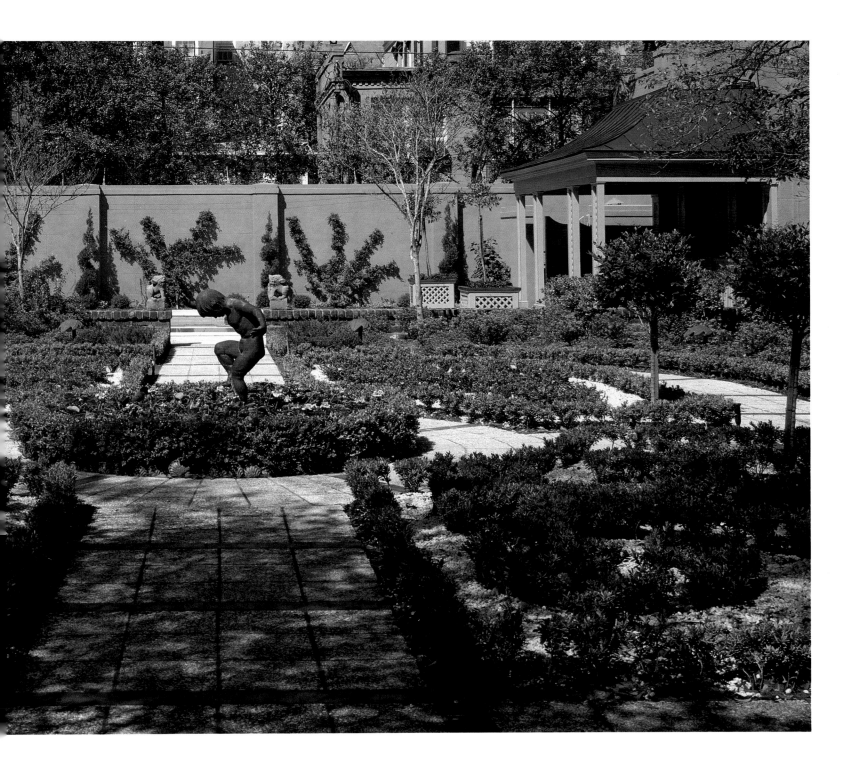

East Jones Street

WOOD GARDEN

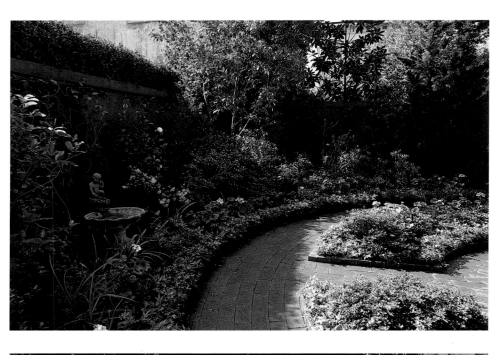

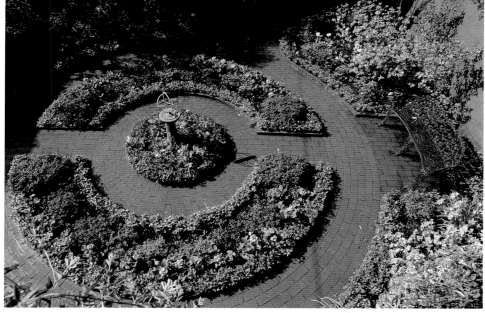

Louisa Farrand Wood, a leader in designing and maintaining traditional Savannah gardens, planned her intimate garden as a circle within the square at the rear of her mid-nineteenth-century townhouse. Surrounded by terra-cotta stained stucco walls and brick paths of the same hue, Mrs. Wood's garden—like most others in Savannah— is designed to be viewed from the "parlor floor" above the street level, as well as from within the walls. This and the Jones Street gardens nearby are fine representations of the revived art of enclosed gardening in Savannah.

East Jones Street
MORTON GARDEN

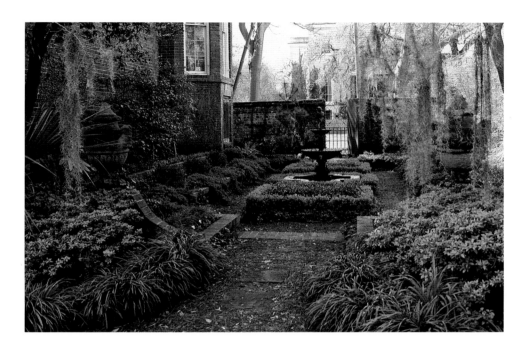

In Georgia the plot of land around one's home is often called "the yard." Until Mr. Morton began to restore this property, the area that has become his garden was what he calls a "flat dirt yard." The walled space dates from the late 1850s when this corner townhouse of Savannah grey brick was built. The L-shaped garden, designed by Morton with a front, south-north axis (top) and a rear, east-west axis (above), has evolved since 1976 into an oasis in the style of nineteenth-century Savannah gardens. The cast-iron fountain in the center of the sunken parterre dates from about 1870, when it was imported from New York for a Savannah garden. Among the myriad plants that thrive in "this happy Climate" are: Savannah holly, creeping fig, crape myrtle, azalea, daylilies, dogwood, nandina, fanpalm, tea olive, gardenia, bamboo, pampas grass, cherry laurel, Spanish bayonet, Chinese wisteria, Chinese tallow (popcorn) tree, and Japanese boxwood, yew, and maple. Morton's across-the-street neighbor, Louisa Farrand Wood, inspired his work as she has many others in her adopted city.

West Charlton Street
WEBSTER GARDEN

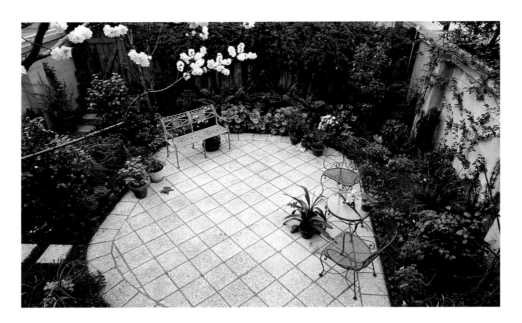

The owner planned this courtyard garden to give herself space for growing some of her favorite plants,
including the double-flowering peach shown as it bloomed in the spring of 1988. She reports: "My friends say
that in my space of twenty-two-by-twenty-six feet, I have enough plants to cover Forsyth Park
(thirty-two acres)." She has graciously opened her garden for the numerous fund-raising tours
that Savannah organizations are known for. Maintaining the garden herself, she states: "I do believe the old saying
that one is 'nearer to God in a garden than anywhere else on earth.'"

Abercorn Street in Ardsley Park
TROSDAL-MOORE GARDEN

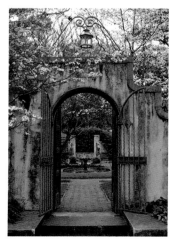

Mrs. Lucy Boyd Trosdal created this series of two adjoining walled gardens more than fifty years ago in Ardsley Park, the garden suburb south of the historic district. When her garden was featured in black and white in the Garden History of Georgia, 1733-1933, Mrs. Trosdal had enjoyed it for only three years. The Rutledge Moores have retained many of the original elements, including the decorative well-head (top) pictured on page 378 in the Garden History.

Atlantic Avenue in Ardsley Park
DULANY GARDEN

This walled garden in the Ardsley Park neighborhood was begun in the 1930s, and it retains many of its original elements. It has thrived and evolved with the help and inspiration of many people: the Dulanys; Miss Clermont Lee; Ryan Gainey, a garden designer from Atlanta; and Rosemary Verey of England. Mrs. Dulany tries plants seldom found in Savannah and reports: "The old camellias and azaleas planted in the 1940s form a background for the newly planted patterns of the garden's interior." She adds: "It is a blend of structure — with the pattern of paths and clipped box — and freedom — with the profusion of flowers spilling over on all sides."

Washington Avenue in Ardsley Park
DIXON GARDEN

Washington Avenue runs east and west parallel to Victory Drive through the garden-like suburb of Ardsley Park; the oak-lined avenue and the palm-lined drive help establish the special Savannah quality of this neighborhood now listed in the National Register of Historic Places. The Merritt Dixons call their Washington Avenue garden the "Hideaway of Four Seasons." Their hideaway is a contemporary variation on the Savannah garden; behind its eight-foot-high brick walls are found native azaleas, coral woodbine, Florida anise, yellow gloriosa lilies, and trailing rosemary.

Chatham County
REEVE AND BRADLEY GARDENS OF SYLVAN ISLAND

*The gardens of the four families that reside on Sylvan Island are represented here by those of the Reeves (top)
and Bradleys (above). Sylvan Island is a Shangri-la on the Herb River southeast of downtown. Elwin J. Lasser,
a Savannah landscape architect, formed the grounds of these two residences with an emphasis on preserving the
natural setting. Native plants such as yaupon holly, dogwood, magnolia, and sweet shrub abound in this island enclave.*

Beaulieu Avenue, Chatham County

ANGELL GARDEN

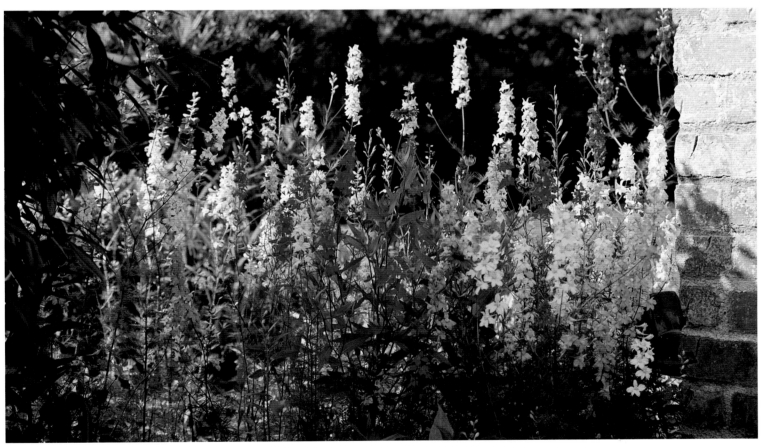

The neighborhood called Beaulieu has been settled since the eighteenth century on the east bank of the Vernon River,
south of downtown Savannah. This Beaulieu Avenue garden was designed by its original owner, George S. Clarke, Jr.,
with additions by Mrs. John Angell and her son, Thomas W. Angell, a landscape architect. In addition to
beds of larkspur (above) and other perennials, she has a large collection of azaleas and camellias and states: "I am
increasingly interested in perennials and decorative herbs that will survive the heat and humidity of our Georgia
summers. With research and experience, I feel strongly that year-round bloom can be achieved in this climate."

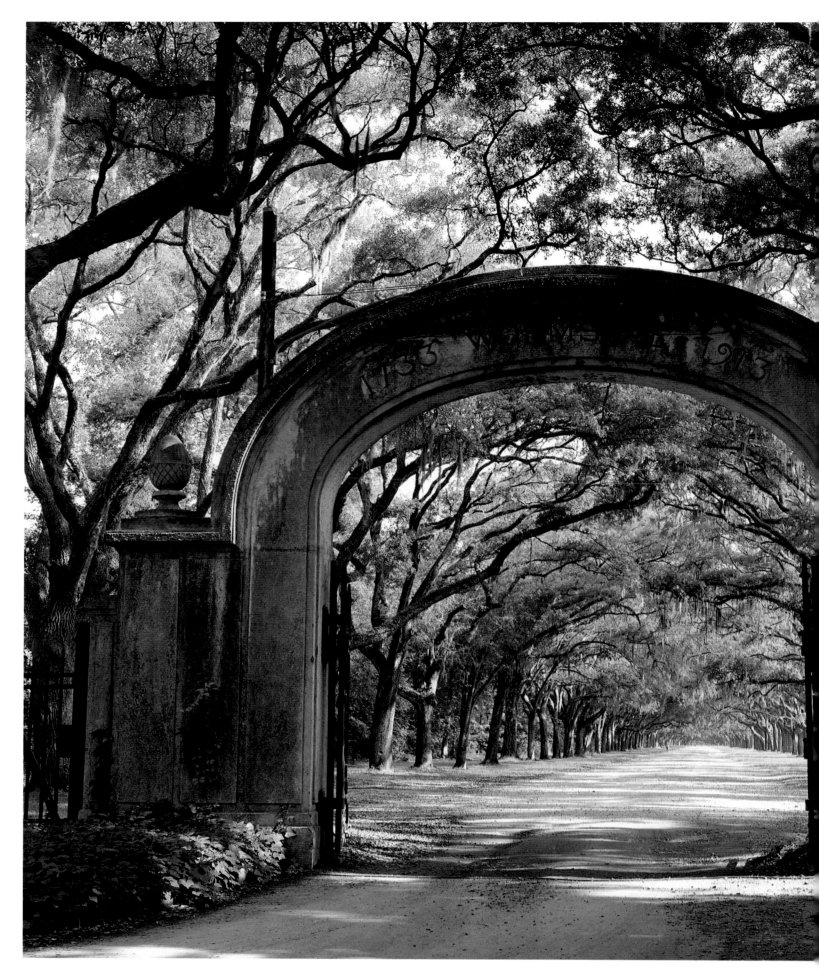

Isle of Hope, Chatham County
WORMSLOE

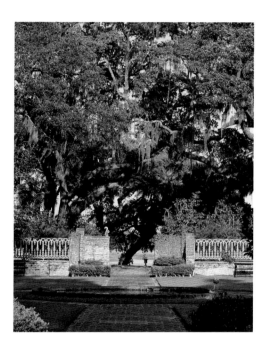

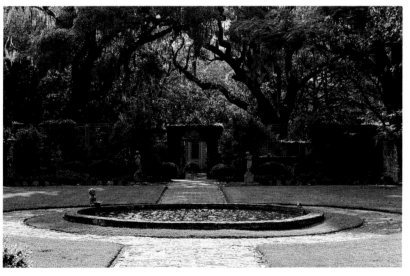

Noble Jones acquired Wormsloe in the 1730s soon after he arrived with Oglethorpe aboard the Anne. (The Isle of Hope and Wormsloe were named for the early colonists' hope that silk worms feeding on the leaves of white mulberry trees would produce the white gold of a profitable silk crop.) Almost two centuries later, in 1928, Augusta Floyd DeRenne and her husband, Wymberley W. DeRenne, a descendant of Noble Jones, designed the formal walled garden at the rear of the house at Wormsloe. A significant plantation, Wormsloe and its garden were featured in the Garden History of Georgia, 1733-1933, and, although somewhat simplified, the garden remains as designed. Members of the Noble Jones family have owned Wormsloe since the earliest days of the Georgia colony, and the present generation of Jones descendants is the family of Mr. and Mrs. Craig Barrow III. Mrs. Barrow says much of the old plantation has become a deer park, and, because of the animals' voracious habits, "Unfortunately very few plants survive."

I was fain to think that I had landed on some one of those fairy islands said to have existed in the Golden Age.
John James Audubon, 1831

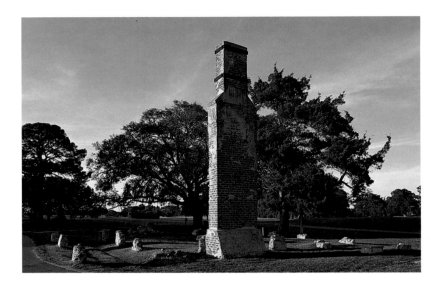

COASTAL GEORGIA

RURAL LIFE in eighteenth- and nineteenth-century coastal Georgia rarely matched the idyllic expectations of many early settlers. Vivid descriptions of the aesthetic and botanical glories of the Golden Isles created a popular, but misleading, concept of a natural paradise of leisure and plenty. For example, a 1745 description by an anonymous "itinerant observer":

> Nature, in all its gay Varieties, seem'd to open her Charms to delight our Senses, in our little inland Voyage from St. Simons Island. . . . My Mind will ever retain the Diversity of Scenes that presented to our admiring Eyes in this Passage; . . . the prodigious Confusion of Objects . . . make Imagination sick with Wonder. . . . the delicious Mulberry, the swelling Peach, the Olive, the Pomegranate, the Walnut, all combine to furnish out the Paradisaical Banquet.

But the banquet in paradise came with hidden costs. The same conditions that encouraged the proliferation of botanical excess—short mild winters, rich damp soil, and moist ocean air—also had effects that were not so desirable. The combination of high humidity and searing heat had a considerable depressing effect on midsummer productivity; the hearty, multitudinous, indigenous weeds overran an untended garden practically overnight; and the voracious sand gnat and malarial mosquitoes found this to be a "happy climate" as well. As a result, many plantation owners were only part-time residents of their low-country farms and had retreats in more hospitable climes during the

The ruins of several eighteenth- and nineteenth-century buildings at Retreat Plantation
have been preserved as part of the unique atmosphere at the Sea Island Golf Club on St. Simons Island.

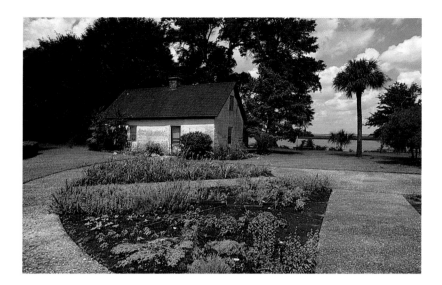

summer months. Even into the mid-nineteenth century, coastal Georgia remained a somewhat wild and isolated place. Grand plantation homes and formal gardens were uncommon, but there were some splendid exceptions.

Several significant plantation families resided on St. Simons Island. The Spalding, King, Couper, and Hamilton families were known and respected not only on the East Coast, but in Europe as well. At Cannon's Point, John Couper and his son, James Hamilton Couper, maintained a remarkable garden of plants brought from all over the world, including two hundred olive trees imported from France.

At Retreat Plantation, on the south end of the island, Anna Page King developed one of the most famous gardens in the South. When John James Audubon happened on Retreat in 1831, he wrote, "I was fain to think that I had landed on some one of those fairy islands said to have existed in the Golden Age."

On the mainland, just south of Darien, was the extensive rice plantation of Pierce Butler, who also owned Hampton Plantation, on St. Simons. Butler's wife, the English actress Fanny Kemble, was the quintessential disillusioned coastal resident — probably the most literate, and certainly the most outspoken. Her *Journal of a Residence on a Georgian Plantation in 1838-1839* is a litany of bitterness and contempt for her rude accommodations and the institution of slavery, but it also contains some of the most lovely descriptions of the natural grandeur of coastal Georgia ever written. In a letter to Elizabeth Dwight Sedgwick, she wrote:

> As I skirted one of these thickets today, I stood still to admire the beauty of the shrubbery. Every shade of green, every variety of form, every degree of varnish, and all in full leaf and beauty in the very depth of winter . . . [and] I, bethinking me of the pinching cold that is at this hour tyrannizing over your region, look round on this strange scene — on these green woods, this unfettered river, and sunny sky — and feel very much like one in another planet from yourself.

This tabby slave cabin, one of two that are preserved on the site, dates from the 1820s, when it was one of many on the Hamilton Plantation at Gascoigne Bluff on St. Simons Island. Since the late 1920s, these two cabins have been headquarters of the Cassina Garden Club.

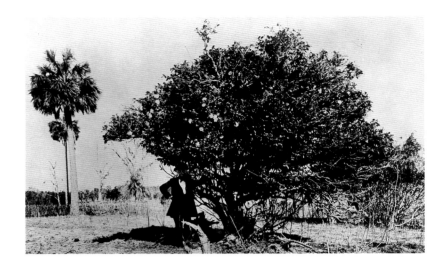

The Couper family of Cannon's Point, with that of James Hamilton, also established a notable mainland plantation called Hopeton on the Altamaha River, and James Hamilton Couper developed a simple, but elegant, formal garden at his mainland plantation, Altama. At Elizafield Plantation nearby, Hugh Frazer Grant established a large garden designed in the European tradition.

Further south, on the Satilla River, Colonel Charles Floyd and his son John developed large formal gardens at their plantations, Bellevue and Fairfield. On adjacent Cumberland, the largest and southernmost Georgia island, John Lyon maintained a grand walled garden at the plantation of Phineas Miller.

Perhaps the most intriguing of the mainland plantations was in one of the most unlikely of places—the soggy wilderness of Bulltown Swamp near Riceboro in Liberty County. Woodmanston Plantation was the home of Dr. Louis LeConte of New York, whose family contributed considerably to natural science. Dr. LeConte had made many visits south to his father John's Georgia property, and in 1810 he decided to manage it. When he fell in love and married a Liberty County girl, he forsook eastern city life for good and devoted his interest, energy, and intelligence to Woodmanston, and, most notably, to his botanical garden there.

By the 1830s, his garden was known throughout the East and in Europe—an 1850 article in Loudon's *Encyclopedia of Gardening* referred to an earlier account from Alexander Gordon: "The Garden of Lewis [sic] LeConte Esq., near Riceborough, is said by Mr. Gordon to be the richest in bulbs that he had ever seen. M. LeConte is an excellent botanist and vegetable physiologist. He has also paid great attention to the subject of arboriculture."

Mention of the huge camellias at Woodmanston is found in horticulturist George Lowe's report, "Horticultural History of the Georgia Coast": "In the LeConte gardens *Camellia japonica* reached its American peak, a double white growing to be two feet in diameter, of great height for the family, and furnishing 2,000 blooms for a wedding at

Dr. Joseph LeConte, standing in the shade of a large double white camellia, visited the abandoned Woodmanston gardens in 1897.

Walthourville in the memory of people still living. Joseph LeConte (Lewis [sic] LeConte's son) gave it as his opinion that the type had never grown larger anywhere."

The Civil War destroyed the coastal economy and ruined most of the great plantations mentioned here. At Woodmanston, nature quickly reclaimed the rice fields, and by the 1930s vandals and thieves had destroyed or carried off most of the remaining camellias and azaleas. Tragically, the last surviving camellia was lost to the careless blade of a bulldozer. The Garden Club of Georgia, Inc., has cleared the old home site and has ambitious plans to restore portions of the world-famous botanical garden.

Woodmanston is located on the old Fort Barrington Road, a principal north-south route often used by botanists in the early days of the colony. The Bartrams, John and his son William, passed this way several times on their travels in the eighteenth century, and, near Fort Barrington in McIntosh County, they discovered the rare (and now lost) *Franklinia alatamaha*. In his *Travels Through North and South Carolina, Georgia, East and West Florida*, William Bartram wrote: "I had the opportunity of observing the new flowering shrub, resembling the Gordonia, in perfect bloom, as well as bearing ripe fruit. It is a flowering tree, of the first order for beauty and fragrance of blossoms.... We never saw it grow in any other place, nor have I ever since seen it growing wild, in all my travels."

As a footnote, he added: "We have honoured [it] with the name of the illustrious Dr. Benjamin Franklin. *Franklinia alatamaha*."

The Bartrams did take specimens and seeds, and the plant was successfully propagated in Philadelphia and English greenhouses; but *Franklinia alatamaha* was last documented in the wild in 1790, and the mystery of its passing remains hidden in the swamps along the Altamaha River.

Today, coastal Georgians share the excitement and wonder of travelers like the Bartrams, and many would privately agree with Sir Robert Montgomery's opinion of the land of the "Golden Islands"—that "Paradise...may be modestly suppos'd at most but equal to its Native Excellencies....'Tis beautified with odoriferous Plants, green all the Year....The Air is healthy and the Soil in general fruitful." But, on a stifling August afternoon, even the most dedicated Georgians may feel Oglethorpe overstated the case about "this happy Climate." Then they can retreat to the shade of a screened summerhouse to turn on a ceiling fan and bless their glasses of iced tea garnished with sprigs of garden mint.

Regardless of the earthly reminders, the following gardens from the Golden Isles suggest the visions of Montgomery and Oglethorpe were not just dreams of a "paradise" or a "future Eden." From the swamps of Woodmanston to the manicured lawns of Sea Island, many coastal residents continue to believe the wisdom of a popular old verse—that one is "nearer God's heart in a garden, than anywhere else on earth."

Sea Island Golf Course, St. Simons Island
RETREAT PLANTATION

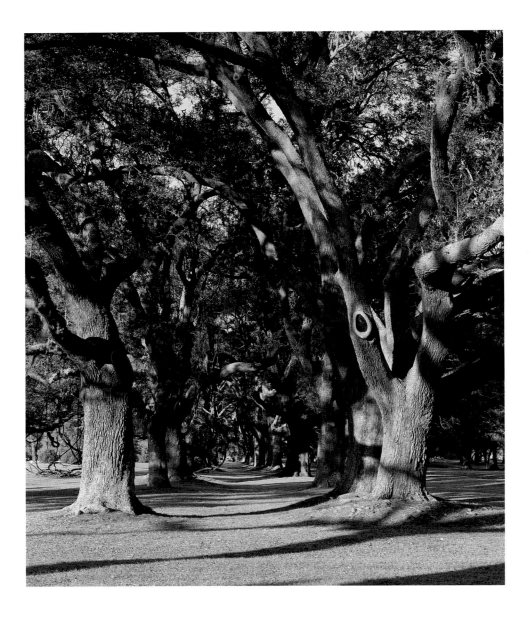

"Plantation life on the Georgia sea islands and the coast early took on a glamour that lasted until the economic organization which made it possible was smashed in the Civil War." So wrote E. M. Coulter in his classic Georgia: A Short History. Dr. Coulter singled out the Thomas Butler Kings of Retreat Plantation as coastal planters who "lived the life of feudal barons." The Kings' Retreat, on the south shore of St. Simons Island, was one of the four largest estates on the island and was previously owned by the Spalding and Page families. Anna Matilda Page King inherited the cotton plantation from her father in 1827, and, in addition to personally developing the Retreat brand of sea island cotton, she made the place into a garden spot known all along the Atlantic coast. Retreat has been called one of the first great arboretums in America.

Rare trees, plants, and flowers from all over the world were brought to Mrs. King, and visitors came, among them John James Audubon. Audubon extolled the exotic beauty of the Retreat gardens, where at one time Mrs. King had ninety-two kinds of roses in bloom. Little of her work survived the Civil War and Reconstruction. In 1927 Howard E. Coffin purchased the plantation site to incorporate into his Sea Island Club. A preservationist far ahead of his time, he adapted the tabby corn barn for use as the golf clubhouse, protected the ruins of several other buildings, maintained a proper space and respect for the slave cemetery, and preserved the stately plantation avenue of live oaks as the signature feature of the club. As a result, the Sea Island Golf Club has an aura of romantic history unlike any other course in the South.

Sea Island
THE GARDEN GROUNDS OF THE CLOISTER HOTEL

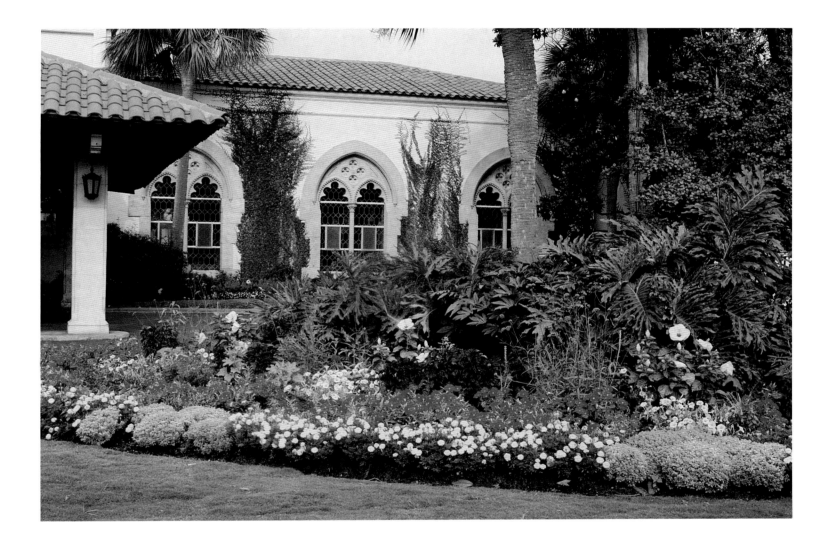

Among the smallest of the "golden" islands of the Georgia coast, Sea Island is the home of the elegant Cloister Hotel (top), designed by Addison Mizner of Palm Beach. Begun in the late 1920s, this entire resort community is now an exquisite garden landscape with a beguiling balance of natural and man-made beauty. Much of the latter can be attributed to T. M. Baumgardner, the long-time gardening genius of the island.

Sea Island
ABREU-BARNES GARDEN

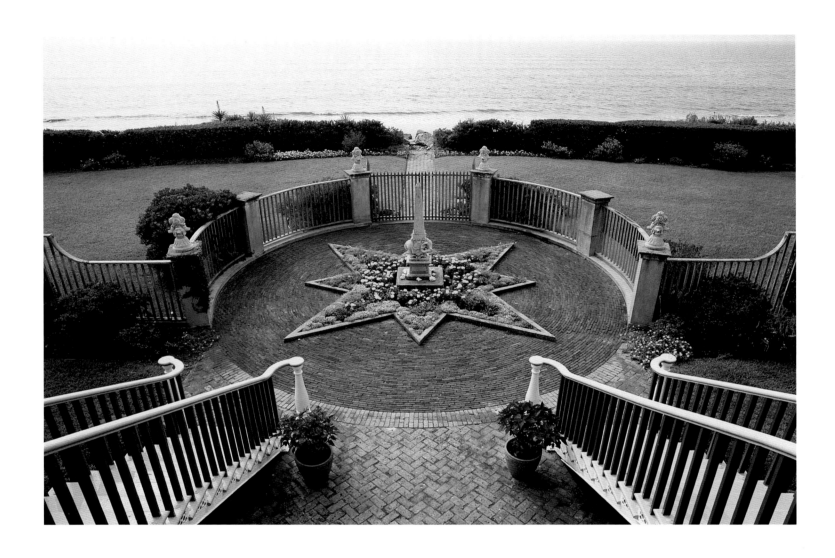

During 1927 the Sea Island Company
built its first seven island cottages on lots
landscaped by T.M. Baumgardner, the resident
landscape architect. The company established a
nursery on the island to provide trees, shrubs,
and flowers for Baumgardner's designs.
Today there are hundreds of cottages in the colony,
and the company has a degree of architectural
control over their exterior appearance.

This charming seaside cottage from the 1930s once
belonged to Francis Abreu, an architect
who designed many of the early buildings
and residences on the island. Atlanta architect
Philip Trammell Shutze created the basic design for
the house and garden using a carefully interrelated
scheme inspired by Caribbean precedents,
which is still preserved by the present owners,
Mr. and Mrs. Emmett Barnes of Macon, Georgia.

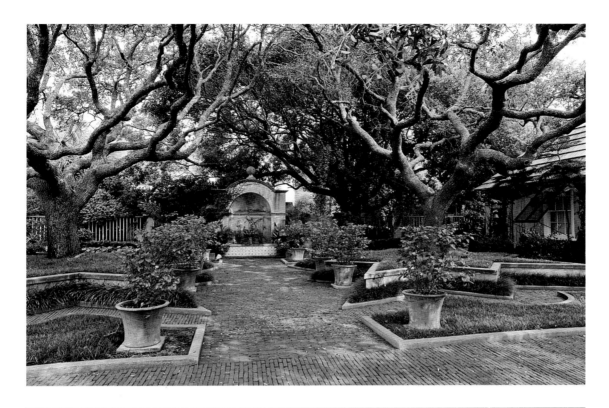

Sea Island

PORTMAN GARDEN

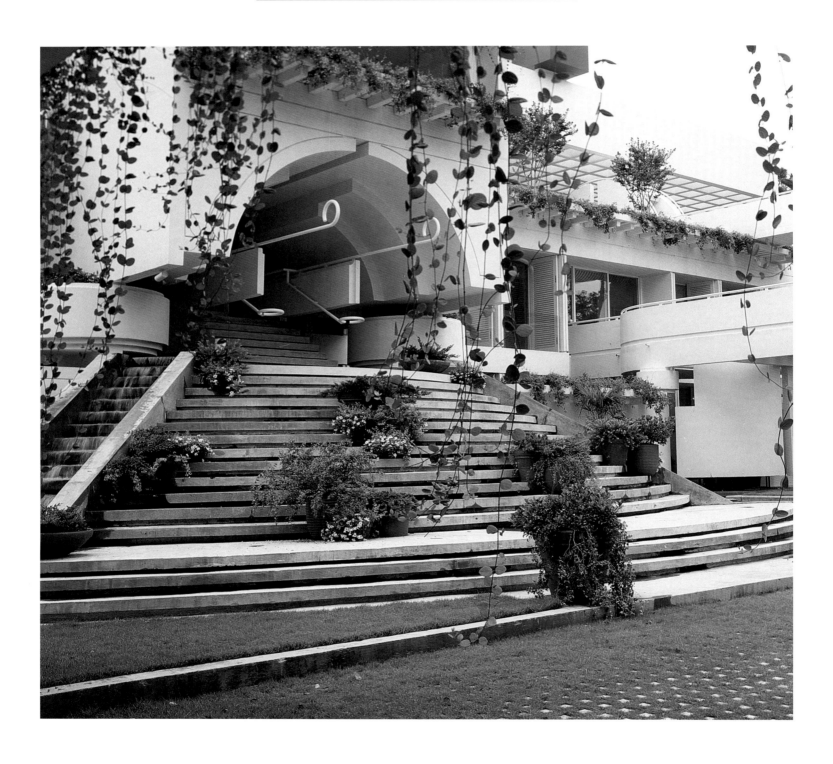

In 1987 internationally known Atlanta architect John Portman put the finishing touches
on a personal cottage compound of an entirely new style in the quiet Sea Island community.
If Sir Robert Montgomery, the eighteenth-century dreamer who called these "Golden Islands" a "future Eden,"
were to return to the land he called Azilia, he would recognize the Portman beach house
as surely being of the future — an exotic addition to the paradise on the golden coast of Georgia.

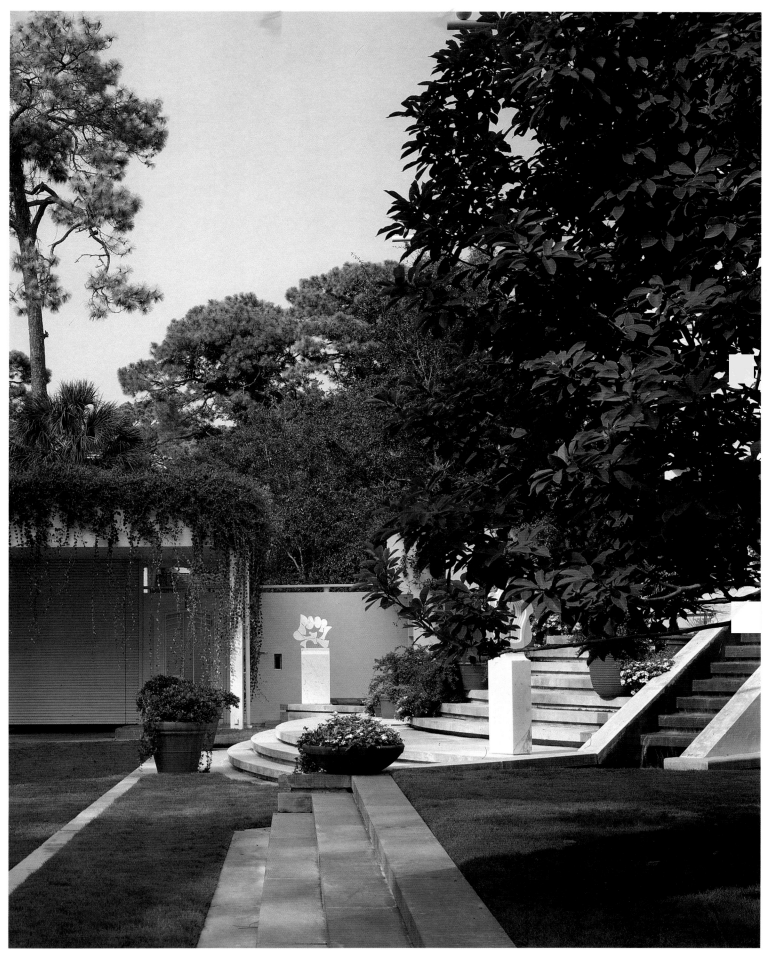

St. Simons Island
MUSGROVE PLANTATION

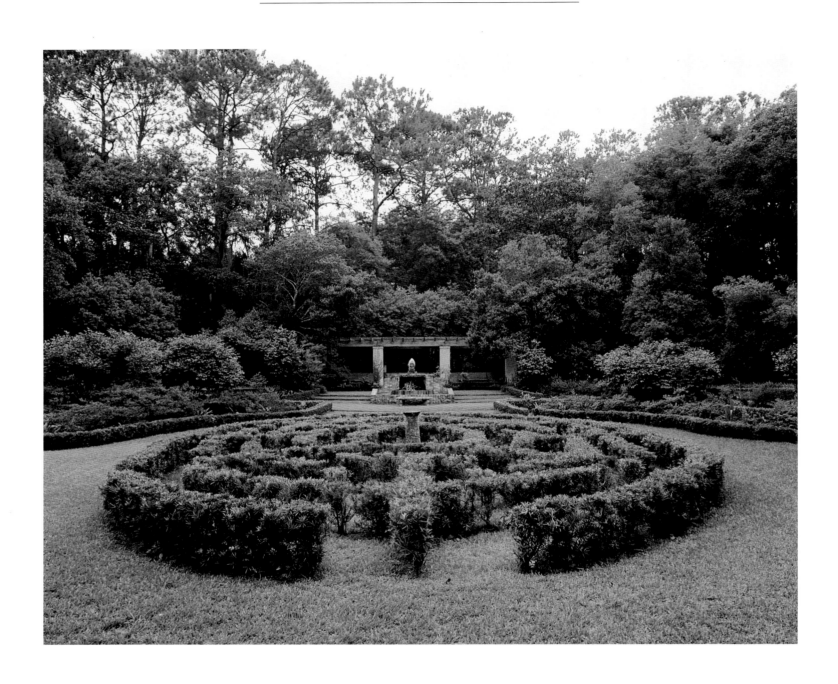

The 1,250-acre private compound of the Smith Bagleys is on the eastern edge of St. Simons across the marsh from Sea Island. Here in the late 1970s President Jimmy Carter and his cabinet stayed, met, and relaxed. The grounds of Musgrove Plantation demonstrate that long-felt need in Georgia to place a formal, symmetrical order on the native landscape. The geometry of clipped hedges, here including a superb maze, stands out against a background of live oaks and the broad horizons of nature — the marshes of Glynn:
*"Where Georgia's oaks with moss-curled beards
Wave by the shining strand"* (Sidney Lanier, "The Marshes of Glynn," 1877).

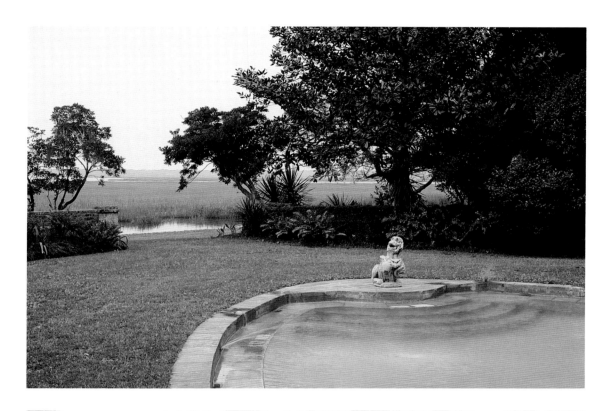

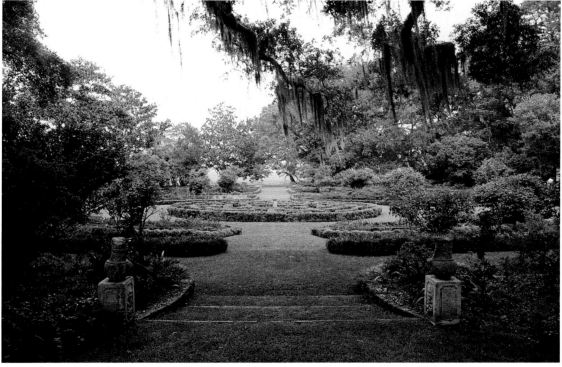

A Summerville garden, Augusta.

THE PIEDMONT PLATEAU

*T*HE PIEDMONT is a rolling plateau between the southeastern coastal plain and the Appalachian Mountains, stretching from Virginia through the Carolinas and Georgia to Alabama. In Georgia this piedmont, which literally means "foot of the mountains," is a plateau ranging in elevation from 500 to 2,000 feet; thirty-one percent of Georgia is within this region. Separating the Georgia piedmont region from the lower elevations of the coastal plain is the fall line—the point of rocky shoals, or the head of navigation, on navigable rivers. In Georgia, Augusta on the Savannah, Macon on the Ocmulgee, and Columbus on the Chattahoochee are three principal cities founded at the falls of these major rivers.

In 1736, only three years after founding the colony of Georgia, James Edward Oglethorpe established a fort at the falls of the Savannah River. Fort Augusta, which Oglethorpe visited in 1739, became the first town in the Georgia piedmont. In the spring of 1773, the great Philadelphia naturalist, William Bartram (1739-1823), came to Augusta and later wrote in his *Travels Through North and South Carolina, Georgia, East and West Florida*:

> The village of Augusta is situated on a rich fertile plain, on the Savannah
> River; the buildings are near its banks, and extend nearly two miles up to

Betty Prior rose blossoms in the large formal garden at Bankshaven, Newnan.

the cataracts, or falls, which are formed by the first chain of rocky hills. . . . It was now about the middle of the month of May; vegetation, in perfection, appeared with all her attractive charms, breathing fragrance every where; the atmosphere was now animated with the efficient principle of vegetative life; the arbustive hills, gay lawns, and green meadows, which on every side invest the villa of Augusta, had already received my frequent visits.

Bartram's enthusiastic description continued, as only a botanist might choose to phrase it:

Upon the rich rocky hills at the cataracts of Augusta, I first observed the perfumed *Rhododendron ferrugineum*, white-robed *Philadelphus inodorus*, and *Cerulean malva*; but nothing in vegetable nature was more pleasing than the odoriferous *Pancratium fluitans*.

Bartram cataloged great Latin lists of the native plants he saw on "the vast plain lying between the region of Augusta and the sea coast." He gloried in what he saw in the frontier forests of late-colonial Georgia.

A generation later, in 1820, Adam Hodgson, a businessman from Liverpool, England, left Savannah by stagecoach to go to Augusta. The cotton era had begun, but the countryside was still relatively unspoiled, even though he found Augusta itself to be a bustling center of trade. On his way there Hodgson passed through lofty forests of pine, oak, elm, tulip, and walnut. He wrote: "In addition, . . . you meet with cypress, beech, maple, the *Magnolia grandiflora*, azaleas, . . . and a variety of flowering shrubs, whose names I would send you if I were a botanist."

View of Augusta from a Summerville garden, Appleton's Journal, *Vol. 6, 1871.*

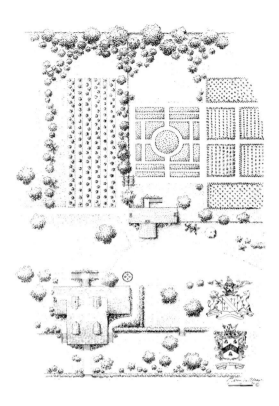

Leaving the Coastal Plain, Hodgson crossed the fall line, which Augusta straddles at the Sandhills. "Soon after leaving the plain, you reach what are called the Sandhills, 200 to 300 feet above the level of the sea . . . until you approach Augusta . . . and all the 'pomp and circumstance' of commerce."

Downtown Augusta, with its well-named Broad Street—the historic center of local commerce—is on the coastal plain adjacent to the Savannah River. But much of the town is on the piedmont above the river lowlands, especially the neighborhood called the Hill, or Summerville, which overlooks the town from an elevation of 300 feet. Incorporated in 1861, the village of Summerville was annexed by Augusta in 1912. It is here in about 1800 that the earliest houses were built as summer retreats in a form called Sandhills cottage. Behind the Peter Carnes cottage, the earliest of these to survive, is a still discernible outline of the pattern of a parterre garden, possibly the oldest in the up-country, if not the entire state.

This cottage is located near the historic center of Summerville, which was measured in a one-mile radius from a granite post at the intersection of Walton Way and Milledge Avenue. The "pomp and circumstance" of commerce in Augusta, despite floods and fires, centered around Broad Street, and there were many fine houses within walking distance, particularly on Greene and Telfair streets. Then about the time of World War I, Summerville became the focus of residential life in Augusta. The Bon Air Hotel, overlooking downtown from a landscaped park at the crest of the Summerville ridge, was the center of activity for a winter colony of part-time, quite well-to-do residents. The Bon Air is now a retirement home, and the parks and gardens of Summerville, some of them dating from the winter colony era (c. 1890-1935), have been among the most beautiful and intriguing in the Georgia piedmont.

Today Augusta is perhaps best known as the home of one of the most famous rites of

Peter Carnes cottage and parterre garden, late eighteenth century,
drawing by P. Thornton Marye on page 57 of Garden History of Georgia, 1733-1933.

spring, the Masters Golf Tournament. Bobby Jones, the great Georgia golfer, created the Augusta National Golf Course on the grounds of an earlier also-famous institution, the Fruitlands Nursery of the Berckmans family. In 1857 Dr. Louis E. M. Berckmans, a titled baron, began purchasing property northwest of downtown Augusta. His son, P. J. A. Berckmans, soon bought the entire tract and developed it into one of the most important nurseries in America. Fruitlands supplied plants to gardens in Augusta, throughout the South, the East Coast, and even abroad.

When Bobby Jones acquired Fruitlands in 1931, he retained Dr. Louis Berckmans's grandsons, L. A. and P. J. A. Berckmans, to landscape the grounds; they saved 4,000 of the old trees and shrubs on the site, virtually making the Augusta National a botanical garden and one of the most beautiful man-made places in Georgia. Each of the eighteen holes is named for and characterized by a different plant. For example, one is Tea Olive; two, Pink Dogwood; five, Magnolia; ten, Camellia; thirteen, Azalea; and eighteen, Holly. Bobby Jones once reminisced, "It seemed that this land had been lying there for years waiting for someone to lay a golf course upon it. When I walked out on the grass terrace under the big trees . . . and looked down on the property, it was unforgettable." It still is.

During the first three quarters of the eighteenth century, when Savannah and coastal Georgia were being settled and Augusta was still basically a trading outpost, the fertile land of the piedmont plateau remained Indian territory. In 1773, the Cherokees ceded large portions of the eastern Georgia piedmont, and in the Georgia Constitution of 1777 this region became Wilkes County, a sprawling frontier area that would later be divided into smaller counties. This major land cession, coupled with the optimism of American independence, made the piedmont region in Georgia a focus of pioneers migrating from the Carolinas and Virginia.

A magnolia lane planted by Fruitlands nurseryman P.J.A. Berckmans in 1858 lines the entrance to the Augusta National clubhouse, adapted from the 1854 concrete main house on Dennis Redmond's indigo plantation.

The Fall Line Road was a wagon route extending south from Philadelphia (the "Philadelphia Wagon Road") through Baltimore, Richmond, Raleigh, and Columbia to Augusta. The first settlers in the Georgia piedmont poured down this road and spread north and west from Augusta into Wilkes County. By 1790, the original county of Wilkes had a population of 36,000—more than one-third of the 82,500 people in the entire settled regions of eastern Georgia.

Among the forests of pines and hardwoods in the rolling terrain of the piedmont was the most consistently fertile soil in Georgia—sandy loams, clay loams, and clays—and, in time, the greatest prosperity and the largest population concentrations. Among the piedmont cities, in addition to the fall line towns of Augusta, Macon, and Columbus, are Athens, LaGrange, Madison, Milledgeville, Newnan, and Washington. (Atlanta, although technically an upper piedmont city, is by tradition more often considered a gateway to the Blue Ridge and will be included in the section on north Georgia.)

In 1839 James Silk Buckingham, an English traveler and often-quoted observer, passed through the piedmont town of Athens, founded in 1804 as the site of the state-chartered university, and described the town admiringly: "The mansions are almost all detached buildings, constructed of wood, with porticos, pediments, and piazzas, surrounded with spacious and well-planted gardens; and as all the houses are painted white, with green venetian blinds, they afford a striking relief to the deep-green foliage in which they are embossomed."

Buckingham's description of the place Georgians still call the Classic City gives a general visual impression of many of the new towns in the eastern Georgia piedmont. By reading his observations further, one also gains an appreciation of the more mundane aspects of these young towns: "There was one drawback to our comfort, which, it is true, was a large one, and that was the incessant and uninterrupted chorus kept up every night by the dogs, cows, and hogs that seemed to divide among them the undisputed possession of the streets at night." No wonder the "well-planted gardens" were always safely enclosed behind fences, walls, and hedges.

The Carolinians and Virginians who began to take up lands and settle towns in the Georgia piedmont during the late eighteenth century and early nineteenth century planted tobacco and grains and raised livestock (even, it seems, in town). Large plantations at first were rare, especially before cotton became the king of crops. Yeoman farmers of the Piedmont owned small subsistence farms with frame houses of the kind now called Plantation Plain. The Tullie Smith House (c. 1840), a Plain-style farm dwelling restored on the grounds of the Atlanta Historical Society, is a later example of the kind of house and garden those settlers maintained throughout the southern Piedmont, and sometimes continued to prefer even after columned Federal and Greek Revival styles had become fashionable.

Plantation Plain houses had swept yards enclosed by fences and walls, with flower and herb beds interspersed and occasionally boxwood-edged parterres. This manner of

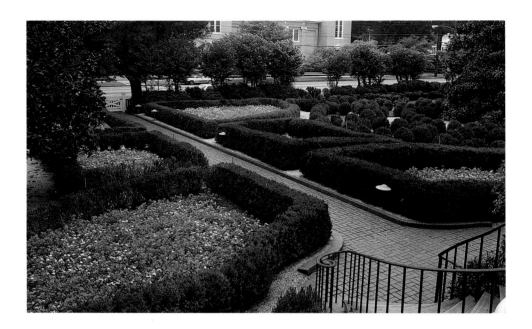

arranging the home grounds, but with even more elaborate geometric patterns and formality, continued to be employed for urban and rural classical revival houses during the antebellum cotton era. Examples of these gardens have been preserved throughout the Georgia piedmont, and quite a number have been reconstituted in this style. Among the earliest of these surviving boxwood parterre gardens are the Ferrell Garden at Hills and Dales in LaGrange; the garden at the home of the president of the University of Georgia in Athens; and Boxwood, the Kolb-Newton House in Madison. All of these urban gardens are among the oldest of the classic Georgia boxwood gardens, even older than several in Savannah.

In the first half of the nineteenth century, as the population of the state began to be centered up-country from coastal Georgia, the capital was located at Milledgeville. One of the many piedmont towns that began to flourish in the antebellum cotton era, Milledgeville became the state capital in 1804. (When Lafayette visited Milledgeville in 1825, his secretary described the town as having "a multitude of beautiful gardens.") Today, these piedmont towns still retain many gracious vestiges of the prosperity and style of that period. In that era, everyone who could possibly afford a pedimented portico had one, even if it meant, as so often happened, adding a colonnade or piazza around a much plainer and simpler house built earlier in the nineteenth century. But the home grounds remained essentially unchanged — balanced, if not always symmetrical, parterre gardens, often edged with boxwood — enclosed front, side, and rear yards for viewing from the piazza and for afternoon strolls.

After Oglethorpe founded Augusta at the falls of the Savannah, almost one hundred years passed before another river town was laid out along the Georgia fall line. As with Augusta, government initiative also brought Macon into being — in 1823, near the center

The formal boxwood parterre designs typical of the Greek Revival garden have survived at the Col. John T. Grant home, 1857-58, now the home of the president of the University of Georgia in Athens (above). The drawing by P. Thornton Marye (opposite page) is on page 79 of the Garden History of Georgia, *1733-1933.*

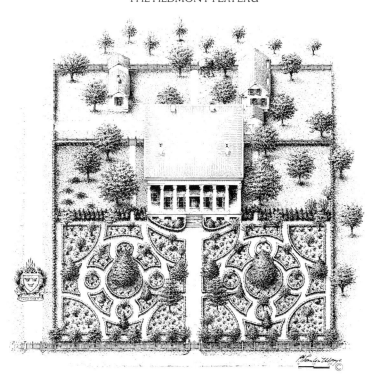

of the state at the head of the navigable waters of the Ocmulgee River. With the Indian cession of 1821, the state took a large portion of land lying between the Oconee and Flint rivers. At Fort Hawkins, a federal trading post on the Ocmulgee, the state reserved 21,000 acres for a "trading town." On a bluff above the river, the town of Macon was staked out in a grid pattern (with the exception of Cotton Avenue, a diagonal street that began as an Indian trail, became the Federal Road, and then a main thoroughfare through the town). One of the first acts of the Macon Board of Commissioners was to plant shade trees along the sides and in the center of the downtown streets.

Just northwest of downtown a village, or suburb, developed called Vineville, which is to Macon what Summerville is to Augusta—a piedmont promontory above the river lowlands. Beginning with Coleman Hill, on which several of the finest houses and gardens in Macon were located, north Macon was the most desired residential section in town. There was even a cemetery, Rose Hill, designed as a public garden or park in the manner of Mount Auburn in Cambridge, Massachusetts. To this day, it is one of the most picturesque spots in Georgia.

James Silk Buckingham also visited Macon, as he had Athens and Savannah, when he passed through Georgia in 1839. In *The Slave States of America*, he wrote: "The town of Macon . . . is of very recent origin, as, only fifteen years ago, the ground on which it stands was covered with primeval forests . . . and though only fifteen years old, its exports of cotton amounted last year to 5,000,000 dollars. . . . The town is very agreeably located and advantageously situated on the western bank of the river Ocmulgee."

In 1851, at a meeting of the Southern Central Agricultural Society held in Macon, the Right Reverend Bishop Stephen Elliott, Jr., stated in an address on horticulture, "The very spot on which I now stand . . . was but yesterday the home of the Indian." The bishop said, despite the recent settlement of the town, "There is no homestead so poor, no plot of ground so small, but that it may be made with a little labor and a little care redolent with

beauty and perfume." Macon residents evidently took the bishop's admonitions to heart, and a strong gardening tradition thrives there to this day. Among other things, Macon is the home of an annual downtown cherry-tree festival of truly spectacular proportions. The bishop would be proud.

In a situation remarkably similar to Augusta and Macon, Columbus was settled in 1828 on the Chattahoochee River at the western edge of the state. After an 1826 treaty with the Creek nation opened the land between the Flint and Chattahoochee rivers, the state legislature passed an act to "lay out a trading town . . . near the Coweta Falls." The legislature appointed five commissioners to create a 1,200-acre town fronting the river, with squares, commons, parks, streets, and alleys in a grid pattern. Literally as the town was founded, an English traveler named Basil Hall arrived and stepped among the surveyor's stakes: "We arrived, fortunately, just in the nick of time to see the curious phenomenon of an embryo town—a city as yet without a name . . . but crowded with inhabitants. . . . At some points of this strange scene, the forest, which thereabouts consists of a mixture of pines and oaks, was growing as densely as ever, and even in the most cleared streets some trees were left standing." There were already three hotels, but only a few houses had been built and some huts, "partly of planks, partly of bark," and many of the people "were encamped in the forest."

Columbus became an important industrial center, especially for textiles, because of the water power at the rapids, access by boat to the Gulf of Mexico, the arrival of railroads in the 1850s, and an abundance of available and fertile land suitable for cotton cultivation. Respect for the original beauty of the riverside site was not lost, and today the Columbus historic district is a garden spot of special charm. Many of the old brick manufacturing facilities have been adapted for civic uses, and the old park-like commons along the river

Macon has been called "A City in a Park" for the extensive use of trees in the city landscape.
Through the influence and generosity of William A. Fickling, Sr., and his family, Macon is now adorned
with thousands of Yoshino cherry trees and celebrates a nationally known Cherry Blossom Festival each spring.

have been re-landscaped to great advantage.

Columbus also has a piedmont elevation above the river plain, Wynnton, a portion of which is called Overlook. It is the Summerville and Vineville of Columbus, and many houses and gardens from the antebellum and later periods in the vicinity of Wynnton Road are among the loveliest in the state.

A few miles northeast of Columbus on the northern slope of Pine Mountain, a rare combination of topography, climate, soil, and inspired gardeners has brought about a miracle of conservation—a 2,500-acre series of gardens called Callaway. Led by Virginia and Cason Callaway in the 1930s, the Cason Callaway family has restored and transformed this corner of Eden in the Georgia piedmont. Evolving from the Callaways' private Blue Springs retreat at Barnes Creek, and their desire to protect a rare native azalea unique to the area—the *Rhododendron prunifolium*—Callaway Gardens has become a botanical and horticultural, educational and recreational institution of national importance, accessible to everyone. Opened in May of 1952, the gardens are administered by the non-profit Ida Cason Callaway Foundation.

Piedmont means "foot of the mountains," Callaway Gardens at the foot of Pine Mountain, which rises 1,300 feet only a few miles from the fall line, displays the very best of this land we call piedmont and of those Georgians who have made it their own. Cason J. Callaway (1894-1961) once told his son Howard, "We don't want to just build the finest garden seen on earth since Adam was a boy. What we want to do is build the prettiest garden that will ever be seen on earth till Gabriel blows his horn."

That goal expresses the feelings many other Georgians of the piedmont have held toward their own gardens on a more intimate scale—feelings surely inspired by the natural beauty of the land around them. Shortly after the Civil War, author Mary Lennox wrote of these surroundings:

> In the beautiful South, on the eastern bank of the Chattahoochee, where the tall pines like stalwart grenadiers of the forest rear their green-crested heads far into the blue vaulted canopy above, and the magnolias bow their royal diadems over the modest violet, there is a lovely bower, formed by a jasmine-vine, which twines itself around the wide-spreading arms of a gnarled oak. From its trailing branches the sweet, golden bells are continually dropping into the flowing stream, where they whirl awhile in a merry waltz, then glide swiftly on, disappearing from sight in the distant waters. Nature has lavished her rarest gifts to adorn this beautiful spot.

The gardens that follow reflect the natural and social heritage of the Georgia piedmont—from the wild ambience in a secluded Athens vale to the grand and formal perfection at Hills and Dales. Nature has truly "lavished her rarest gifts" on this region, and, as Bishop Elliott said, even the smallest plot "may be made with a little labor and a little care redolent with beauty and perfume."

Milledge Road, Augusta
LANDON A. THOMAS GARDEN

In the very last years of the eighteenth century, a sandhills promontory several miles west of downtown Augusta began to be settled. At first a summer retreat from the Savannah River lowlands, and later a place of permanent residence, the neighborhood was called the Hill. In 1861 it was incorporated as the village of Summerville, and in the 1890s it became a fashionable winter resort and golf capital. In 1912 Augusta annexed the village, and

Summerville became the most affluent ward in the city. At that time, Augusta acquired its nickname, "The Garden City of the South," a designation largely made plausible by the magnificent homes and gardens of Summerville.

The Landon A. Thomas garden, formal, yet romantic—and intensely private— dates from the first decade of our century and evokes the history and lore of Summerville as only a few others can.

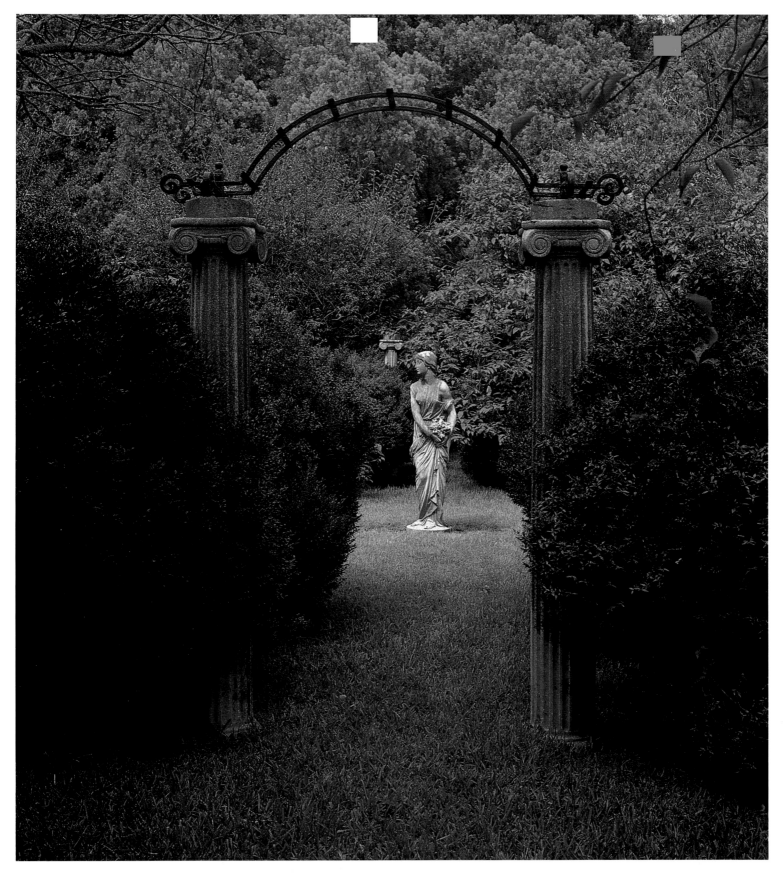

Hidden behind a high garden wall are nearly three landscaped acres, with individual gardens formally arranged according
to a plan drawn by Mrs. Thomas, with consultation from the Boston landscape firm of Herbert, Pray, and White.
One lone Italian cypress remains of thirty or so which helped to capture the spirit of classic Italian villa gardens, as
late-nineteenth-century Americans imagined them translated to their own estates. The graceful statue, arch with Ionic columns,
reflecting pools, and mature boxwoods further intensify this Old World ambience. A grandson of the Landon Thomases lives
here and says finding trained gardeners to trim and maintain these extensive grounds properly is nearly impossible.
President William Howard Taft visited this garden on numerous occasions when he wintered in Augusta.

Meigs Street, Augusta
"Le Manoir Fleuri"

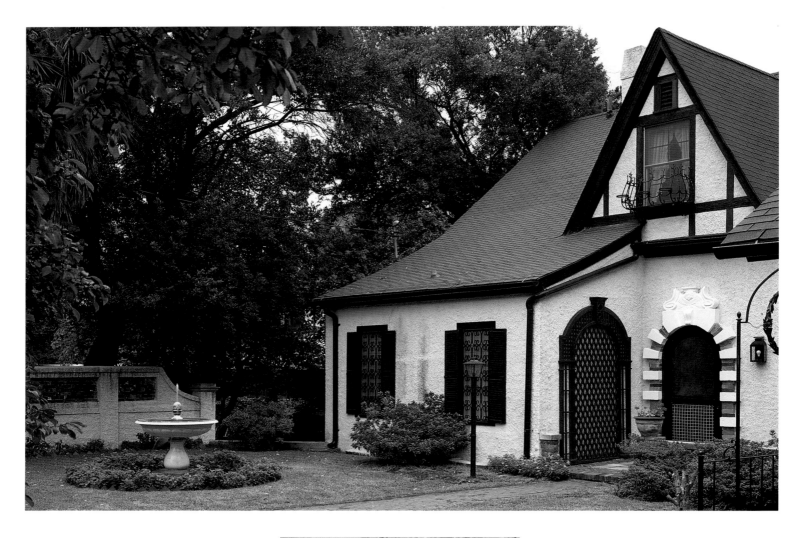

Truly quaint is this charmingly picturesque garden and house, which is a French provincial style cottage of the early twentieth century. The entrance wall and gate, contrasting—as does the entire ensemble—formal and informal elements with a sense of Arts and Crafts, capture the imaginations of passersby, perhaps evoking images of Hansel and Gretel in a Georgia piedmont home. The iron work alone is worthy of pausing to contemplate on a Summerville stroll. House and garden merge into a unit in the entrance courtyard, with an Italian marble fountain as a major focus, circled here with a bed of late summer blooms.

McDowell Street, Augusta
BARRETT GARDEN

The Summerville neighborhood is a mixture of old cottages, twenties bungalows, handsome, two-story Colonial Revival houses, and some great estates, all nestled in a beautiful landscape of mature vegetation. Among the Georgia "champion trees" in the Summerville district, for example, are a cucumber magnolia and Japanese varnish tree on Milledge Road, a deodar cedar on Cumming Road, and a crape myrtle on Gary Street, all specimens that were originally obtained at nearby Fruitlands Nursery. This shingled "cottage-bungalow," with its walled grounds and cottage garden inside and outside of the walls, is the home of one of the most well-known gardeners in Augusta, who writes: "In 1967, I moved to this house, and the plan for this small yard has evolved into a simple cottage garden. My main interest has been the propagation of old-fashioned, hard-to-find plants, from seeds and cuttings."

Walton Way, Augusta
BARROW GARDEN

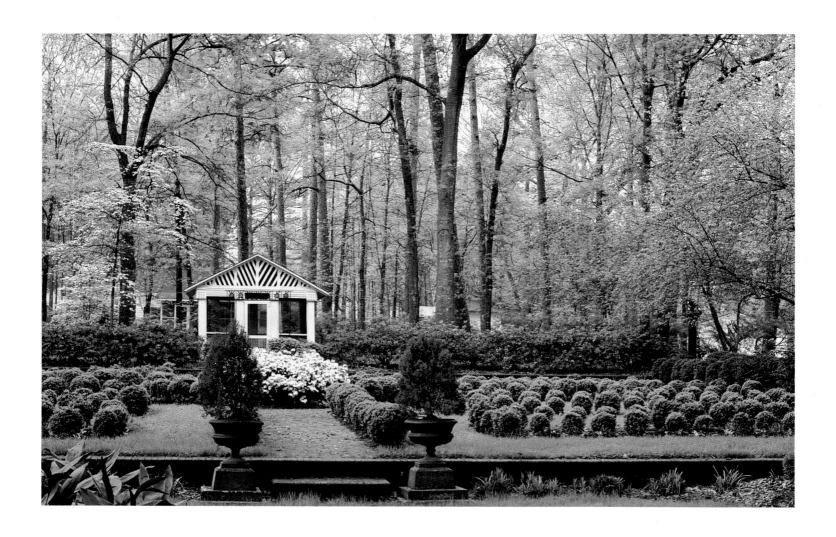

As Walton Way heads northwest from Summerville into the piedmont, the countryside grows hillier,
the suburban lots become larger, and the front yards more dramatically spacious, with sweeping lawns
dotted with dogwoods and bordered with vivid azaleas—a springtime fantasy. The influence of the
Augusta National Golf Club and the Masters Tournament is sensed. Perhaps the most photographed Augusta
front yard garden is this one with a white-columned portico as backdrop, as though it were a classical folly in an
English country-house landscape garden. The picturesque grounds also have a formal boxwood layout,
which for generations has been a hallmark characteristic of the completed proper Georgia garden.

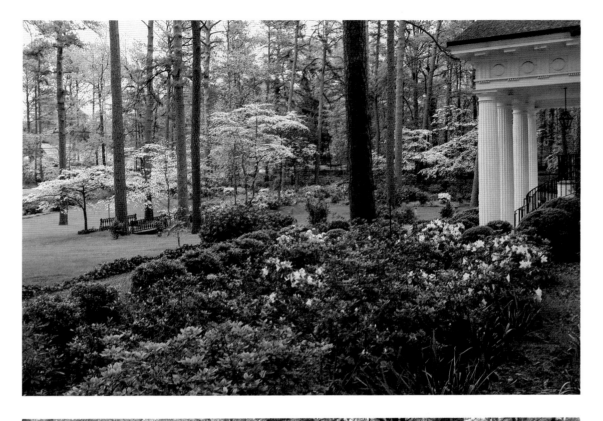

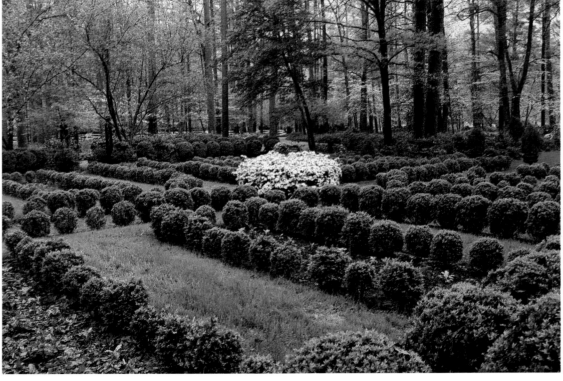

Augusta
Two Suburban Summerville Gardens

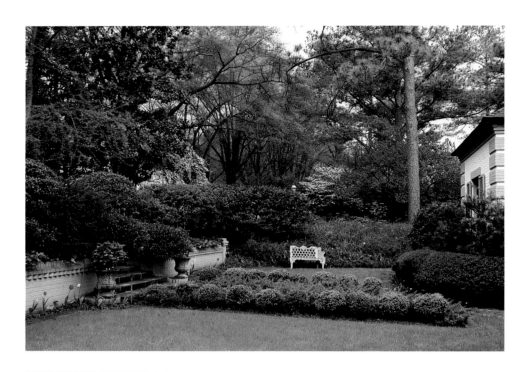

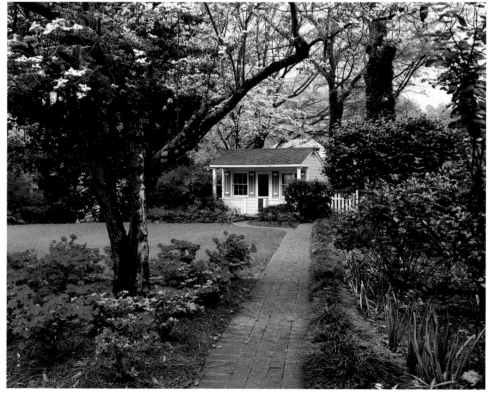

*The Augusta sobriquet, "The Garden City of the South," is clearly illustrated by these two suburban
Summerville gardens. With the Barrow garden, they are among the most photogenic "yards" in the region,
blending geometric and formal, naturalistic and picturesque elements in a recognizable twentieth-century manner.*

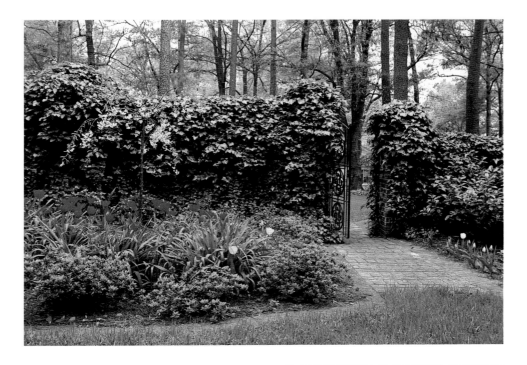

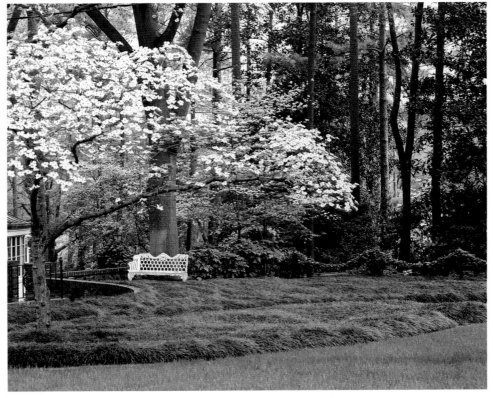

*Together such private, suburban pleasure grounds combine to create a much larger residential park,
reminiscent of the gently rolling grounds of an early nineteenth-century English
country house influenced by the landscape gardening of such designers as Humphrey Repton.*

Athens
UNIVERSITY OF GEORGIA GARDENS

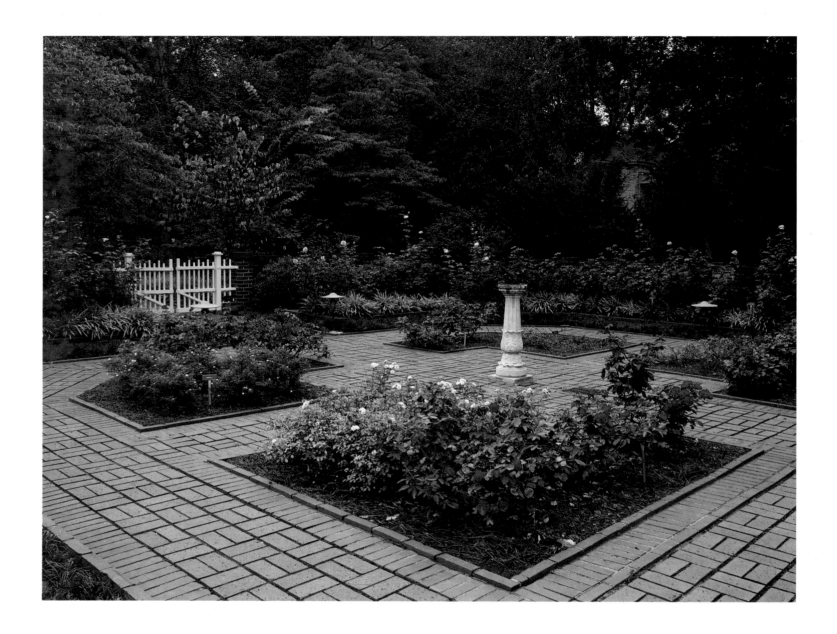

Athens, the county seat of Clarke County and the principal city of northeast Georgia, is located among gently rolling hills overlooking the north fork of the Oconee River at Cedar Shoals. In 1801 the state legislature founded Athens as the site of the state college, now the University of Georgia. Josiah Meigs, the first president of the college, described the site as "healthy and beautiful." As *Gardens of Georgia* demonstrates, no place in the state has had greater influence on gardens and on

landscape design than Athens.

The president's home at the University of Georgia was built in 1857-58 by Col. John T. Grant. The five-acre landscaped lot, the house, and outbuildings were acquired in 1949 to serve its present purpose. The classic Corinthian portico overlooks a formal boxwood parterre garden surviving from the antebellum period. At the rear are additional gardens installed after 1949, including the formal rose garden designed by Dean Hubert Owens, FASLA.

The President's Club Garden (phlox, top), designed by Gordon Chappell, is adjacent to the old Franklin College on the historic North Campus. The 293-acre State Botanical Garden (entrance drive, above left) is located on the south edge of the university campus along the Middle Oconee River. Committed to the conservation of rare and endangered species, the garden serves as an outdoor laboratory for university classes in agronomy, botany, ecology, environmental design, forestry, horticulture, pharmacy, and plant pathology. The Department of Horticulture experimental garden (above right), also on the South Campus, is shown in late summer bloom.

University of Georgia North Campus, Athens
FOUNDERS' MEMORIAL GARDEN

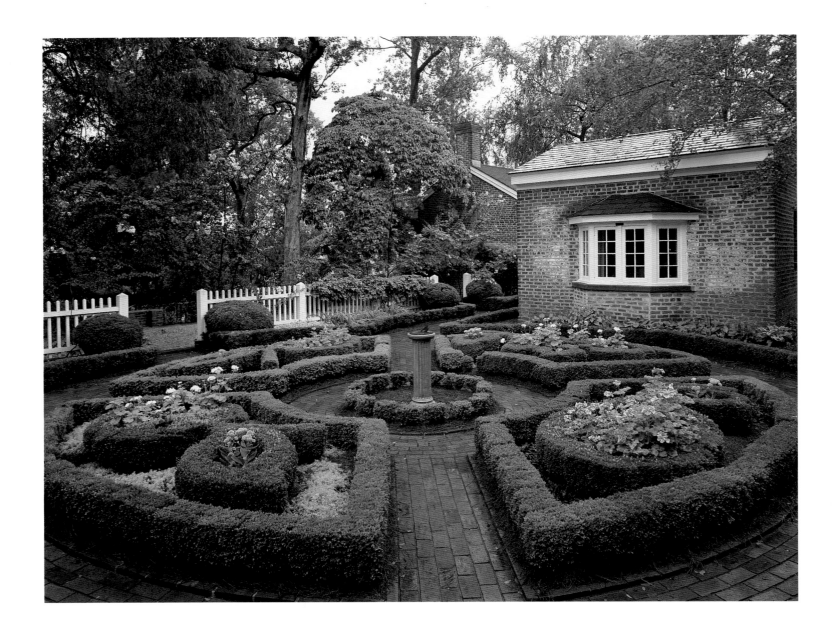

Near the School of Environmental Design — formerly the Department of Landscape Architecture — on the old North Campus of the University of Georgia is a two-and-one-half-acre series of formal and informal gardens surrounding several historic buildings. There are two courtyards, a formal boxwood garden, a terrace, a perennial garden, an arboretum, and the museum-headquarters of The Garden Club of Georgia, Inc. Begun in 1939-40, these gardens are museums of landscape design and outdoor laboratories for students of landscape architecture and the plant sciences.

Founders' Memorial Garden serves as a successor to the original botanical garden of the university developed nearby in the 1830s. This garden has one of the finest collections of Georgia and Piedmont flora to be found in the South, including: sweet bay magnolia, leatherleaf viburnum, Franklinia, flowering quince, lenten rose, Cherokee rose, and double flowering dogwood.

The boxwood parterres (top) are accented with "knots" of Cherokee rose, peach, cotton boll, and watermelon.

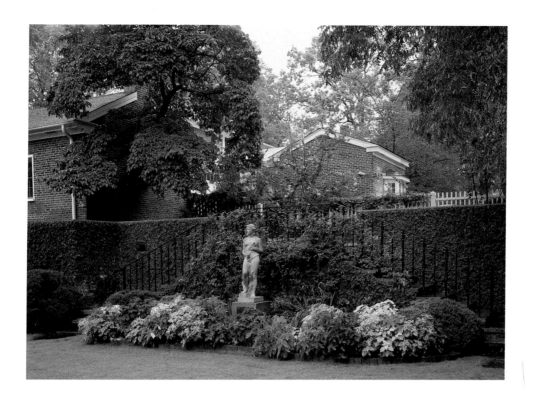

The garden complex, designed and developed by Dean Hubert Owens, his staff, and advanced students in landscape architecture, was dedicated in 1946 as a memorial to the twelve founders of the Ladies Garden Club of Athens — organized in 1891 and the first garden club in the United States. The courtyard of paving stones (opposite page, bottom) provides an entrance to the museum-headquarters, an 1857 faculty residence restored in 1964. The perennial garden (above) has a Coleus border in a serpentine bed. "For every good thing has a beginning — and the beginning was here" is inscribed on the base of the garden figure presented to the Founders' Memorial by the National Council of State Garden Clubs, Inc., in 1954.

Pulaski Street, Athens
LINLEY GARDEN

Within walking distance of downtown Athens and the University of Georgia campus is this professor of
environmental design's own townhouse garden, an informal design that follows the curves of the
hillside as it slopes down to a stream. Begun in 1966, and still essentially as Prof. John Linley sketched it,
the walkways spiral to a natural outcropping he recently uncovered by the brook. The house and garden are Linley's
unified creation. He writes: "As much as possible, I let climate, surroundings, existing house, drainage requirements,
and natural features guide me in the design." He adds: "There are sitting areas, restful retreats, inspirational views,
and the therapy of working in the garden." Replacing the kudzu and litter on the hillside as he found it
in 1966 are rhododendron, cryptomeria, bald cypress, English boxwood, Japanese yew, and a large variety of ferns.

Westlake Drive, Athens

ROGERS GARDEN

This formal urban garden enclosed by a white picket fence was originally designed by Edward L. Daugherty, FASLA. With the help of Joe Gayle and Wes Terrell of Classic Nurseries, Mitchael and Lili Rogers enlarged the garden and added a T-shaped pool with a fountain and statue. In the design are old boxwoods, azaleas, daylilies, wisteria, crape myrtles, iris, acanthus, lotus, water lilies, and many herbs. Adjoining the arboretum of the Bobbin Mill Garden Club, the Rogers home and garden are beautifully sited atop an Athens hill.

Milledge Circle, Athens
SEGREST GARDEN

The private gardens of Athens have benefited from the influence of the Department of Landscape Architecture
at the University of Georgia, which has encouraged good residential design since its founding in 1928.
Atlantan Edith Henderson, FASLA, designed this garden. Later additions were by Prof. Robert J. Hill,
ASLA, of Athens. The owner, Mrs. Robert Segrest, writes: "I garden for the joy of digging in the ground
and creating spots of beauty for my pleasure and that of my friends and family."

Picadilly Farm, Bishop
JONES GARDEN

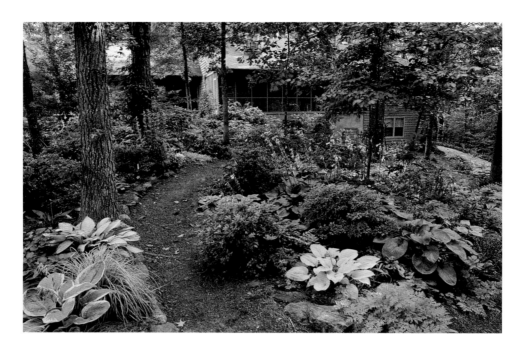

Southwest of Athens at Bishop reside Carleen and Sam Jones, who share the work on their shade garden,
which features hostas. He is a botany professor at the University of Georgia, and she is the
"resident gardener," whom Dr. Jones credits with the true success of their endeavor. Picadilly Farm is yet
another garden that the presence of the university has helped spawn in the Athens sector of the Georgia piedmont.

Oglethorpe and Madison Counties
TWO GARDENS OF THE EASTERN GEORGIA PIEDMONT

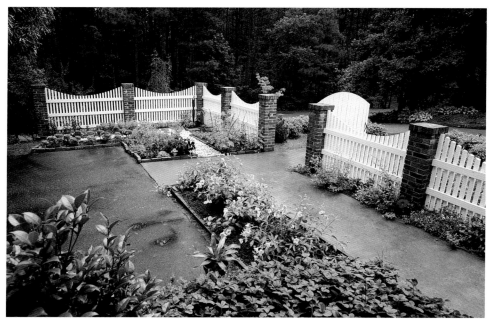

*Richardson-Berry Garden, Lexington (top). This is the private garden of two University of Georgia alumni
who have teamed up to grow perennials professionally, although neither was a student of plant sciences.
Their place has a country-garden quality with old favorites such as pinky-purple thrift
and moss pinks. Yet they are equally interested in the future of perennials. They state: "Never be frustrated by any
one plant or any gardening season, because there will always be another." Bullock Garden, Spratlin Mill,
Lexington (above). This garden was designed by David Childers, ASLA, using a combination of period plants,
native plants, and hybrids. The entrance courtyard garden provides a play area for children
and illustrates the blend of traditional and contemporary gardening styles on the hilltop suburban site.*

Cedar Lane Farm, Morgan County
SYMMES GARDENS

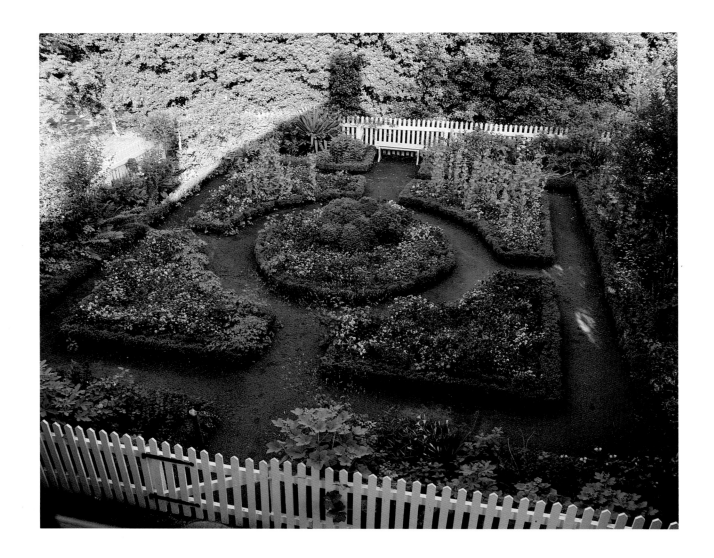

South of Athens, out from the beautiful piedmont town of Madison, are the well-known gardens of Cedar Lane Farm, which the John Symmeses began to create in the 1960s. When they started their conservation project, a dilapidated Plain-style farmhouse built about 1840 stood at the edge of eroded cotton fields. Today, Cedar Lane Farm would fit the description by Sergeant Mead, a Connecticut Yankee in the Federal Army who passed through the neighborhood, November 19, 1865: "Madison is the prettiest village I've seen in the state. One garden and yard I never saw excelled, even in Connecticut." Jane Symmes wrote in The American Woman's Garden: "I wanted to

reclaim the grounds around the house in the manner of a nineteenth-century Georgia plantation, using a characteristic layout and growing plants of the period." In Southern Living she said: "I really look at the entire landscape as just one garden, with the other gardens within it." Her grounds are divided into three gardens: a boxwood parterre and a kitchen garden, both enclosed with pickets, and a perennial border. As to the location, Mrs. Symmes says: "Here in the Georgia piedmont we have tremendous advantages of a varied climate and a long growing season, provided we are sure of an adequate water supply and the ability to apply it."

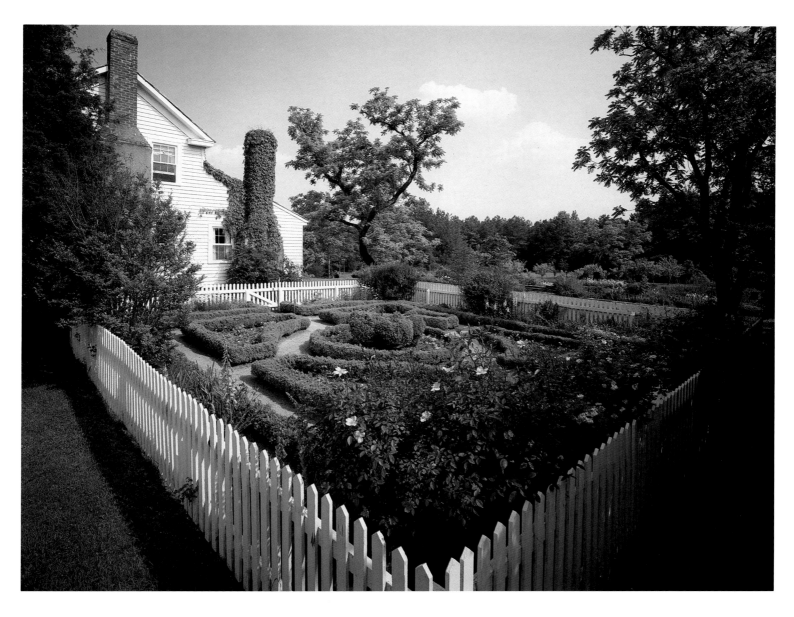

College Avenue, Macon
HOLLIDAY GARDEN

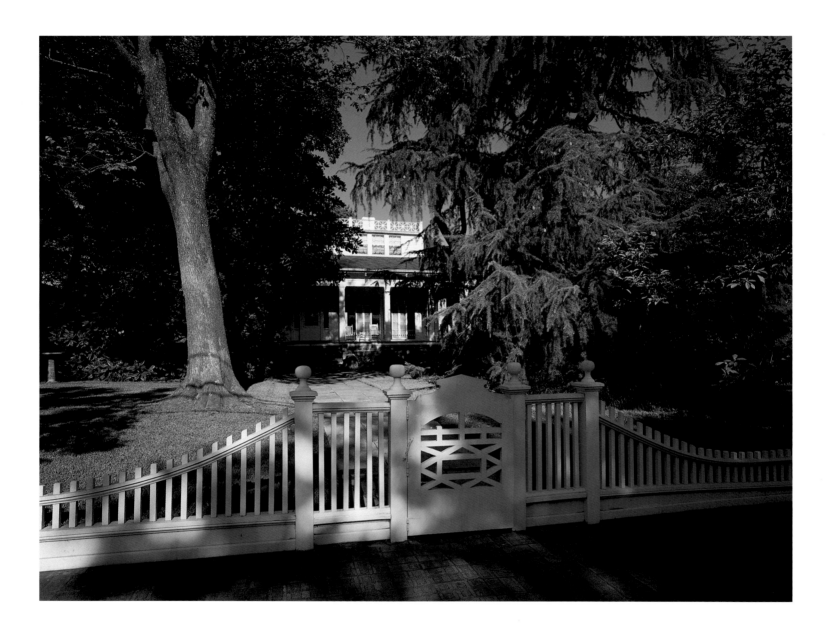

Incorporated in 1823, Macon was laid out in a grid pattern with streets parallel to the river. Tradition says the commissioners based the plan on the ancient Gardens of Babylon. The wide thoroughfares, named Walnut, Mulberry, Cherry, Poplar, Plum, and Pine, were planted with shade trees along the sides and in the center, as they are today—which gave rise to the slogan "A City in a Park." From the very beginnings of the town, therefore, Macon has been identified with a tree-lined landscape, and the shady grounds of this splendid old cottage form one of the most venerable gardens in this "park." The cottage was built in 1854 on College Hill, which overlooks Washington Park and downtown Macon, and the grounds have evolved in the loving hands of only four owners— the Norths, Tinsleys, Corns, and Hollidays. A large lot for its now-urban site, this carefully planned small estate features a wealth of mature plants, a boxwood parterre, and is surrounded by distinctive fences, walls, and gates.

College Avenue, Macon
HOGAN GARDEN

On College Hill at a prominent intersection stands a Georgia landmark of early twentieth-century taste,
a Beaux-Arts villa designed by Neel Reid (1885-1926) of Macon and Atlanta, who was the leading Georgia
architect of houses and gardens as unified designs. The house, originally an 1889 red-brick Victorian hybrid,
was remodeled in 1911 by Reid and renovated in 1978 by Frank McCall, FAIA, of Moultrie.
Important features of the Neel Reid scheme for the grounds remain, such as this classical loggia,
with garden urns and treillage. The Hogans have enclosed the site with evergreen hedges and oak trees to screen
the grounds from motor traffic. The arched hedge doorway leads to a rose garden and the Reid garden loggia.

Stanislaus Circle, Macon
SIMMONS GARDEN

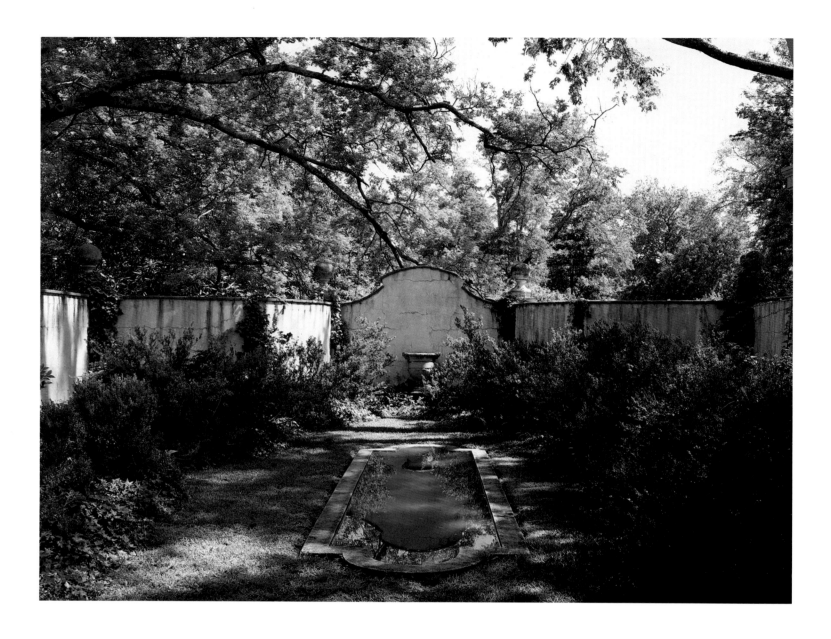

Around the turn of this century, Americans began to rekindle their romance with the Italian villa.
Villa, in Italian, signifies not the house alone, but the buildings, grounds, and gardens conceived as a unit in which
indoors and outdoors merge into harmonious subdivisions of space. Georgians felt their home climate and landscape
were perfect for villas of their own. Atlantan Philip Trammell Shutze (1890-1982), a native of Columbus, Georgia,
who had studied at the American Academy in Rome, designed this Macon villa in 1929-30 for
the Morris Michaels. The Simmonses fell in love with the Michaels' villa, and Mrs. Simmons preserves
the place with an air of the romance she and her late husband felt for it. Stanislaus Circle, in the Vineville section
of Macon, was built on the grounds of Saint Stanislaus School, and many of the old trees in this small
select neighborhood were planted by the priests who ran the school before the turn of the century.
The walled <u>giardino segréto</u> is attached to the house and entered from a loggia off of the dining room.

Vineville Avenue, Macon
SHERIDAN GARDEN

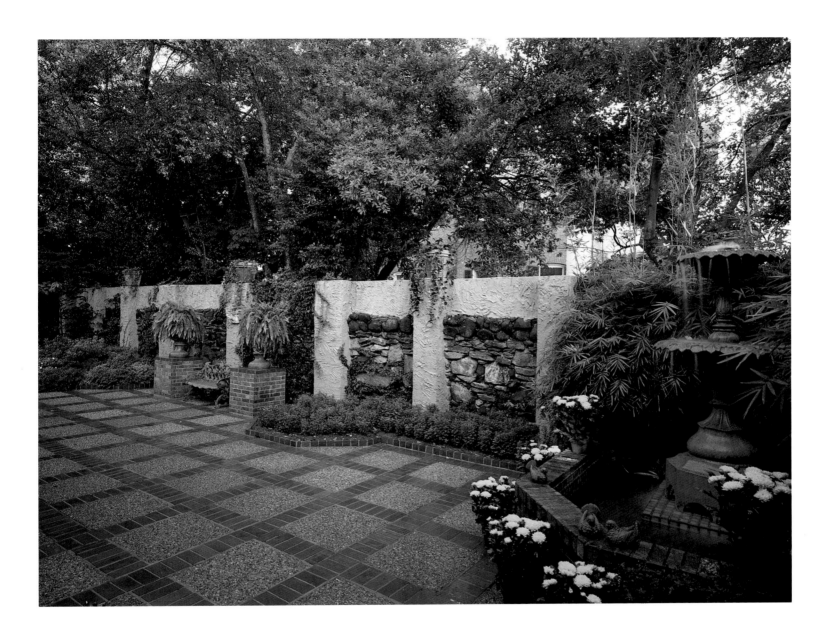

Historic Vineville Avenue, which leads north into the Georgia piedmont toward the Weslyan College Rivoli campus, was once a quiet country road. Now that it has become a major thoroughfare, many of its fine homes have been converted to other uses or destroyed altogether. This house, designed in the late 1920s by Macon architect W. Elliott Dunwody, Jr., FAIA, is now the home of the Val Sheridans. The Sheridans have added a walled garden—an urban courtyard—designed by Daniel B. Franklin, FASLA, an Atlanta landscape architect. Uniting the inside and outside, this contemporary addition speaks the older language of stucco, brick, and cast iron with a period flavor that complements the character of the 1920s house. Mr. Franklin designed the courtyard around a sixty-year-old cast-iron fountain made in Macon by Taylor Iron Works.

Macon
Two Vineville Gardens

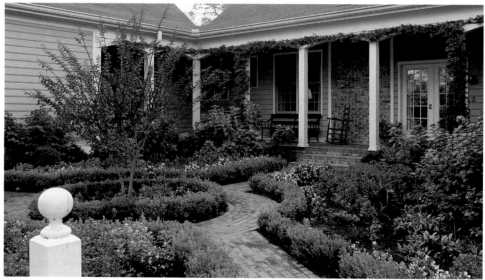

Vineville has been one of the most desirable Macon suburbs since the antebellum period. Part of a family enclave on Napier Avenue, the welcoming front porch of the Mitchell House home (top) is a comfortable extension of both house and garden. Beyond the porch is a series of garden vignettes. Mrs. House writes: "We are creating a haven of beauty combining formal settings within an informal overall scheme, using as many different varieties of plants as possible." Mrs. Jack Huckabee and her late husband designed their side flower yard (above), a boxwood parterre courtyard, which she maintains in his memory. Mrs. Huckabee writes: "I think flowers are one of the Heavenly Father's greatest gifts."

Macon
TWO SHIRLEY HILLS GARDENS

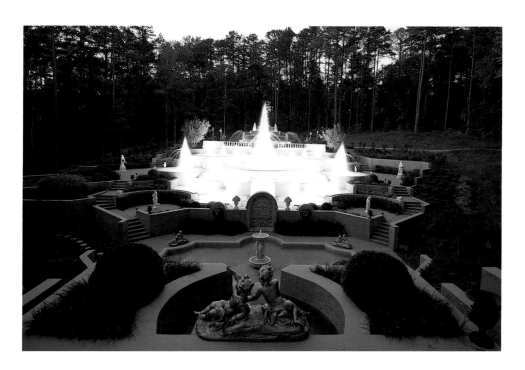

The rolling terrain of the Shirley Hills suburb above the east bank of the Ocmulgee River is the site of gardens of varying styles. The hillside formal water garden of A. E. Barnes III (top) was designed by Robert W. Brown, ASLA, to be seen from Mrs. Barnes's balcony. Specimen boxwood, holly trees, and smaller hedge-forming hollies are among 3,000 trees, shrubs, and ground covers. A "Pool of Three Graces," "The Falls," and an "Angel Fountain" are among the elements of this spectacular garden, which, according to Mr. Brown, has some "features inspired by the French gardens of Versailles" but overall is more "in character with those of the Italian Renaissance."

The Willingham garden (above) was planned in 1940 by William C. Pauley (1893-1975), FASLA, a leading Georgia landscape designer who specialized in naturalistic gardens. Lovingly maintained by its original owners, this serene hillside landscape of shade and privacy has as accents large rocks placed according to Pauley's design.

Columbus
City and Suburban Gardens

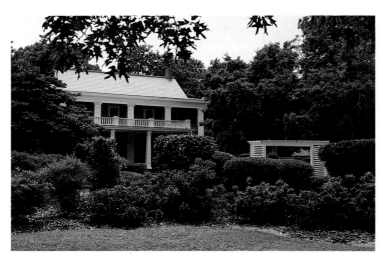

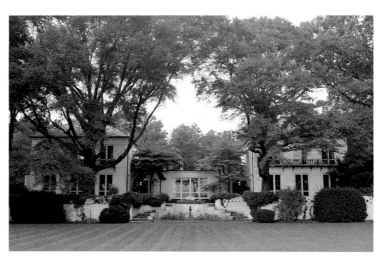

Columbus was incorporated in 1828 on the eastern banks of the Chattahoochee amid what English actor Tyrone Power described in 1833 as "wildly beautiful scenery along the falls of the river." The town was laid out along the river in a grid pattern of streets with medians, squares for public buildings, and parks of common land. The planners even included a promenade at the south end of town to view the spectacular shoals. The promenade was restored in recent years and is now part of the charming historic district, which includes the Walker-Peters-Langdon House and its garden and the Rankin House and garden. The garden of the Walker-Peters-Langdon House (top left), traditionally known as the oldest house in Columbus, was re-created by the Tea Olive Garden Club for the Historic Columbus Foundation, Inc. The downtown garden courtyard of the Rankin House (top right) was given in memory of C. F. Williams to complement the circa 1860 house and is popular for receptions. Shortly after settlers began building homes on the river plain of

downtown Columbus, other families began to erect homes above town on the heights that marked the beginning of the Piedmont plateau.
One of the favorite places was nearby Wynnton, and through the years other suburban locations were established to take advantage of the "wildly beautiful scenery." Riverside, (above left) now home of the commanding general of Fort Benning Military Reservation, was built by Arthur Bussey in 1909 as a summer retreat on the grounds of a nineteenth-century plantation. This house and the surrounding ten and one-half acres of gardens is at Fort Benning, near the confluence of the Chattahoochee River and Upatoi Creek. About five miles north of downtown Columbus is a beautiful suburb called Green Island, which overlooks the Chattahoochee from the hills above the river. The Dexter Jordan house (above right), designed by Henry Toombs (1896-1967), has a rear courtyard garden, a pierced, white-painted brick wall, a fish pond, and a sweeping lawn presided over by fine old trees.

McDowell Street, Augusta
BARRETT GARDEN

The Summerville neighborhood is a mixture of old cottages, twenties bungalows, handsome, two-story Colonial Revival houses, and some great estates, all nestled in a beautiful landscape of mature vegetation. Among the Georgia "champion trees" in the Summerville district, for example, are a cucumber magnolia and Japanese varnish tree on Milledge Road, a deodar cedar on Cumming Road, and a crape myrtle on Gary Street, all specimens that were

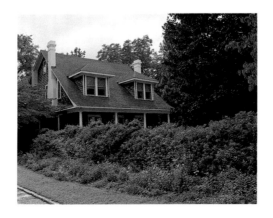

originally obtained at nearby Fruitlands Nursery. This shingled "cottage-bungalow," with its walled grounds and cottage garden inside and outside of the walls, is the home of one of the most well-known gardeners in Augusta, who writes: "In 1967, I moved to this house, and the plan for this small yard has evolved into a simple cottage garden. My main interest has been the propagation of old-fashioned, hard-to-find plants, from seeds and cuttings."

Walton Way, Augusta
BARROW GARDEN

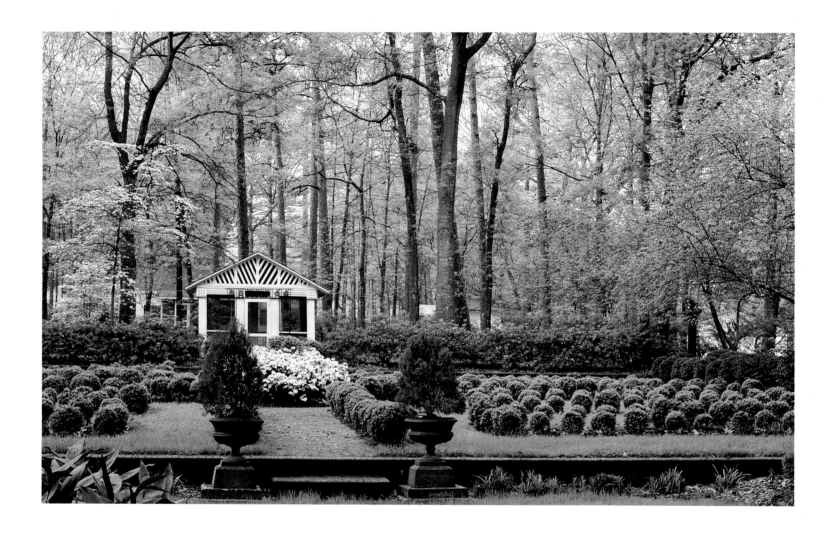

As Walton Way heads northwest from Summerville into the piedmont, the countryside grows hillier,
the suburban lots become larger, and the front yards more dramatically spacious, with sweeping lawns
dotted with dogwoods and bordered with vivid azaleas—a springtime fantasy. The influence of the
Augusta National Golf Club and the Masters Tournament is sensed. Perhaps the most photographed Augusta
front yard garden is this one with a white-columned portico as backdrop, as though it were a classical folly in an
English country-house landscape garden. The picturesque grounds also have a formal boxwood layout,
which for generations has been a hallmark characteristic of the completed proper Georgia garden.

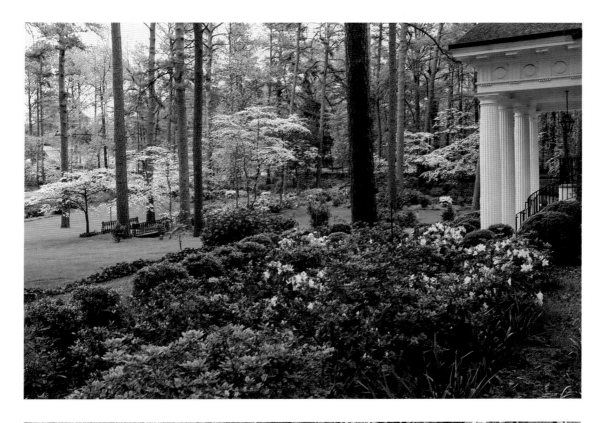

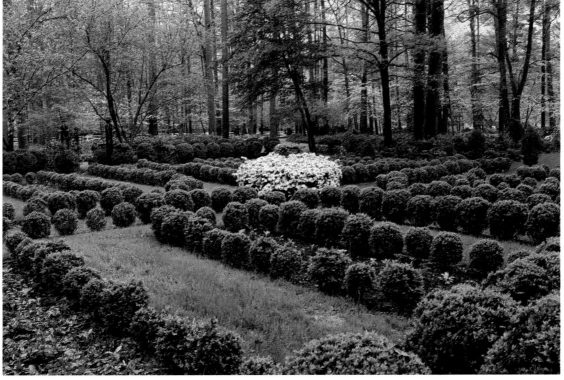

Augusta
Two Suburban Summerville Gardens

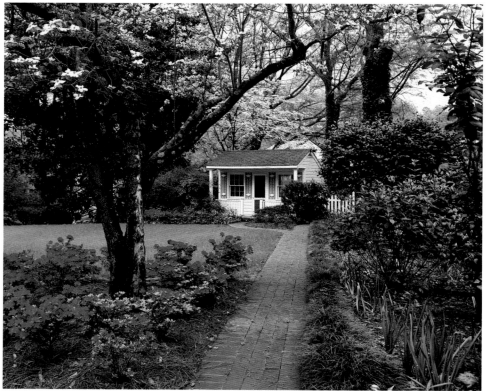

The Augusta sobriquet, "The Garden City of the South," is clearly illustrated by these two suburban
Summerville gardens. With the Barrow garden, they are among the most photogenic "yards" in the region,
blending geometric and formal, naturalistic and picturesque elements in a recognizable twentieth-century manner.

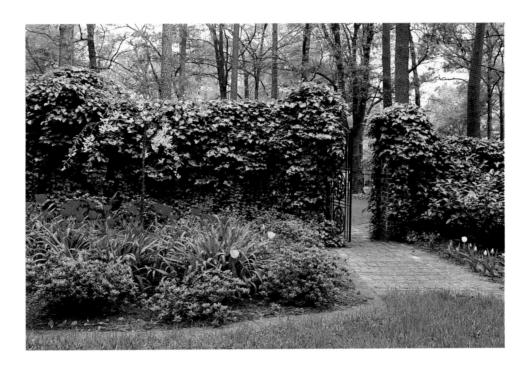

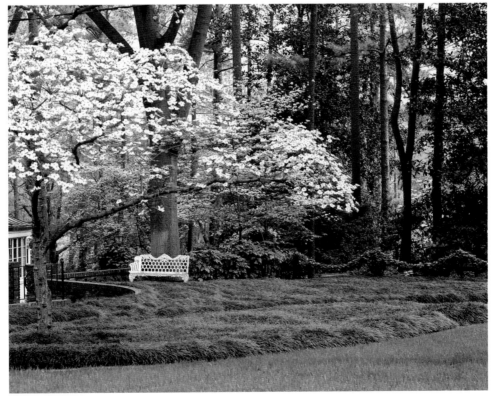

*Together such private, suburban pleasure grounds combine to create a much larger residential park,
reminiscent of the gently rolling grounds of an early nineteenth-century English
country house influenced by the landscape gardening of such designers as Humphrey Repton.*

Athens
UNIVERSITY OF GEORGIA GARDENS

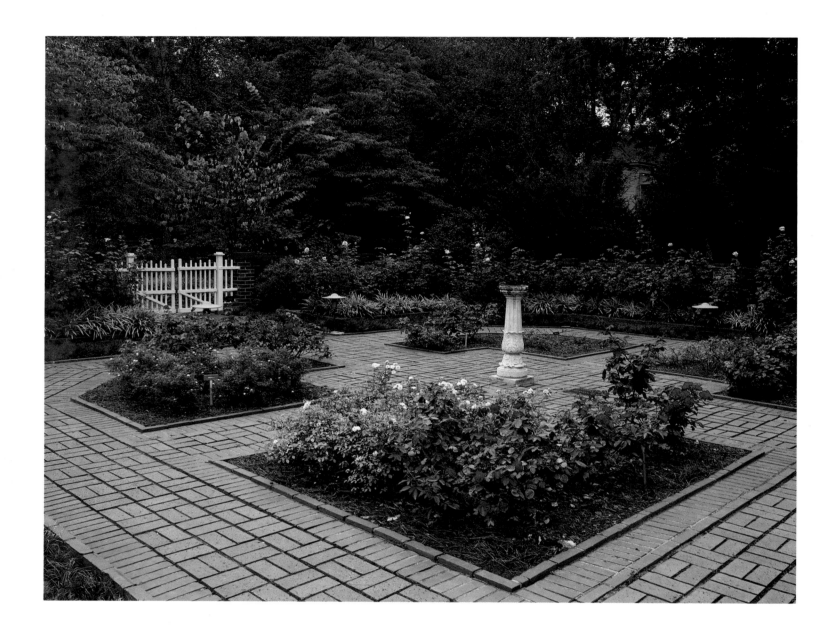

Athens, the county seat of Clarke County and the principal city of northeast Georgia, is located among gently rolling hills overlooking the north fork of the Oconee River at Cedar Shoals. In 1801 the state legislature founded Athens as the site of the state college, now the University of Georgia. Josiah Meigs, the first president of the college, described the site as "healthy and beautiful." As *Gardens of Georgia* demonstrates, no place in the state has had greater influence on gardens and on

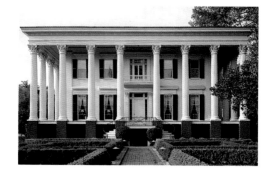

landscape design than Athens.

The president's home at the University of Georgia was built in 1857-58 by Col. John T. Grant. The five-acre landscaped lot, the house, and outbuildings were acquired in 1949 to serve its present purpose. The classic Corinthian portico overlooks a formal boxwood parterre garden surviving from the antebellum period. At the rear are additional gardens installed after 1949, including the formal rose garden designed by Dean Hubert Owens, FASLA.

The President's Club Garden (phlox, top), designed by Gordon Chappell, is adjacent to the old Franklin College on the historic North Campus. The 293-acre State Botanical Garden (entrance drive, above left) is located on the south edge of the university campus along the Middle Oconee River. Committed to the conservation of rare and endangered species, the garden serves as an outdoor laboratory for university classes in agronomy, botany, ecology, environmental design, forestry, horticulture, pharmacy, and plant pathology. The Department of Horticulture experimental garden (above right), also on the South Campus, is shown in late summer bloom.

University of Georgia North Campus, Athens
FOUNDERS' MEMORIAL GARDEN

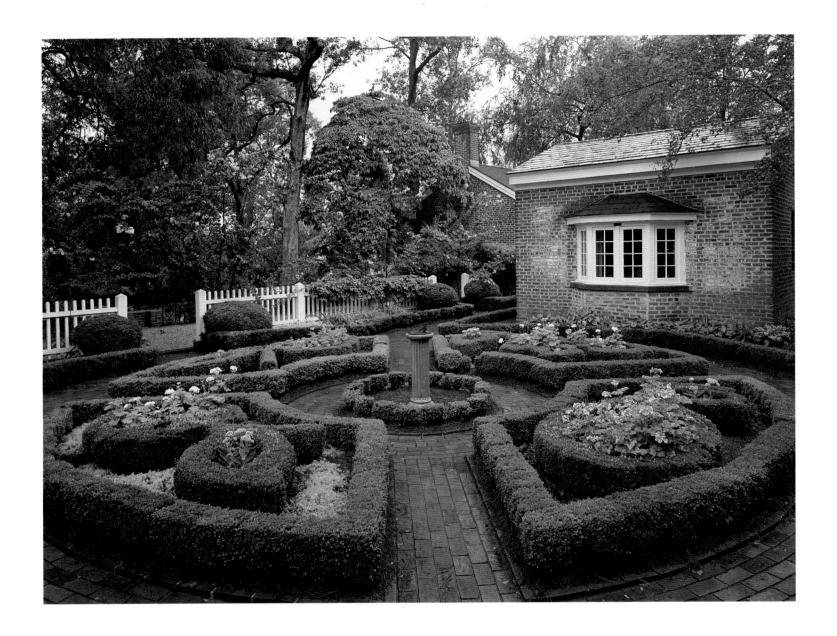

Near the School of Environmental Design — formerly the Department of Landscape Architecture — on the old North Campus of the University of Georgia is a two-and-one-half-acre series of formal and informal gardens surrounding several historic buildings. There are two courtyards, a formal boxwood garden, a terrace, a perennial garden, an arboretum, and the museum-headquarters of The Garden Club of Georgia, Inc. Begun in 1939-40, these gardens are museums of landscape design and outdoor laboratories for students

of landscape architecture and the plant sciences. Founders' Memorial Garden serves as a successor to the original botanical garden of the university developed nearby in the 1830s. This garden has one of the finest collections of Georgia and Piedmont flora to be found in the South, including: sweet bay magnolia, leatherleaf viburnum, Franklinia, flowering quince, lenten rose, Cherokee rose, and double flowering dogwood. The boxwood parterres (top) are accented with "knots" of Cherokee rose, peach, cotton boll, and watermelon.

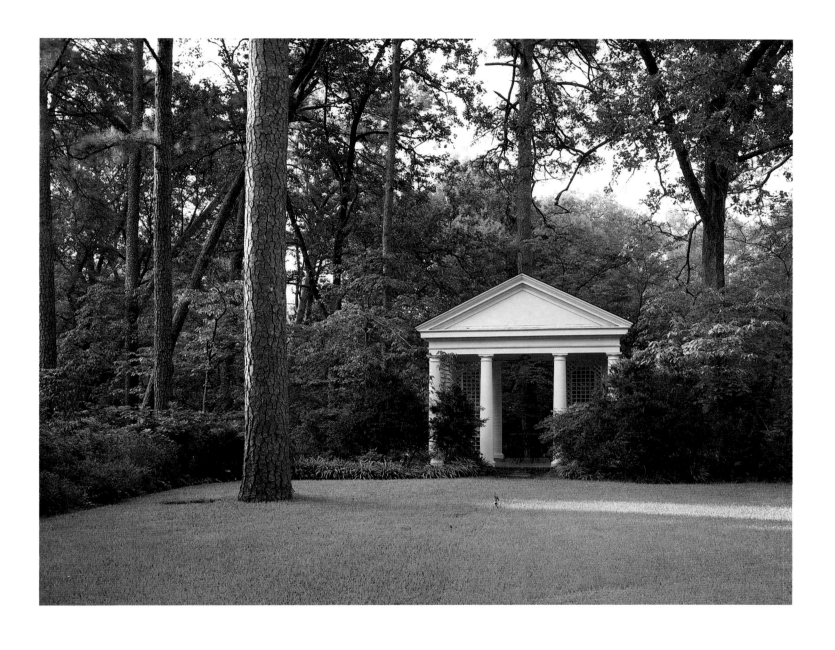

Wynnton, the residential area on top of Wynn's Hill, was a popular suburban site in the mid-nineteenth century
and continues to be the location of some of the most interesting homes and gardens in the city.
Within the Wynnton area are many quiet curving streets, tree-shaded havens of peace. The house and grounds
at Peace Garden, Peacock Woods (above), were designed in the mid-1920s by architect Neel Reid
shortly before he died. The handsome temple-form gazebo is an element of serene
classical formality in an overall woodland garden — like the grounds of an English country house.

Wynnton, Columbus
GORDONIDO AND KYLE GARDENS

On Wynnton Road at the top of Wynn's Hill in a quiet area called Overlook stands the historic house Gordonido with its rear gardens and garden house (above) designed in 1960 by Atlanta landscape architect Edward L. Daugherty, FASLA. Gordonido was built in the late 1830s by early Columbus settler John R. Dawson, who purchased the land from William L. Wynn, for whom the surrounding suburb is named. Daugherty's design complements the classicism of the house with gardens that are formal in character but contemporary enough for modern entertaining and upkeep.

The current owner, Mrs. Jerry Newman, writes: "In our world of strife and stress a visit to our garden sanctuary truly restores the soul, and we love sharing its beauty with friends and guests at social events."Very near to Gordonido is the home and garden of Clason Kyle. Maintaining and augmenting a design landscape architect Max Lindsay created in 1940 for his parents, Mr. Kyle has added such improvements as a swimming pool, dining pavilion, and this gazebo (top), which he calls a "Buddha House." Mr. Kyle, a retired journalist who is his own head gardener, writes: "Except for the spring when the garden is quite festive because of the blooming azaleas and camellias, the garden is basically a green oasis in a midtown suburb. Quiet, peaceful, walled-in formality, seemingly more remote from busy highways and commerce than it really is."

Wynnton, Columbus
NORDHAUSEN GARDEN AND "TRANQUILLA"

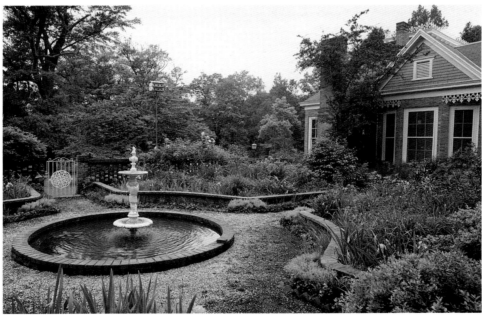

Entered from an avenue that runs beside the late-nineteenth-century house, the Nordhausen walled garden (top) is like another room of the beautifully restored house—its green foyer. The wooden windmill that presides over this courtyard was once used to pump water, and later was the studio of A. Henry Nordhausen, a well-known artist formerly of New York City. His wife, Ethel Nordhausen, who created this garden, states: "Every day my garden gives me pleasure—except when something dies and I do not know why. When I was younger I had garden parties in the early spring and fall—just the right size for a few people— but now just something growing is a pleasure as we come and go.

It is a thing of beauty." The garden at "Tranquilla" was the creation of Mrs. Mallory Reynolds Flournoy, president of The Garden Club of Georgia, Inc., from 1938 to 1940 and founder of the Charter Garden Club, the first of its kind in Columbus. Her daughter, Mrs. Jack Passailaigue, designed many aspects of the present landscape, including the formal garden next to her studio at the rear of the grounds (above). Mary Passailaigue writes: "When the garden was originally begun by my mother, she sold butter and eggs from her cow and chickens to buy daffodil bulbs." She adds: "My philosophy of gardening is, 'The peace of a Garden filled with the blossoms of Love, Goodness, and Beauty.'"

Wynnton, Columbus

ILLGES GARDEN

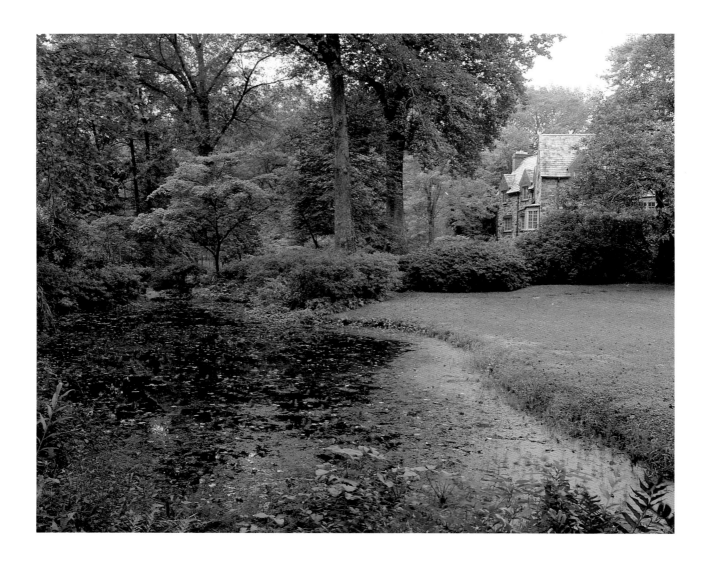

Peacock Woods, laid out in the 1920s by E. S. Draper, a landscape architect from Charlotte, North Carolina, is like one large garden neighborhood. In the 1930s, Atlanta landscape architect William C. Pauley, FASLA, created this naturalistic landscape garden for the Illges family to complement their English Tudor revival house. The house, viewed from the rose garden or the spring-fed pond, seems very much a part of an English country scene, as the grounds attractively combine formal and informal elements to create a landscape of serenity and charm. The side terrace with its irregular pattern of stones separated by grass is an appealing romantic device and an interesting accompaniment to the stone Tudor house. Virginia Illges says: "The garden exists simply to provide beauty during each season of the year."

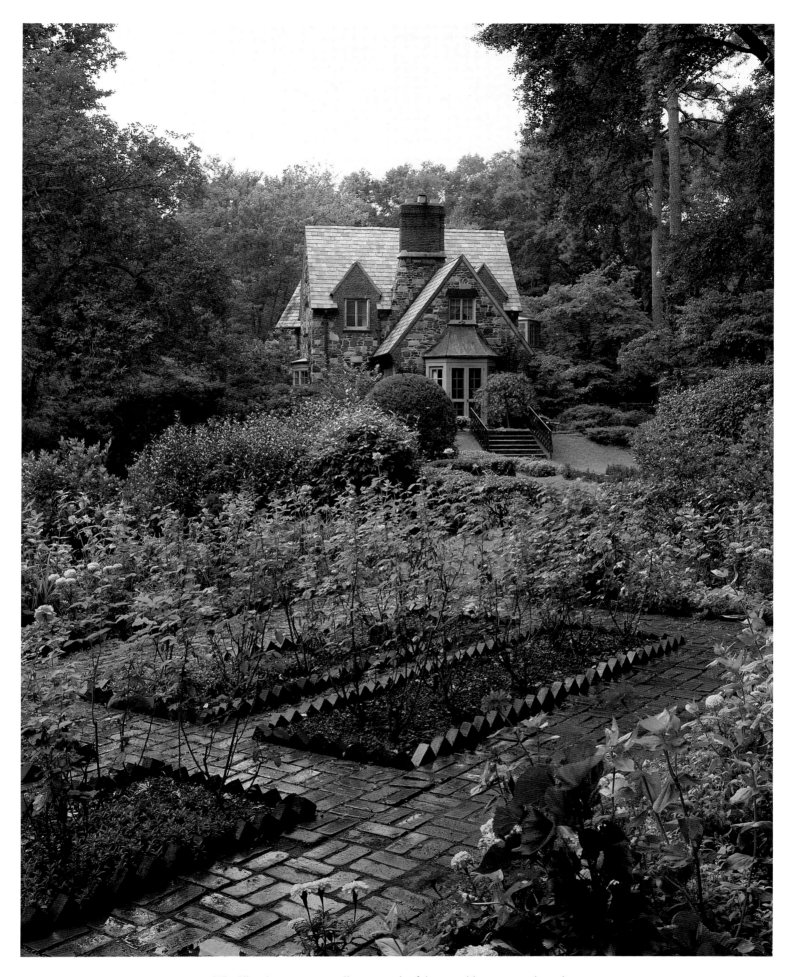

The Illges house is an excellent example of the visual harmony achieved
when the architecture of a home and its grounds are carefully planned and coordinated.

Newnan
Bankshaven

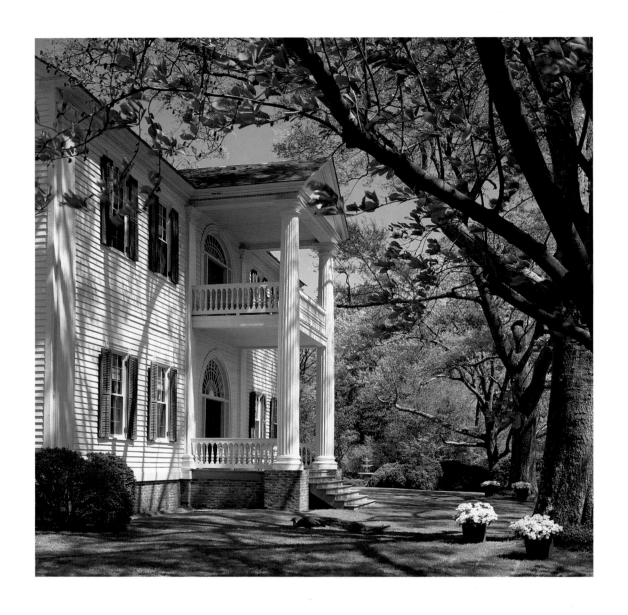

Bankshaven is an estate in two defined senses: "a landed property usually with a large house on it" and "assets left by a person at death." The late William N. Banks, Sr., left Bankshaven as part of his assets to his son William Jr. And it is a landed property with a large house, which replaced the larger family house that stood on this site. (In 1969, William Banks, Jr., moved the John W. Gordon house here from Jones County near Milledgeville.) William C. Pauley, FASLA, designed the grounds of Bankshaven for the elder Banks in the late 1920s, and they remain essentially as designed and planted. The grounds of the estate are

like those of an English country house—a park as designed by one of the great figures of the English landscape garden school, such as Humphrey Repton (1752-1818) or one of his followers. Within this landscaped park there are 300 acres, five major gardens, and a broad lawn leading to a ten-acre lake. No wonder William Banks, who counts himself "one among five gardeners" at Bankshaven, writes that the special purposes the garden serves are "pain (for developing character) and sometimes pleasure." The wide doorways and fanlights of the 1828 Federal-style Gordon-Banks house offer splendid views of the lawn and lake.

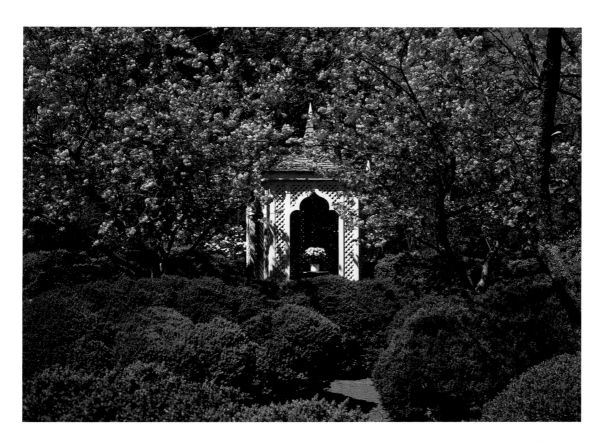

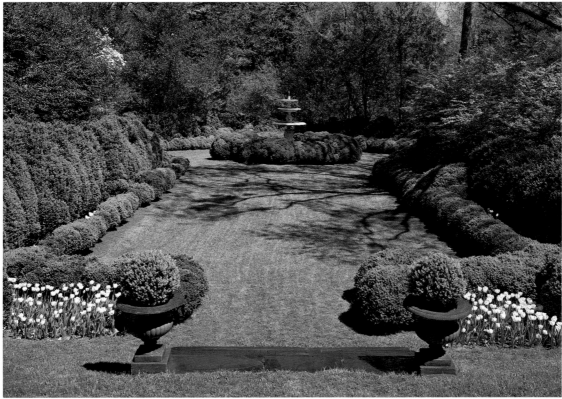

The focal point of one mature boxwood garden, accented with triumphator tulips, is a three-tiered Carrara marble fountain carved in Italy for the fabled antebellum garden of Godfrey Barnsley in north Georgia. William Banks commissioned Robert L. Raley to design a Gothic-style gazebo to grace another of the established boxwood gardens. One of the major gardens in Georgia and the nation, Bankshaven has been featured in many fine magazines and books.

The Ferrell-Callaway Garden
Vernon Road, LaGrange
HILLS AND DALES

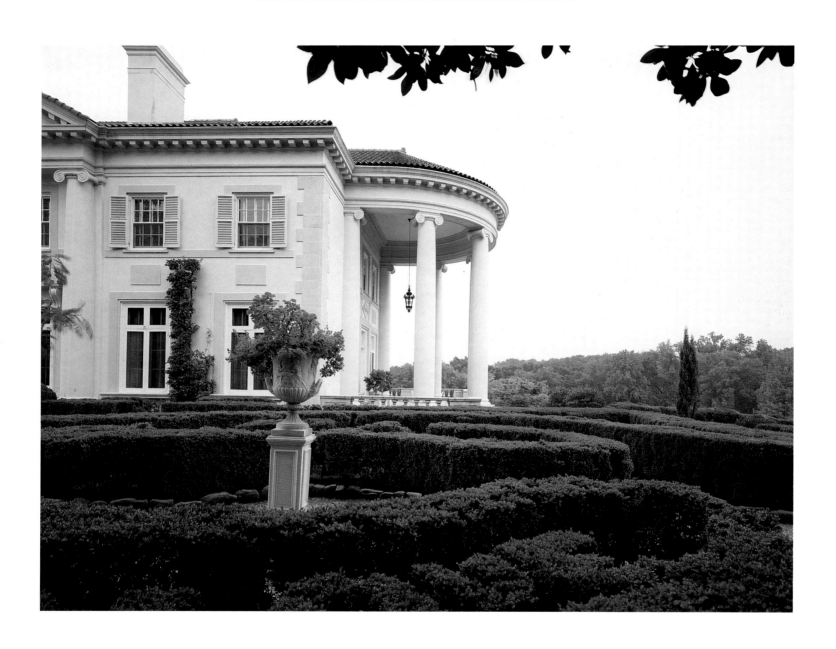

In January 1916, Fuller E. Callaway, Sr., of LaGrange, received a long report from P. J. A. Berckmans Company, Inc., Landscape Architects, Augusta, Georgia. The report stated: "In studying your residence property it has been our purpose to make suggestions that will preserve, as far as possible, the atmosphere of the fine old garden, which you have been very fortunate in acquiring. With the wealth of luxuriant growth, there is but little need, in most sections, to make any additions, except where plants have failed." In 1912 Callaway had acquired "the fine old garden" from the estate of Mrs. Sara Coleman Ferrell, who had begun the garden in 1841. To replace Mrs. Ferrell's frame cottage, Callaway retained the leading practitioner of coordinated house and garden design in Georgia, Neel Reid (1885-1926) of the Atlanta firm of Hentz, Reid, and Adler.

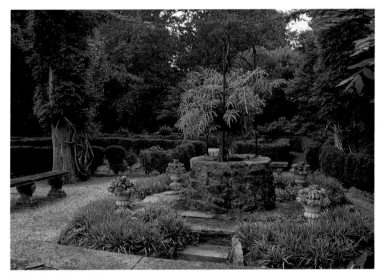

To complement the formal Renaissance character of the garden, Reid designed a Palladian-style villa (entrance portico, opposite page, top), placing it on the ridge where Mrs. Ferrell's cottage had stood. This helped to preserve the integrity of the garden, which covered a series of six terraces descending from the ridge toward Vernon Road (top, left and right).

Within the five-acre park surrounding the house, there were formal and informal elements. Perhaps the best known formal aspects of this most famous of all private Georgia gardens, and one of the most extensive in the state, were the boxwood mottoes and designs, bordered paths, beds shaded by ancient trees, and quiet spots for relaxation and reflection, all of which the Callaways loved and retained. On the third terrace is a Socrates Herm, or sculptured pedestal (opposite page, bottom), in the Lovers' Lane garden. On the fourth terrace is this old well (above, left), one of three in the garden that used to service hand watering but now is dry. Also on the fourth level, Mrs. Ferrell planted a boxwood pattern in the form of a harp, or lyre (above, right). Nearby on the fifth level there is an enormous boxwood bunch of grapes. In 1841 this was a remote corner of Georgia, but Mrs. Ferrell's designs had precedents in classical gardens as long ago as the time of Pliny the Younger (62-113), who wrote of a villa boxwood garden: "Sometimes the box are even made into letters."

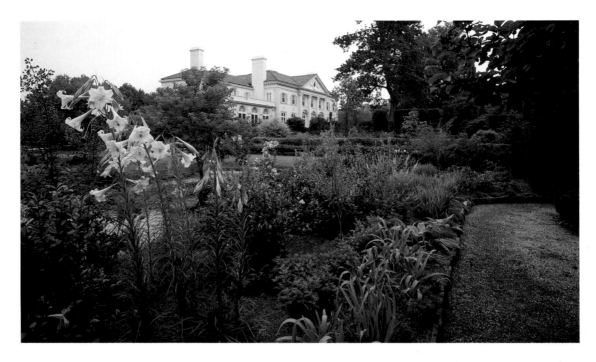

The present owners of Hills and Dales are Fuller Callaway, Jr., and his wife, Alice Hand Callaway.
Alice Callaway's "white garden" (top) was inspired by Vita Sackville-West's garden at Sissinghurst.
In the foreground are pure white Philippine lilies. This bed is near the old well and the greenhouse. The lower terraces
(above), more informal and curvilinear than the upper terraces, are a green sanctuary just off of busy Vernon Road.
Local stone was used to form retaining walls and stairways. In such secluded areas one can sense the spirit of
Mrs. Ferrell, who once wrote to a friend: "You know how I have ever loved beautiful plants and gardens."
The garden now consists of the original five acres and one-half acre more.

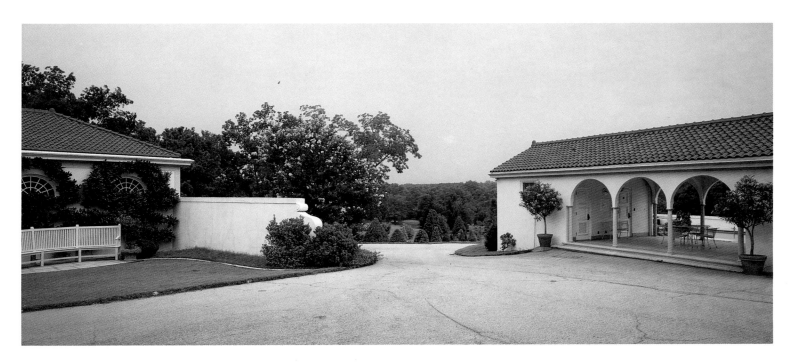

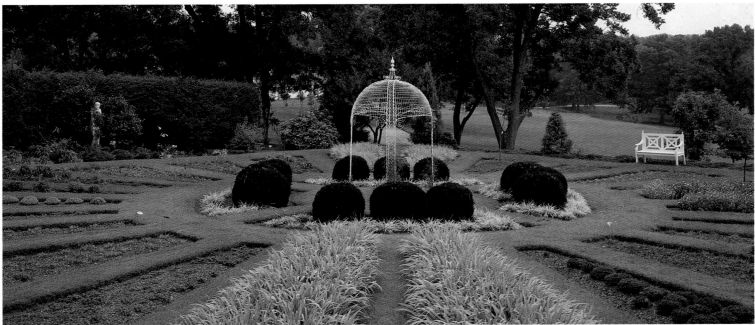

The entire estate of Hills and Dales, named by Fuller Callaway, Sr., for the rolling piedmont of the countryside,
is approximately 1,500 acres — Mrs. Ferrell had eighty. Two Italianate tile-roofed outbuildings (top)
sit atop one of the hills with a view in the distance of the surrounding property. On the north side of the house
below the entry drive is the spoke-patterned gazebo garden (above) added by Alice Callaway.
Obviously, the Callaways care for the old garden in the spirit of Mrs. Ferrell; of Fuller, Sr.,
and his wife, Ida Cason Callaway; and the Berckmans's report. Alice Callaway states: "A garden is a joy forever."
Certainly this garden has provided such joy now for nearly 150 years.

Pine Mountain
CALLAWAY GARDENS

In the 1920s and 1930s, Cason Callaway, Sr., (1894-1961) and his wife, Virginia Hand Callaway, (older brother and older sister of Fuller and Alice Callaway of Hills and Dales) often motored out from LaGrange into the rolling Appalachian foothills at Pine Mountain. Blue Springs Farm, their large private Eden on the northern slopes of the mountain, was a weekend retreat until they moved there permanently in 1938. There they had discovered the plumleaf azalea, <u>Rhododendron prunifolium</u> (right), a rare native wildflower that blooms in July and is found naturally only in about a 100-mile radius of Blue Springs. The Callaways had found it amidst a wasteland of once fertile, now abandoned corn and cotton farms, which they began buying to improve—first 3,000 acres and later many times that. Cason Callaway started resurrecting the land and making it into a botanical reservation. He also constructed lakes, flower trails, a golf course and clubhouse, and a country store. All of which formed the nucleus when they opened 2,500 acres to the public in 1952 and established the Ida Cason Callaway Gardens, named for Cason's mother.

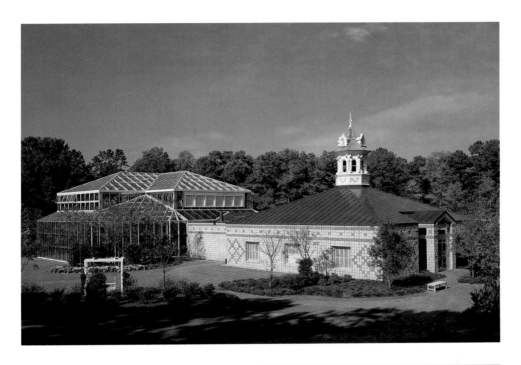

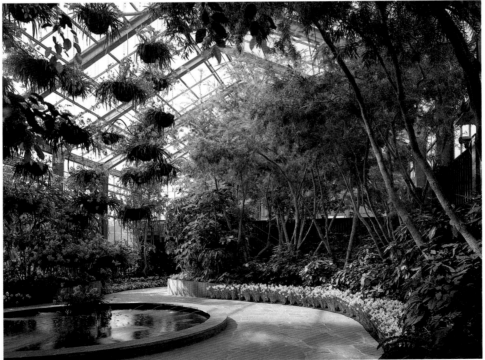

As clearly defined in the official statement for the gardens: "The purpose of the Ida Cason Callaway Foundation
is to provide a garden of natural beauty where people may find relaxation, inspiration, and a better
understanding of the living world." Today there are thirteen miles of scenic drives; a five-mile bicycle trail;
nature trails winding through acres of woodlands, water, and wildflowers; wildlife sanctuaries; a chapel;
two garden conservatory buildings—the Cecil B. Day Butterfly Center (top) and the John A. Sibley
Horticultural Center (above); and a seven-and-one-half-acre fruit, vegetable, and berry garden.
The gardens are maintained by a professional staff of sixty-five and attract more than 750,000 visitors a year.

Hjort rose test garden, Thomasville.

SOUTH GEORGIA

GEORGIANS call the region south of the fall line and west of the immediate coast "south Georgia." Geographers call it the Coastal Plain, which they divide east from west at the Ocmulgee River in the center of the state. East of the Ocmulgee is the Atlantic Coastal Plain; west to the Chattahoochee River is the Gulf Coastal Plain.

In a survey of the area in 1772, William Gerard de Brahm reported: "The Land is rising gradually from the Sea Coast . . . and then it begins to form in Hills; . . . [it] proves by Experience to be calculated for the Culture of all European Granes, for Flax, Hemp, Grape Vine, Tobacco and Silk; as also for Mays (maize), Potatoes, Pompions, Melons, Rice, and Indigo; for the Culture of Mulberry Trees, both Spanish and Portugal, for Apples, Peaches, Necterons, Plumbs, Pears, and Apple Quinces; also for all manner of European Garden Products."

Despite de Brahm's assertions, however, the first wave of settlers to try the interior of Georgia eventually moved farther north into the piedmont region—only to farm it carelessly until they exhausted the soil.

Meanwhile, cessions of Indian territories, followed by state land lotteries, opened south Georgia for white settlement from the mid-eighteenth century into the late 1820s. Before cultivation, this region was basically composed of wire grass in the east, pine barrens in the center, and rich fertile soil (the lower Black Belt) in the west. By

Camellia blossoms at the American Camellia Society Garden brighten the winter and early spring at Fort Valley.

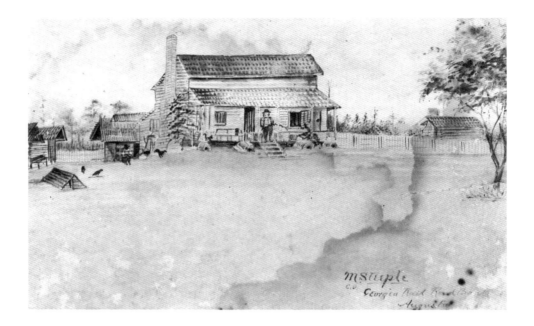

the mid-nineteenth century, even the vast acreage of wire grass and pine barrens became Deep South cotton country as plantation owners in the piedmont areas of Georgia and the Carolinas migrated here in search of fresh soil.

In the era when cotton was king, the first settlers naturally planted that profitable but soil-consuming crop. Subsequently, farmers of the region succeeded with corn and tobacco, and later soybeans and peanuts, as well as peaches and pecans. Visitors to south Georgia were (and still are) amazed at the numbers and variety of plants which thrived there, and nineteenth-century promoters of the region were as unashamedly enthusiastic as their eighteenth-century predecessors Sir Robert Montgomery and James Edward Oglethorpe. A booklet written in 1897 by J. C. Haile, "General Passenger Agent" for the Central of Georgia Railway Company, boldly proclaimed: "The fruit paradise of the country is along the lines of the Central of Georgia Railway, running through sections of Georgia which claim the unique distinction of having the largest peach, pear, and plum orchards in the world. The rare sight of 1,000,000 peach trees, 30,000 pear trees, with plums and grapes in proportion, gives but a faint idea of the possibilities of this great State."

With a growing season of around 240 days, south Georgia offers opportunities for gardeners unavailable to their counterparts farther north. Boston journalist Sidney Andrews visited Albany in November 1865 and was taken with the effects of the mild climate. Accustomed to a quite different late autumn landscape, the Yankee traveler wrote: "A dozen varieties of roses are in full bloom and fragrance in the gardens and dooryards of the town; wild flowers blossom in the old fields and by the roadside; the grass still shows freshness and greenness; the leaves of the mulberry are beginning to fall, but those of the oak and china and willow have hardly lost any of their summer color."

This drawing of the Charles H. Johnson house, an 1842 double-pen log cabin,
illustrates a typical rural nineteenth-century south Georgia home and yard.

Sixty miles due south of Albany, and ten miles from the Florida line, is Thomasville, one of the most attractive towns in Georgia. The site of an annual rose festival and show, Thomasville is also the home of the nationally known Hjort rose test garden. *Newsweek* magazine reported in July 1981: "Thomasville, Georgia, population 18,430, is a storybook town near the Florida border whose wide brick-paved streets are lined with oak, dogwood, and long-leafed yellow pine trees. The town still maintains its many nineteenth-century mansions — and an estimated 60,000 rose bushes."

Almost eighty years earlier, in 1903, *Harper's Weekly* devoted an entire issue to Georgia. Of the area around Thomasville it noted: "In [south Georgia] are vast pine forests, a highly productive soil, and a balmy climate which is eagerly sought as a winter resort for invalids. . . . In fact, Thomasville is a health resort, numbers of health seekers coming every winter from the severe climates of the North and East to breathe the life-giving fragrance of the pine forests by which it is surrounded."

Situated on a ridge 275 feet above sea level, Thomasville is only fifty miles from the Gulf of Mexico, and it has a long and continuing tradition as the winter home of well-to-do people from the "severe climates," especially from Cleveland, Ohio, and the Midwest. (The average year-round temperature of Thomasville is 66.7 degrees Fahrenheit.)

The nineteenth- and twentieth-century houses and gardens of Thomasville are renowned, including antebellum plantations that are perhaps even more breathtaking today than ever in the past. One of the finest of these is the late Elisabeth Ireland Poe's Pebble Hill Plantation, which Mrs. Poe's generosity allowed to be opened as a museum in 1983. The majority of the old plantations, however, are private; they are part-time residences that come to life during the quail shooting season. Among these is the late John

Rose test garden, Smith Avenue, Thomasville.
Thomasville is called the "city of Roses" and holds a rose show and festival each April,
largely because of the leadership of the Hjort family, Thomasville nurserymen for more than ninety years.
The Hjorts established this public rose test garden in 1960 under the auspices of All-American Rose Selections, Inc.

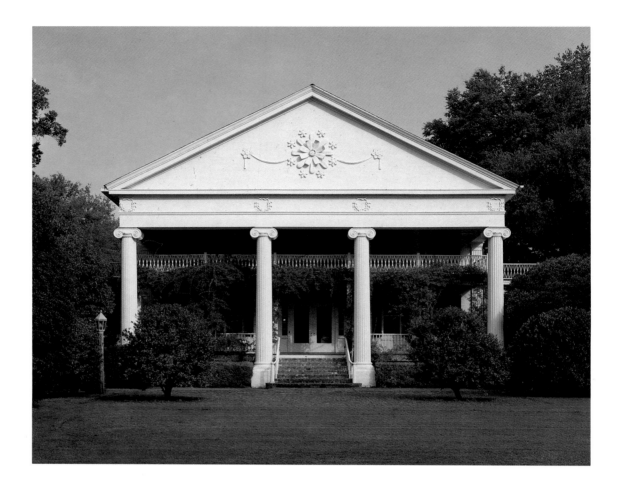

Hay "Jock" Whitney's magnolia-framed Greenwood, begun in the 1830s and one of the most beautiful Greek Revival houses in the nation. The private grounds are no less impressive, from the Cherokee rose-covered entrance gates at Pinetree Boulevard, to the stately palm garden. In the *Garden History of Georgia, 1733-1933*, the editors wrote: "Greenwood is a justly famous place, and its perfect maintenance from field to parterre is as impressive as its architecture and landscape beauty."

For many reasons, south Georgia may well be the most quintessentially Georgian part of the state—a place that visitors immediately recognize as being agricultural and small-town neighborly, while at the same time retaining an aura of the plantation South. Although some might feel the character of the south Georgia landscape is not as remarkable as that of the mountains of the north, the rolling red hills of the piedmont, or the islands of the coast, the countryside of the breadbasket of the state is no less inspirational to those attuned to the aesthetic charms of agriculture and gardening. To understand this, one would only have to read the reminiscences of J. L. Herring, editor of the *Tifton Gazette* in the late nineteenth century, who articulated the feelings of many south Georgians.

Greenwood Plantation, Thomasville, 1839.

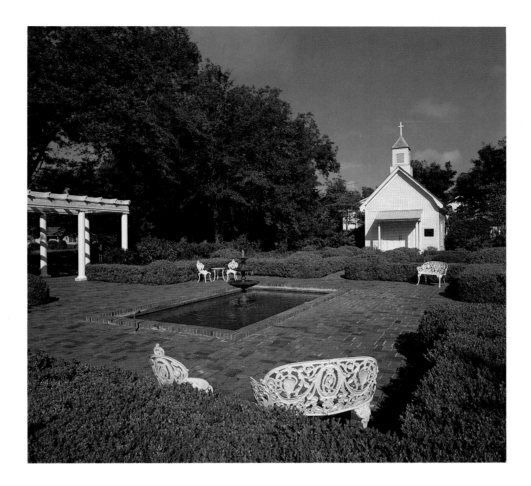

On the slope of the pine-clad hills the new crop of grass was springing, a brilliant green; along the branch below the field the poplars and blackgums were putting out fresh leaves and the evergreen bays and magnolias had taken on a more verdant tinge; down where the field merged into the branch lowlands, the patch of plum trees was a cloud of snow-white bloom; farther up the hillside the peach trees, covered with a pink mantle, perfumed the air; in the yard, the yellow jessamine, the jonquils and crocus were in flower; in the air a feeling of don't-careness; the sunshine had a zigzag haze well called "laziness dancing;" on a nearby stump a lark sang and watched, and from a distant pine a crow looked on and waited. It was mid-March and Bud and the Boy were planting corn.

The gardens that follow are delightfully diverse, from the formal grandeur of a hunting plantation to the inviting natural beauty of a small backyard. In sum they reflect the character and devotion of the variety of gardeners who love the warm climate and tranquil vistas of south Georgia.

The mild climate of south Georgia encourages many residents to enjoy the pleasures of gardening and to share their experiences and interests through garden clubs. The Crescent, a grand house built for Col. William S. West in the 1890s, is now the Valdosta Garden Center. In 1952 the center added a formal boxwood garden with a chapel, fountain, pergola, and a National Display Garden of the American Hemerocallis Society.

Thomas County
PEBBLE HILL PLANTATION

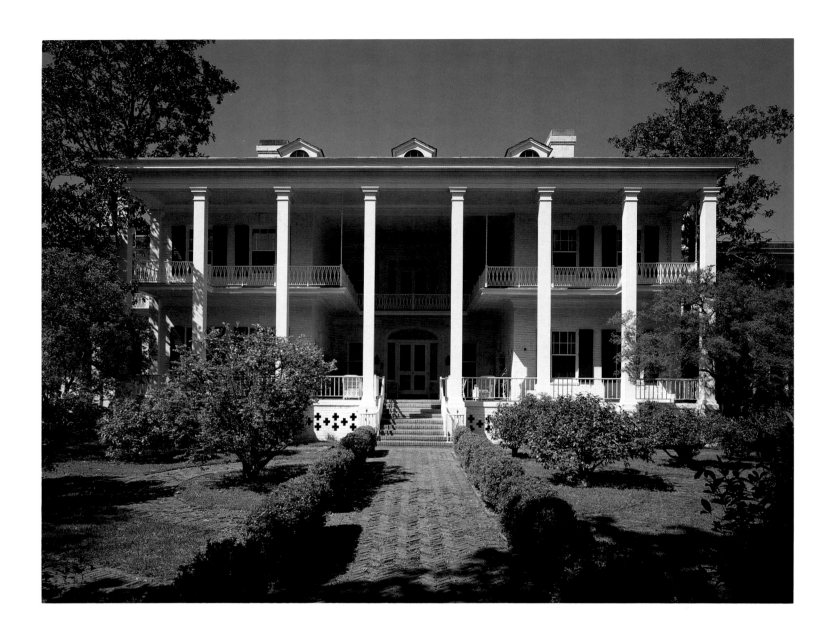

Completed in the winter of 1935-36, this is a two-story, white-painted brick version of the antebellum frame cottage that had stood on the site since the 1850s. The old house, which burned in 1934, had been H-shaped with a front veranda formed by square slender columns. The front of the replacement is also H-shaped with slender columns, which rise two stories from brick piers set out from the porch

floor, as was the Thomas County custom. The front veranda overlooks a green lawn with geometrically patterned brick walkways and old plantings of camellias and azaleas (opposite, top).

Since the 1820s, when the planter who founded Thomas County and Thomasville also started Pebble Hill, this has been an important plantation, inseparable from the development of the county.

During the 1890s winter resort era in the county, Pebble Hill became the winter home and quail-shooting preserve of the Howard Melville Hanna family of Cleveland, Ohio. A Hanna descendant, Elisabeth Ireland ("Miss Pansy") Poe (1897-1978), who loved Pebble Hill and is buried there, was the last owner of the estate. She established a foundation to preserve and display the plantation, and the house and grounds were opened to the public as a museum in 1983. Near the house and formal gardens are the handsome stables (above) that Mrs. Poe, an avid and accomplished horsewoman, adapted from the dairy complex that had previously housed her mother's prize-winning herd of dairy cattle. Also on the landscaped grounds and open to the public are the dog kennel, the fire-engine house, and the historic cemetery.

Thomasville
MILLPOND PLANTATION

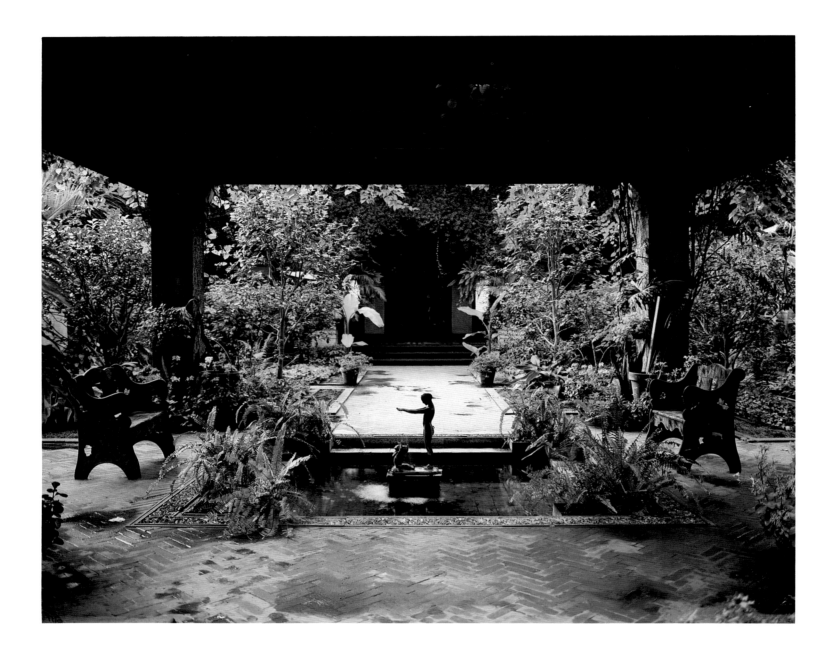

A villa was a country estate developed in a warm Mediterranean climate during the Renaissance with house, gardens, and grounds conceived as a unit—the indoor and outdoor spaces an integrated composition of architecture and landscape architecture. Villas were often arranged around an open courtyard or patio, and Millpond, built in 1905 for Jeptha Wade of Cleveland, Ohio, is a novel version of such a villa. The arcaded courtyard garden,

covered by a boldly engineered steel-and-glass roof is, in effect, a 10,000-square-foot interior greenhouse with a glass canopy designed to be opened in good weather. All of the major rooms and bedrooms open onto this exotic, plant-filled space. The firm of Hubbell and Benes, AIA, of Cleveland, designed the house, and Bostonian Warren Manning, ASLA, a former student of Frederick Law Olmsted, designed the grounds and gardens.

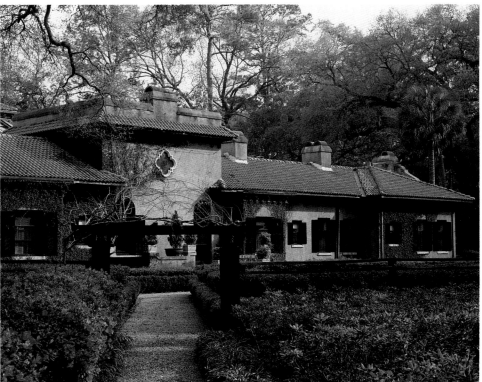

A Wade descendant uses the house seasonally, a custom on many Thomas County plantations since the 1890s.
The warm climate of the area has encouraged the building of large estates with extensive gardens
and landscaped grounds and thousands of acres of piney-woods quail-shooting land. Millpond, one of the
most notable of these villa-plantations, was added to the National Register of Historic Places in 1976.

Thomas County
SPRINGWOOD PLANTATION

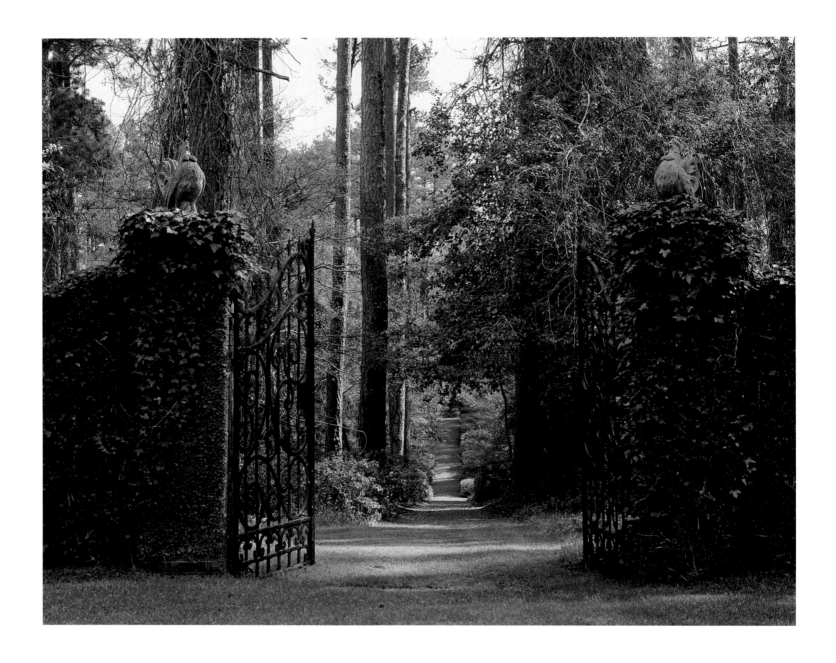

Between Thomasville and Tallahassee, Florida, a stretch of thirty-five miles, are some of the finest
private plantations in the South. One writer called them "playtime plantations," and sometimes they are called
"woodland plantations," which emphasizes the more serious side, for these large tracts of land
are carefully managed with ecologically good sense, and conservation is the watchword. Among these is Springwood,
the beautiful compound of the Chubb family, which has been wintering in the Thomasville area long enough
to be counted as citizens. These gates are the entrance to the azalea-woodland garden,
where a reflecting pond mirrors the tall longleaf pines for which Thomas County has long been famous.

Remington Avenue, Thomasville
GRACE GARDEN

*The post-Civil War leisure class that sought out resorts, at first in the name of health and later for pleasure only,
made Thomasville and Thomas County fashionable and world famous. Thomasville was featured when
Harper's Monthly Magazine included it among "The Winter Resorts of Three Continents" in November 1887.
In addition to the villa-plantations and great hotels, there were many private winter cottages, among them the
1885 house of Mrs. Evelyn S. Burbank, of Wisconsin. Dr. Ben Grace has restored the house
as his residence and in 1983 added this tile-roofed conservatory, which he calls his orangery.
Thomasville still has a winter colony, but proud residents have restored many of the winter cottages
and maintain full-time homes and lovely gardens, making Thomasville a year-round delight.*

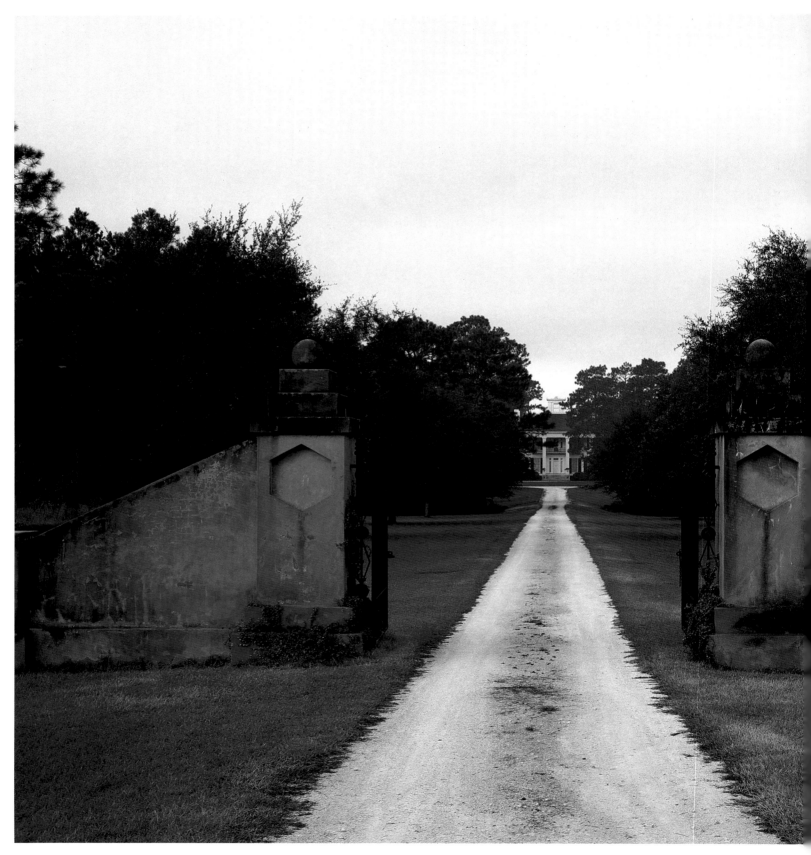

Tallokas Road, Moultrie
IRIS COURT

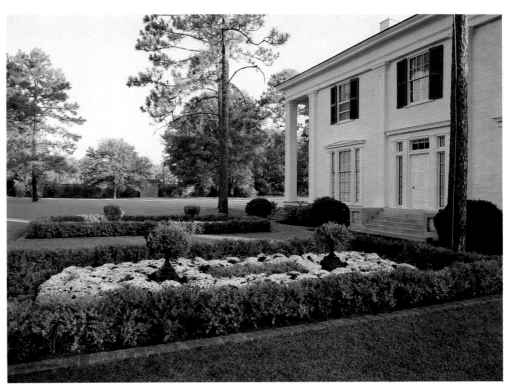

Out from Moultrie now stands a fine Greek Revival house that was originally built in 1853
in Albany and was almost destroyed in the late 1950s. In 1961 Charles O. Smith, Jr., purchased
Iris Court after it had been sold for razing and moved it to this exceptional site on Tallokas Road.
Architect Edward Vason Jones of Albany supervised the entire dismantling, moving,
and renovation/restoration, which was completed in 1965. Mr. Jones also designed the
entrance piers and gate, framing an alley of oak trees and the house beyond. Iris Court is set in
a great sweep of green lawn, and the grounds are very simply done, except for a few formal features,
such as these balancing rear boxwood parterres planted for the fall.

Tallokas Road, Moultrie

CLASSIC MOULTRIE HOUSE AND GARDEN

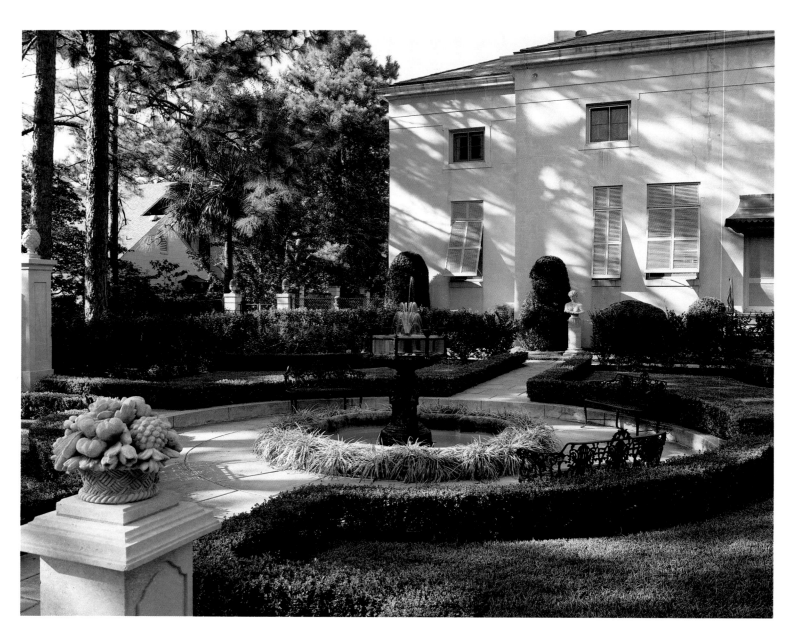

This Palladian Revival villa-townhouse was adapted from the facade of the Howard (Paramount) Theater, an Atlanta film palace that was torn down in 1960. The theater, designed by Philip Shutze of the Atlanta architectural firm of Hentz, Reid, and Adler and built in 1920, became a

Moultrie townhouse under the direction of Moultrie classicist William Frank McCall, Jr., FAIA. Completed in 1962, this was the dream child of the late Robert W. Wright, Jr., who had read of the planned demolition of the theater and had rushed to Atlanta to purchase the facade before it was destroyed.

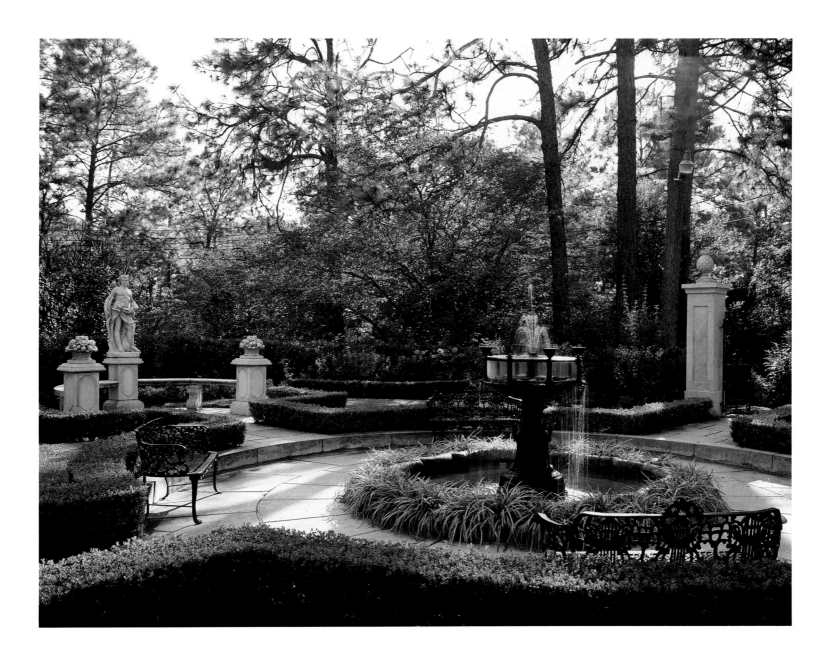

The present owner preserves the house and garden as Wright and McCall had conceived them. From
the front entrance gates and courtyard fountain (lower, opposite) to the rear goldfish fountain
and garden, this formal setting is a romance of classical revivalism. Again, the Georgia love of the
Italian villa is brought to life, this time in the deep southwest sector of the state, where the climate
and vegetation are reminiscent of an antique Mediterranean setting.

Woodland Drive, Plains
CARTER GARDEN

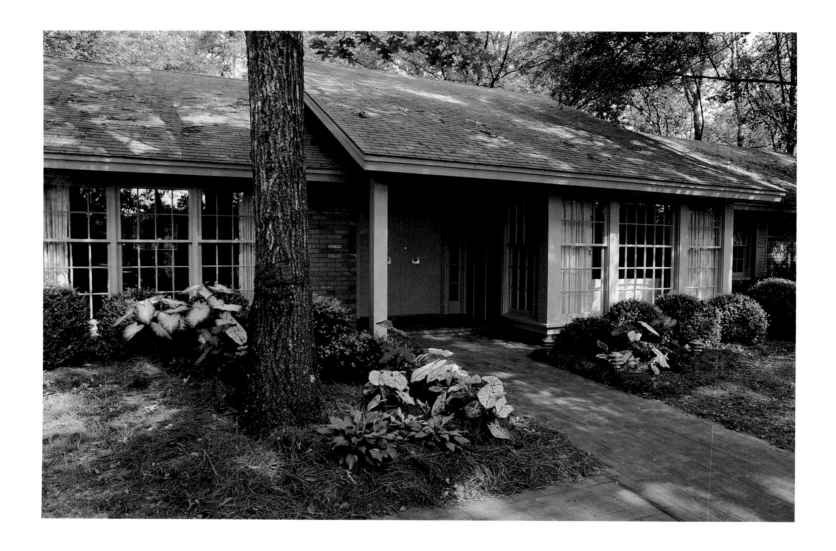

Rosalynn Carter, former first lady of the United States, put it with utter simplicity: "I designed my garden myself for my family to enjoy." She referred to the grounds and this rear terrace of their house in Plains, built in 1961— their south Georgia home, before, during, and after Jimmy Carter's terms as governor of Georgia and president of the United States.

The Plains of Dura, a biblical reference,

was an early name of the settlement, but in 1885 the town moved to take advantage of a newly built railroad, and the name was shortened to Plains. Jimmy Carter's family moved here in 1904 and became peanut farmers when peanuts replaced cotton as the favorite cash crop of the area. Their patio garden has witnessed much history and probably has had more historic visitors than any private garden in the state.

Plains
WEBB HERB GARDEN

Caroline Webb's garden has ninety varieties of herbs used for medicinal, culinary, and decorative purposes—and for potpourri. She designed her own landscape, clearing an acre of land by her lake to make an informal garden with various beds that combine texture and color. She is her only gardener, working approximately four to six hours a day throughout the week.

Former President and Mrs. Jimmy Carter are long-time friends and visit the garden often when they are in Plains. Caroline Webb writes: "My herb garden satisfies all the five senses. Herb gardening is the greatest therapy on earth for the mind, soul, and body. She adds: "Truly one is nearer God's heart in an <u>herb</u> garden, than in any place else on earth."

Plains
DODSON GARDENS

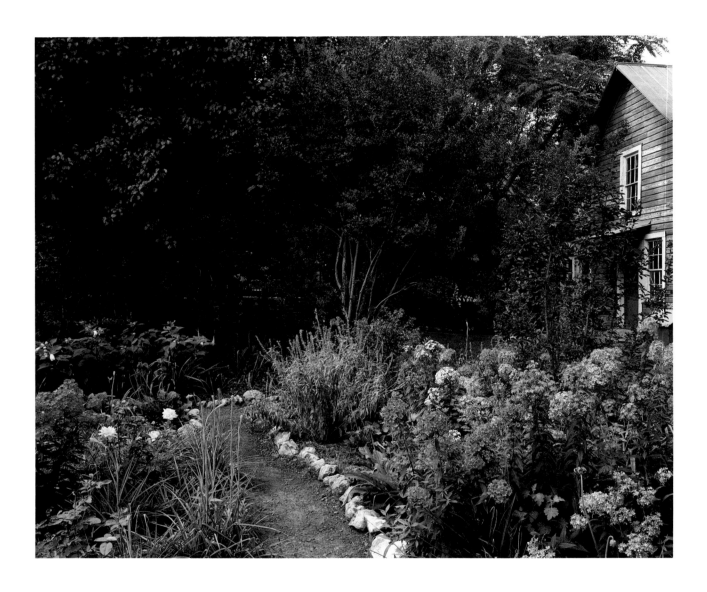

Ann and Clarence Dodson designed and planted their own old-fashioned southwest Georgia farmyard garden. She writes: "We grew our plants from seed: camellias, crape myrtles, hostas, and daylilies. We grow five varieties of hydrangeas that were rooted from cuttings. Our boxwoods were from cuttings. The rocks that line our garden paths were gathered from our family farms in north and south Georgia." The Dodsons are close friends of former President and Mrs. Jimmy Carter. Mrs. Dodson was chairwoman of the decoration committee for the White House when President Carter was inaugurated and used flowers from this garden at the White House. At the Dodson house in Plains, where fifty-year-old ferns decorate the front porch, Jimmy Carter made his first speech announcing his run for the presidency.

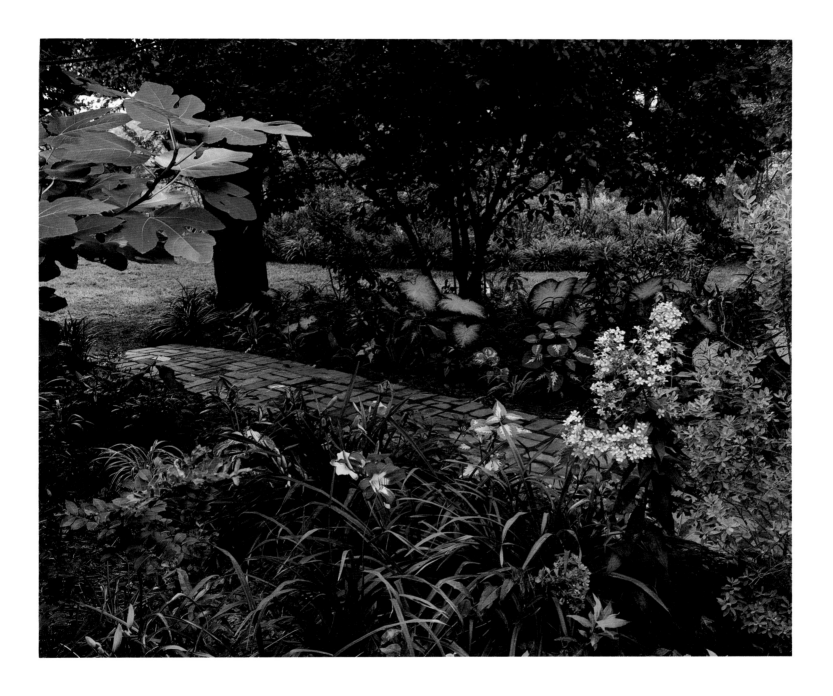

Dawson
Stapleton Garden

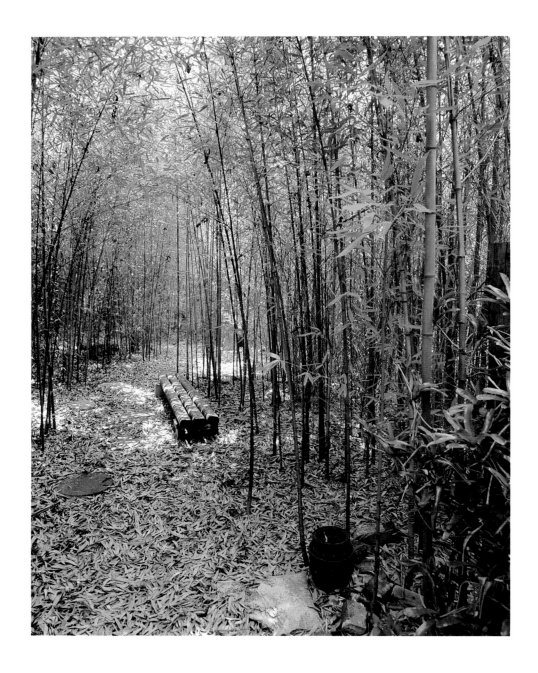

The Stapletons call theirs a "country garden." Their bamboo grove which results
from naturalized existing bamboo, is a "cool and restful garden within the garden," writes Mrs. Stapleton.
They have many other "garden rooms," and use many plants native to the area, which attract
"worlds of birds, bees, and butterflies." She says: "First and foremost a garden should be loved and enjoyed—
and to <u>really</u> enjoy its beauty is to share it with others."

Buena Vista and Perry
McMichael and Green Gardens

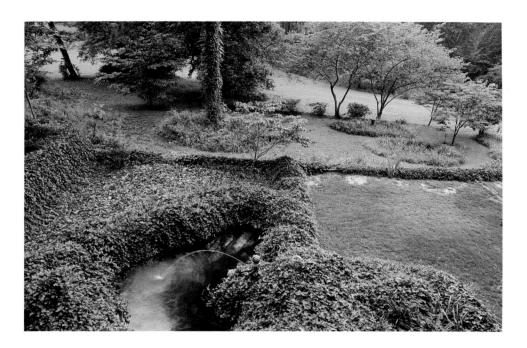

Mrs. E. H. McMichael began this garden in the 1960s, with the help of her son, Mulkey McMichael. In 1987 he became the owner and "head gardener" and has recently renovated the fish pond (top), which he helped create in 1966. Mr. McMichael says: "My grounds represent some twenty-five years of creative terracing, begun when I was thirteen years old. As a professional graphic designer, it is interesting to look at my novice work that has now matured, which I am renovating." The garden of Nannette and Yates Green (above) was built on reclaimed farmland, on a slope from farm terraces, terminating at a stream that feeds an adjoining lake. The Greens have a myriad of plants in their garden including Japanese painted fern, goat's beard, Christmas fern, Cherokee rose, banana shrubs, Yoshino cherries, chestnut oaks, Japanese cedar, Lawson cypress, live oaks, and dogwoods. The Greens have used plants that attract birds, especially blue birds, and other wild life. Mrs. Green writes: "Our love of plants, birds, and small animals has played a dominant part in our garden."

One Horse Farm, Kathleen
CRANSHAW GARDENS

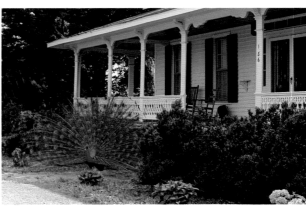

One Horse Farm is on Sandefur Road, property that John Thomas Sandefur farmed before the Civil War. The John Cranshaws purchased the farm in 1964 from J. T. Sandefur's great-grandson and restored the main house, outbuildings, and overgrown yards. On the property is a pecan tree that Mr. Cranshaw says pecan growers believe is "the largest and oldest nut-bearing pecan tree in Georgia." The grounds feature daylilies, herbs, staghorn ferns, native azaleas, hydrangeas, and large boxwoods.

The Cranshaws laid out their arrangement of beds themselves and are "completing the last stage of their plan, an oriental garden." In addition to trees, shrubs, and flowers, they have fifteen strutting peafowl, and their farm is a "stopping off place for purple finches in the winter and hummingbirds in the summer." Their grounds and gardens are open to the public, and they have had visitors from all over, including a Sandefur relative, age ninety-eight, who said, "Thank you, my dears, for loving my home so much!"

"The Pines," Millen
MULKEY GARDEN

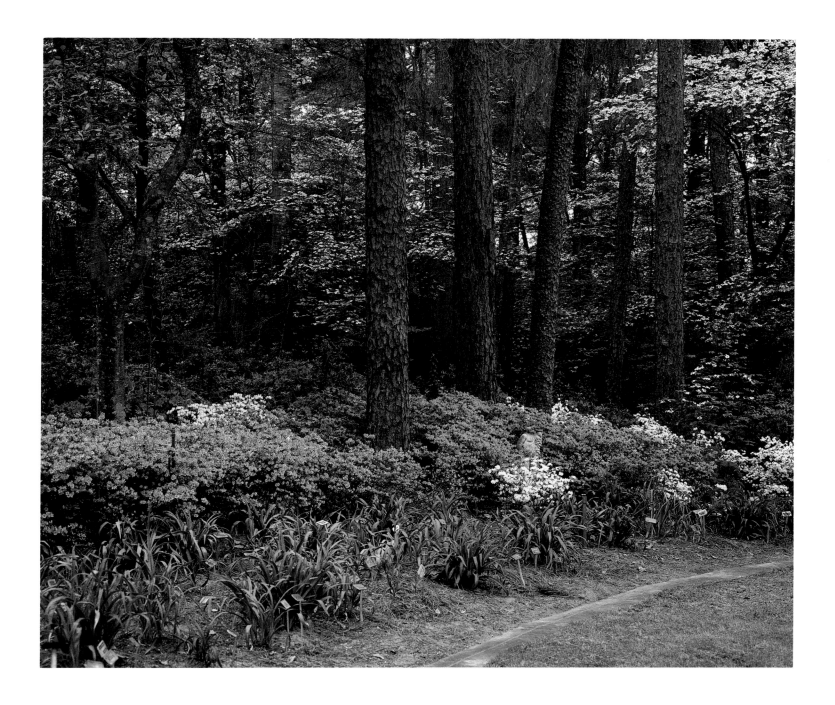

Millen is in the eastern coastal plain south of Augusta and east of Macon. The warm climate brings an early spring, and Mrs. A. P. Mulkey is always ready for it. Her grounds are her own loving creation. She writes: *"Love is the special feature of my garden. It was planted with love, cared for with love, and everyone who visits feels the spirit of love."* She designed and maintains her gardens herself; they surround the house. *"A person inside the house, looking out, sees the beauty from every window,"* she writes. She has daylilies, camellias, roses, azaleas, bulbs, irises, hostas, ferns, cannas, caladiums, annuals and perennials, and many varieties of trees. She writes: *"One year a daylily in my garden was selected as the outstanding one in the state."* It is a year-round garden, but in the early spring with the azaleas and dogwoods blooming among the tall pines, Mrs. Mulkey's garden seems the quintessence of a Georgia garden.

Tullie Smith herb and flower garden, Atlanta Historical Society.

ATLANTA AND NORTH GEORGIA

GEORGIA, as we have seen, is a large and varied place. Tradition, settlement patterns, soil types, temperature zones, topography, and sometimes territorial pride divide it into four principal areas: coastal, south, middle (piedmont), and north. Of these four regions, north Georgia has the greatest variation in elevations and is itself divided into four topographical provinces: the Upper Piedmont, elevations from 600 to 1,200 feet; the Ridge and Valley, elevations 600 to 800 feet, with peaks 1,000 to 2,000 feet; the Cumberland Plateau, average elevation 2,000 feet; and the Blue Ridge Mountains, average elevation 3,000 feet.

The average temperatures of the different elevations naturally affect the growing seasons of north Georgia. For example, Clayton, in Rabun County at 2,100 feet, has a growing season of 191 days (almost twelve weeks shorter than Savannah) and a climate cooled by its altitude. Rome, on the other hand, nestled in a river valley at only 600 feet, is warmer and more humid—almost tropical by comparison—with a growing season of 217 days. Consequently, a great diversity exists among indigenous and imported plants suitable for gardens in the different soil types and altitudes of north Georgia.

To gain 1,000 feet in average elevation above Savannah in coastal Georgia requires traveling 225 miles to Atlanta, in the Upper Piedmont of north Georgia. From Atlanta

White crested iris (Iris cristàta var. álba) in the Rushin garden, Gainesville.

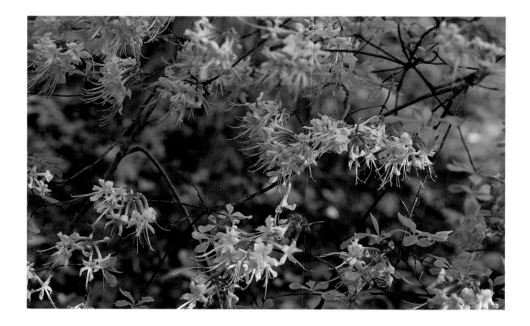

into the foothills of the Blue Ridge and on to the mountains northward, the changes in elevation are decidedly more abrupt and the panoramas more sweeping. Around every turn and over every hill is a fresh view to consider—and, while each section of the state has its own particular characteristic charm and beauty, the variety of vistas offered by the crenulated landscapes of north Georgia is a banquet for the eyes unlike any setting farther south.

After arduous journeys through the dense foliage and thick air of coastal Georgia and Florida, the famous botanist William Bartram was enraptured by the sights and discoveries in the mountains at the head of the Savannah River when he traveled there in 1776.

> The mountainous wilderness . . . appearing regularly undulated as the great ocean after a tempest . . . the nearest ground to me of a perfect full green; next more glaucous; and lastly almost blue as the ether with which the most distant curve of the horizon seemed to be blended.
>
> My imagination thus wholly engaged in the contemplation of this magnificent landscape, infinitely varied, and without bound, I was almost insensible or regardless of the charming objects more within my reach: a new species of Rhododendron foremost in the assembly of mountain beauties; next the flaming Azalea, *Kalmia latifolia*, . . . the soil [is] exceedingly rich, and of an excellent quality for the production of every vegetable suited to the climate. . . . I passed again steep rocky ascents, and then rich levels, where grew many trees and plants common in Pennsylvania, New York, and even Canada, . . . but what seems remarkable, the yellow Jessamine, which is killed by a very slight frost in the open air in

The "flaming" azaleas William Bartram admired still decorate the hills of north Georgia.

Pennsylvania, here, on the summits of the Cherokee mountains associates with the Canadian vegetables, and appears roving with them in perfect bloom and gaiety.

The green hills and fertile river valleys of the area were a blessing to the original inhabitants, as European explorers and writers discovered and documented. In the early part of the sixteenth century, Hernando De Soto led a Spanish expedition into the Coosa Valley in what is now Floyd County. "The Governour departed from Guaxule, and in two daies journie came to a towne called Canasagua. There met him on the way twenty Indians, every one loaden with a basket ful of mulberries; for there be many, and those very good, . . . and also nuts and plummes. And the trees grow in the fields without planting or dressing them, and as big and as rancke as though they grew in gardens digged and watered."

Three centuries later, Cherokee Chief John Ross had developed extensive farms throughout the region. A description of his plantation at Head of Coosa included "a deep well, garden plots, more than 150 acres of cultivated fields, more than 100 acres of fenced but uncleared land, and an orchard of peach, apple, pear, quince, and plum trees."

In 1836, the English traveler and writer George Featherstonhaugh wrote about his visit to Cherokee Chief James Vann's home farther north, near the modern town of Dalton: "We left Spring Place at 8 A.M., passing for twenty-five miles through a wild country with a rolling surface, pleasingly wooded, and sufficiently open to admit of the growth of various beautiful flowers. . . . The soil being derived from the lower Silurian limestone is very fertile, and certainly I never saw heavier Indian corn than in two or three settlements."

When gold was discovered at Dahlonega, the government forced more cessions from

A restful path leads through the "Gardens de Pajarito Montaña."

the Indians and a coarse and short-sighted breed of settler ravaged the land, destroying trees, scouring the ravines, and leaving huge piles of washed gravel. After witnessing the destruction of the landscape at Dahlonega, Featherstonhaugh predicted, "What was once a paradise will become a desert."

Fortunately, the physical destruction was contained for the most part to some of the mountains around Dahlonega. The lovely valleys became home and sustenance for new families. The Reverend Timothy Harley visited the Nacoochee Valley in the winter of 1885-86 and wrote: "The Chattahoochee River winds its silvery way through the charming vale, where broad fields covered over with corn, or soft meadows enamelled with flowers, smile in all the benignity of a loving-kindness which has wrought with the hand of man in making this fair Nacoochee a valley of the sunshine of life." Today, the river valleys still delight the eyes. Their names—Etowah, Coosa, Nacoochee—are poignant reminders of simpler ancient times and of the native families who first tilled the damp dark soil.

Except for the valleys, however, much of mountainous north Georgia is not suited for agriculture on a large scale. In an essay on "Cotton, Land, and Sustenance," George Crawford wrote: "Land form alone discouraged early farm settlement in northern Georgia. The Blue Ridge . . . checked plant culture in the northeastern counties. One-third of the Blue Ridge district was unfit for tillage by any measure. Another third was nearly as bad, for the steep terrain denied the plow a consistent angle and the draft animal a sure footing. Crop production would barely pierce such barriers."

A comparison between the possibilities hidden in such "unfit" rocky terrain and the more obvious possibilities in the verdant hills and valleys can be used to illustrate the gardening vision behind two of the most wonderful spots in Georgia, which are only

The picturesque remains of Woodlands (above), the home and famous boxwood gardens of Godfrey Barnsley, Esq. The drawing (opposite page) is by P. Thornton Marye, from page 109 of the Garden History of Georgia, 1733-1933.

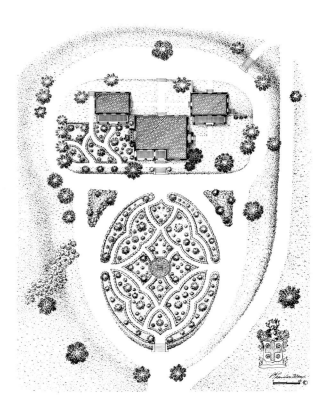

thirty miles apart where the Upper Piedmont merges into the Blue Ridge Mountains. Both garden spots are extensive; the modern one thrives, and the other—a historic garden landscape of great romantic beauty—languishes.

The first, the "Gardens de Pajarito Montaña," is on Little Bird Mountain just north of Canton. It comprises twenty-five acres of horticultural specimens, featuring native south-eastern and American species. The largest private assemblage of wildflowers, shrubs, and trees in the Southeast, it is the personally created botanical garden and arboretum of Eugene and Margarita Cline. The Clines' mountain laurel, conifers, native azaleas, exotics, and other rare plants, glimpsed from winding, fern-edged, pine-bark paths, let one know this is no longer the "wild mountain land" the Clines began with in 1952. Nevertheless, their gardens preserve the native woodland spirit of the untamed land.

The beauty of the natural north Georgia landscape inspires such gardens. The second, historic Woodlands or "Barnsley Gardens," is in Bartow County, and is also twenty-five acres of connected gardens. Yet these gardens were begun about 100 years earlier than those of the Clines. Woodlands was the north Georgia plantation dream, almost realized, of Godfrey Barnsley (1805-73), an English-born cotton broker of Savannah, and his wife, Julia Scarbrough. Enough remains, especially of the front and side English boxwood parterre gardens, for modern photographs to capture their surviving but vulnerable charm. Reminiscent of an English country house landscape of the early to mid-nineteenth century, Woodlands even had a deer park.

Following are examples of gardens as different as the small urban backyard retreats in modern Rome and the splendid nineteenth-century boxwood parterres at Valley View in the Etowah Valley. All contribute to illustrate the gardening spirit thriving within this "magnificent landscape" of north Georgia.

"Gardens de Pajarito Montana," Canton Area
CLINE GARDEN

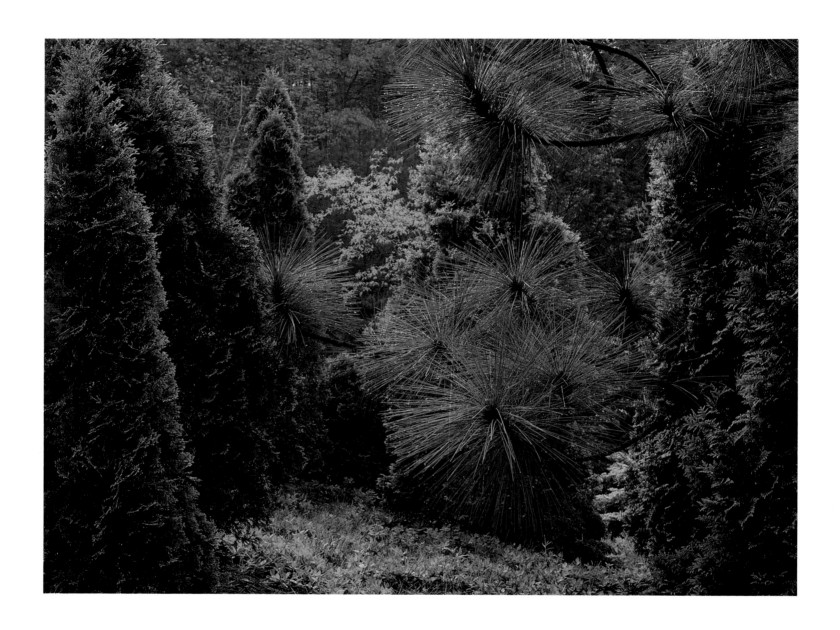

In the hills several miles north of Canton, elevation 894 feet, are Margarita and Eugene Cline's *"Gardens of Little Bird Mountain,"* which they started on *"wild mountain land"* in the 1950s, only about a mile from Gene Cline's birthplace. (Margarita was born in New Mexico.) Gene Cline writes: *"We designed our own gardens, actually one* large garden, which we maintain entirely by ourselves." Comprising about thirty acres of their fifty-nine-acre estate, the gardens are divided into a number of sections for exhibition and study. Extensive areas are devoted almost exclusively to native Southeastern and North American species, and there are sections for foreign and exotic varieties.

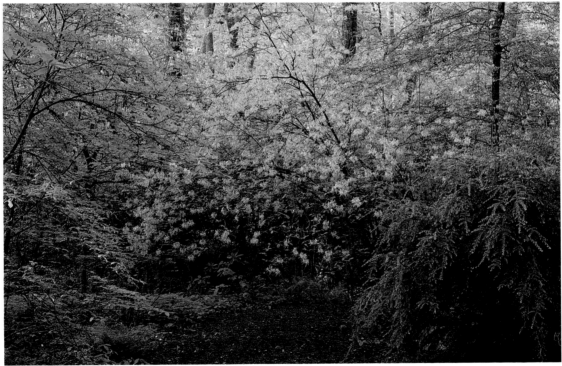

Mr. Cline says: "Ours is the largest private garden in the South specifically designed for the study and conservation of native plants, as well as exotics, and their use in natural settings. We have large collections of conifers (top opposite), ferns (bracken fern with bird's foot violets, lower opposite), native wildflowers (creeping phlox, top), dwarf conifers, maples, magnolias, native mountain laurels and rhododendrons, native azaleas (hybrid, above), viburnums, dogwoods, and many rare plants from all over the world." Dr. Frederick G. Myers, botanist at the National Arboretum in Washington, D. C., has told the Clines: "Yours is the most valuable private arboretum and botanic garden in the South for study." The Clines welcome visitors by appointment, especially in May and June.

Willow Trace, Gainesville Area
RUSHIN GARDEN

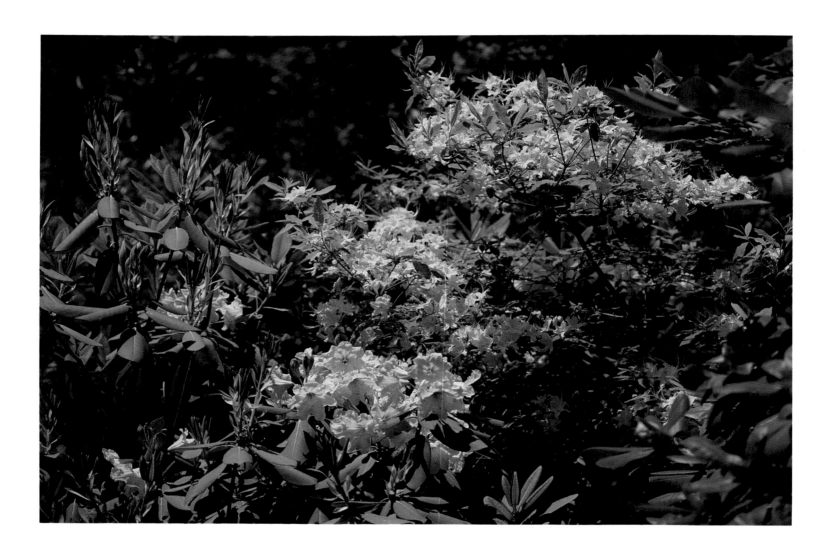

Clyde Rushin has created three gardens since returning from World War II— "Peace," he says, "means garden." He designed this, his third, for a hillside overlooking Lake Lanier, which was formed from the Chattahoochee River among the lower elevations of the Blue Ridge Mountains. The nearest large town is Gainesville, elevation 1,200 feet. About three-fourths of the garden is devoted to woodland plants. These include more than twelve separate species of native azaleas (above, and opposite, top) and numerous hybrids, wildflowers (white crested iris, left), ferns, three species of magnolias, and a large hosta collection of more than 100 varieties.

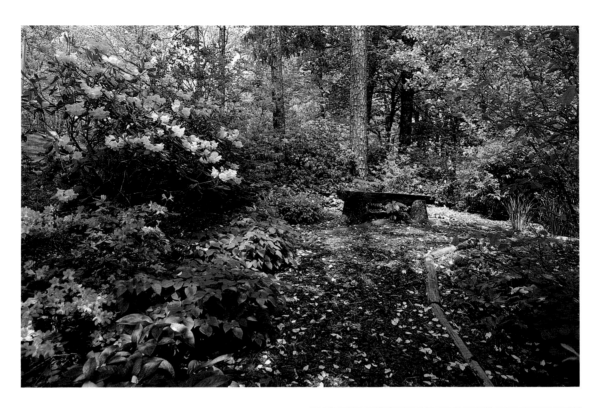

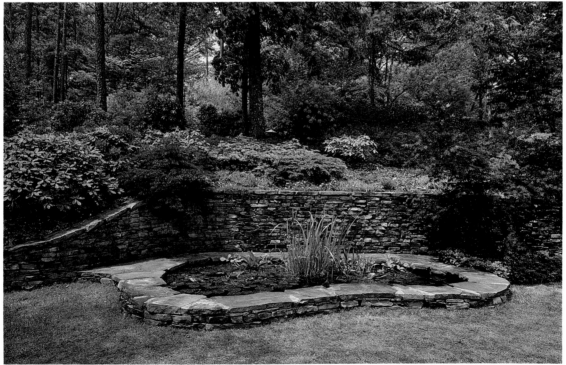

*The rest of the garden has small lawns and perennials, and there is a serpentine dry rock wall with a
lily pond at its base (above). Many of the plants were moved from his previous gardens. One plant is fifty-five years
old and a number are more than twenty-five. Mr. Rushin writes: "I have spent over forty years gardening
and have become attached to many of my plants, and it is a source of great enjoyment and enduring satisfaction
when the plants are well grown. There is nothing that thrills me more than to see a 'happy plant.'"*

Commerce
HARDEN GARDEN

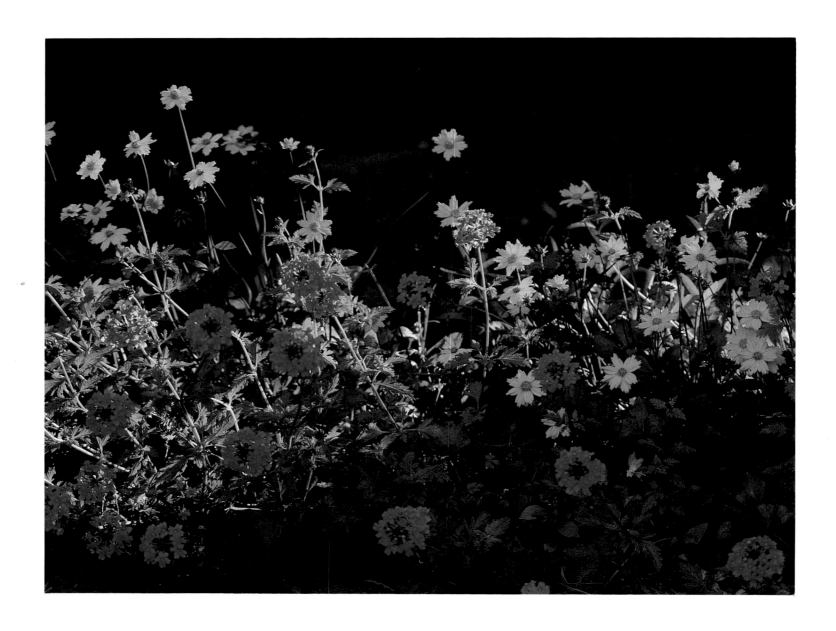

Southeast of Gainesville is Commerce, elevation 965 feet, another Upper Piedmont town where rhododendron gardening is successful, especially in the hands of the Willis Hardens. They have several dozen rare species and more than 200 hybrid varieties. In 1984 the American Rhododendron Society visited the Hardens' garden, and it has been featured in the society journal. The Hardens' rock gardens are also special—one for sun-loving alpine plants and another for shade-loving rock plants. Also, they have a garden area for dry-climate plants. The Hardens were their own designers and do much of their gardening themselves.

Among the many rhododendrons in the Hardens' garden are the cultivar 'Damozel' (top), an English hybrid bred by Lionel de Rothschild at Exbury, England, and the <u>Rhododendron yakushimanum</u> (above), a Japanese species originally found only on Yakushima Island. The latter was sent by K. Wada of Tokyo to Rothschild, who named it 'K. Wada.' Accenting the Hardens' rhododendron collection is a showy bed of helianthus and verbena (opposite, top). A dianthus (<u>Dianthus cv. 'Spottii'</u>, opposite, lower photograph) prospers in the rock garden.

*The Hardens have found their area of the state very satisfying for the enjoyment of rock gardens and delight
in the possibilities available. A fire pink, or <u>Silene virginica</u> (top) seems no more at home in its native Georgia than
the nearby <u>Ramonda myconii</u>, an import from Greece and a member of the same family as the African violet.
Mr. Harden believes this type of gardening will become more popular in Georgia with the opening of the
rock garden exhibit at the Atlanta Botanical Garden.*

Cartersville

HUDSON GARDEN

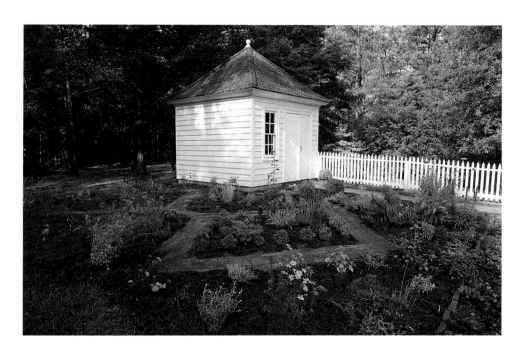

Cartersville is nestled on the edge of the Etowah Valley at an elevation of 748 feet. Virginia, like Georgia, has four topographic regions ranging from the Atlantic to the Piedmont, and many Georgians have Virginia origins. The Carleton Hudsons have harkened back to eighteenth-century Virginia in the style of their story-and-a-half brick house, designed by John Baxter of Atlanta, and in their garden, with its frame outbuilding by Baxter; Mrs. Hudson designed the parterres of herbs, boxwoods, and old-fashioned flowers. With a stretch of picket fence as a backdrop, the geometric beds are outlined with brick paths. Some of the herbs and other plants she has used are: pink and red bee balm; lambs' ears; golden yarrow; dill; chamomile; marjoram; apple, apricot, lemon, peppermint, and rose geranium; anise; sage; thyme; lemon thyme; chives; garlic chives; burnet; rosemary; sweet, holz, and opal basil; lemon verbena; oregano; parsley; lavender; spearmint; tarragon; santolina; marigolds; and hollyhocks against the picket fence.

Etowah Valley
VALLEY VIEW GARDEN

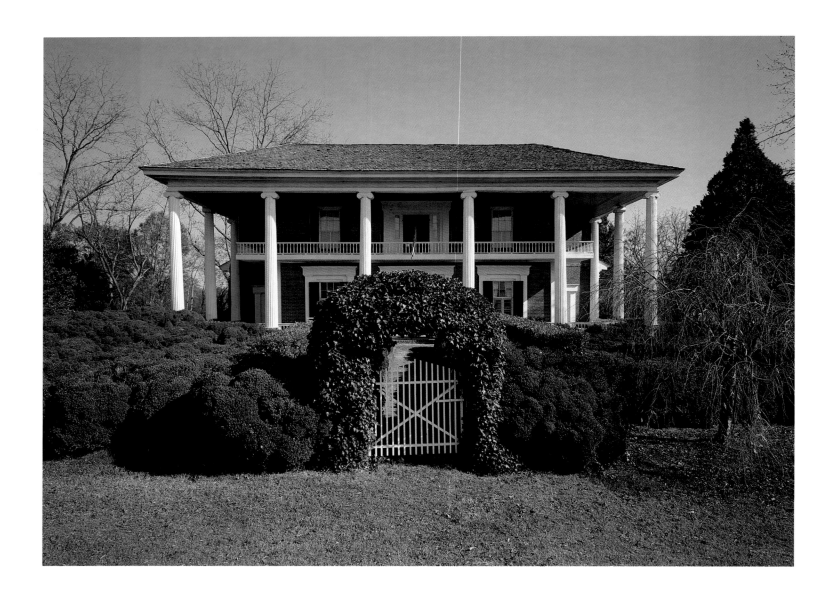

Overlooking the Etowah River valley, on a bluff above the river flowing 250 yards to the east, is Valley View—a Greek Revival plantation house still owned by the builder's direct descendants. The English boxwood parterres that form the front yard were planted at the time the house was built in 1849. Balancing, although not exact duplicate patterns, these front parterres are among the oldest patterned gardens in Georgia. And, just as it should be, beyond the garden is a cattle-dotted meadow sweeping down to the river valley, with a sublime view of low-peaked mountains in the far distance. Planned by the James Caldwell Sproulls, who moved here from Abbeville, South Carolina, this garden retains its earliest outlines. Many of the boxwoods are original plants, and all are descended from those that Mrs. Sproull brought with her from South Carolina. In the side yard is a bed of replacement boxwood from rooted cuttings (lower, opposite). The hedge of boxwood and Carolina cherry along the old herringbone-brick front walk is also original.

The present owner is the fourth generation from James C. Sproull.

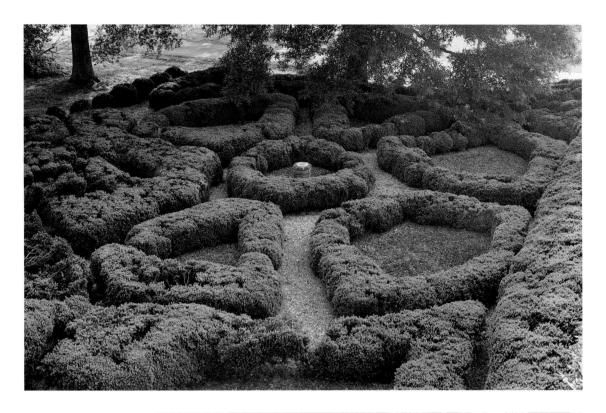

Oak Hill
Mount Berry, Rome
MARTHA BERRY GARDEN

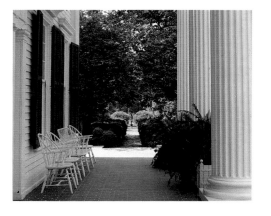

Located at the head of the Coosa River—formed from the confluence of the Etowah and the Oostanaula—Rome is the center of a splendid agricultural region with rich limestone soils. On the eighty-three acres that Martha McChesney Berry (1866-1944) inherited from her father stood Oak Hill, the Berry family plantation house, and Miss Berry used it as part of the nucleus of the Berry schools. Starting at the turn of the century, Miss Berry added land over time to create a 30,000-acre campus with fifty miles of winding roads and drives.

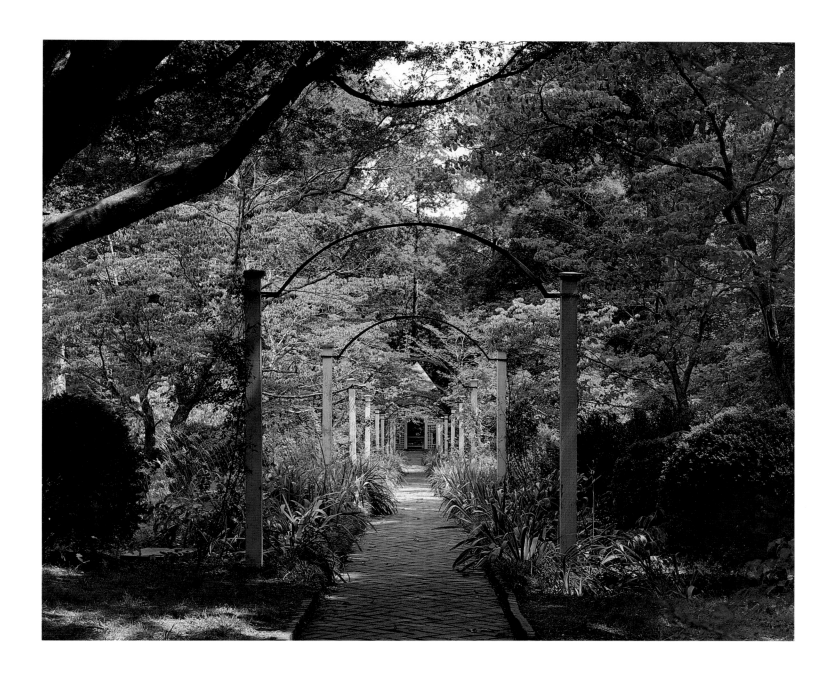

The present appearance of the house, gardens, and much of the grounds dates from Martha Berry's lifetime.
The grounds immediately around the house are beautifully landscaped with formal gardens. The grounds beyond
are treated like a rolling English park on which Miss Berry forbade hunting and decreed
every acre to be a wildlife sanctuary. Oak Hill is on U.S. 27 in the northern suburbs of Rome at Mount Berry.

Rome
THREE ROME GARDENS

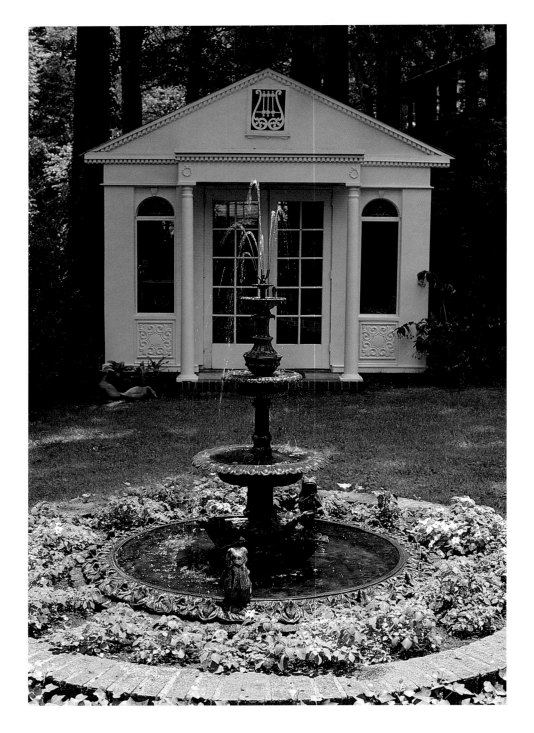

*Two of these gardens, the Neal garden and the Stegall garden, are in downtown Rome
between the Etowah and Oostanaula rivers in a neighborhood listed in the National Register of Historic Places
as the "Between the Rivers" historic district. The Kirby garden is also downtown in a historic district
that recognizes the old East Rome area, once a separate town. These gardens all have artistic ironwork, fountains,
and other ornaments by Karl Dance (1911-1986), whose workshop and foundry near
the Darlington Schools made a major contribution to the city for more than fifty years. The garden of
Mr. and Mrs. Albert J. Kirby, Jr. (above), features a classical garden house and a Karl Dance fountain.*

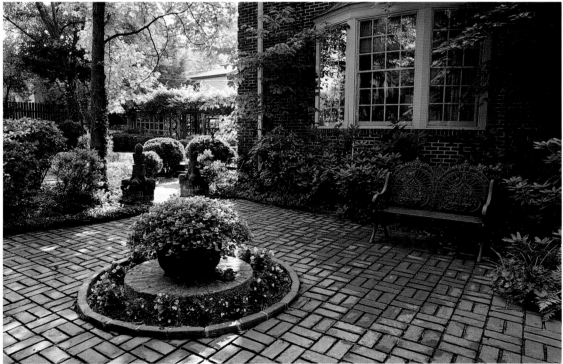

*A colorful serpentine bed (top) distinguishes the "Between the Rivers" garden of Dr. and Mrs. J. H. Stegall, Jr.
The walled garden of Mr. and Mrs. Bernard N. Neal, Jr., complements their Georgian Revival house in downtown Rome.*

"L'Antre Mondes," Dalton
S‍HAHEEN G‍ARDEN

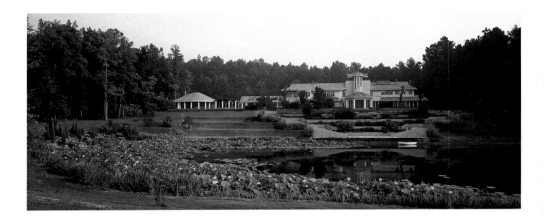

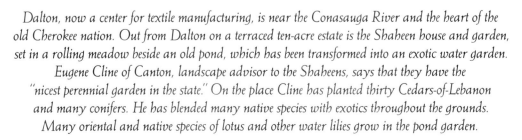

Dalton, now a center for textile manufacturing, is near the Conasauga River and the heart of the old Cherokee nation. Out from Dalton on a terraced ten-acre estate is the Shaheen house and garden, set in a rolling meadow beside an old pond, which has been transformed into an exotic water garden. Eugene Cline of Canton, landscape advisor to the Shaheens, says that they have the "nicest perennial garden in the state." On the place Cline has planted thirty Cedars-of-Lebanon and many conifers. He has blended many native species with exotics throughout the grounds. Many oriental and native species of lotus and other water lilies grow in the pond garden.

I have seen few things so fair in this world of beauty, as were the Atlanta woods in 1848.
Dr. George Gilman Smith

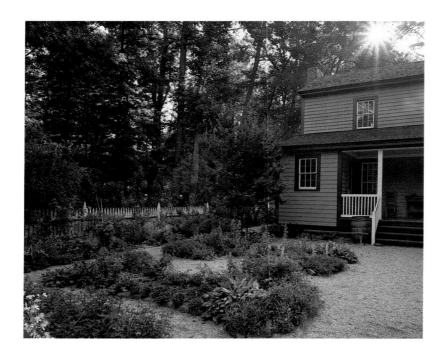

ATLANTA

A*LTHOUGH* traditional reasoning divides Georgia into four regions, sometimes the state has been viewed in two parts—but not always the same two. The division has depended on the historical period and the perspective of the viewer. At one time, looking from the Savannah, low-country perspective, the common division would have been made between Savannah, the oldest town in the oldest region, and the rest of the state. Later, another two-part division was not uncommon: on the one hand, Atlanta, the largest city, one of the newest and fastest growing, and the state capital; and, on the other hand, the rest of the state. In that instance, Atlanta was sometimes viewed from the perspective of people in other parts of Georgia, as though it were almost alien, not really Georgian at all.

From the first, in fact, Atlanta did stand somewhat alone as a special creation of nineteenth-century forces moving toward the future and away from the antebellum past. Founded on the up-country frontier at the dividing line between the Creek and Cherokee nations, it was the bustling child of railroads, commerce, and banking—and only indirectly of agriculture, which formed the basis of life in the Piedmont Plateau. A railroad junction first named Terminus, then Marthasville, it became Atlanta in 1845. It was so incorporated in 1847, 114 years after the founding of Savannah and the colony.

In the 1970s the Atlanta Historical Society restored the c. 1840 Plain-style Tullie Smith farmhouse and planted authentic flower and herb beds in a swept yard as a museum of pioneer life in the area.

Located on a rocky ridge at the high foothills of the Appalachian Mountains, Atlanta was more a part of mountainous north Georgia than it was of piedmont plantation culture. At 1,050 feet elevation, the site of the original city hall (and later of the state capitol building) was well chosen. It is one of the very highest points in the area, making Atlanta today one of the highest large cities in the United States. That too set Atlanta apart; the elevation of Savannah, for example, is twenty-one feet. "Altitude and attitude," said an Atlanta civic leader, has been the basis of its success.

Historically Atlanta has spread north, away from the agriculture of middle Georgia, and the place has always impressed writers with its energy and optimism—an attitude not always considered characteristic of the Deep South. A Boston journalist, Sidney Andrews, who passed through in December 1865, about a year after General Sherman had burned the town practically to the ground, wrote later: "From all this ruin and devastation a new city is springing up with marvelous rapidity. . . . The four railroads centering here groan with freight and passenger traffic, and yet are unable to meet the demand of the nervous and palpitating city."

Andrews made a prediction, which has partially come true: "It can never be a handsome city, but its surrounding hills and slopes offer beautiful sites for elegant residences." His opinion of the natural landscape echoed the thoughts of a former Atlantan, Dr. George Gilman Smith, a Methodist minister and historian who lived in Atlanta from its incorporation in 1847 until 1855. In a newspaper memoir published in 1909, Dr. Smith recalled:

> I never saw more beauty than there was in the springtime in the groves all
> over Atlanta. All the undergrowth except the azaleas and dogwoods had
> been cut out. The sward was covered with the fairest woodland flowers,

The Georgia capitol building was erected between 1884 and 1889 atop the highest hill in downtown Atlanta. Capitol Square has been a public park—and a magnificent horticultural display—for many years.

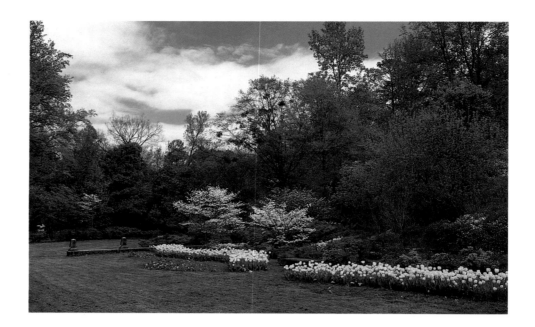

phloxes, lilies, trilliums, violets, pink roots, primroses—a fairer vision than any garden of exotics show now. Honeysuckles of every beautiful hue, deep red, pink, golden, white, were in lavish luxuriance. The white dogwood was everywhere; the red woodbine and now and then a yellow jessamine climbed on the trees. When a stream was found, it was clear as crystal. I have seen few things so fair in this world of beauty, as were the Atlanta woods in 1848.

Smith's description is perhaps the finest ever written about the glory of Atlanta and its environs in the spring, when gardens are at their ultimate. And oftentimes the woods, and sometimes the gardens and home grounds, throughout the area still preserve something of what Dr. Smith remembered long ago of dogwoods, wild azaleas, and other "woodland flowers," which are today more vulnerable and precious than ever before. With foresight, taste, and good fortune, residential areas of Atlanta were planned from the early days of the city to take advantage of the natural landscape.

In 1888, Joel Hurt, an engineer and entrepreneur, began the first planned suburb east of downtown and called it Inman Park. Working with the rolling terrain and using a plan similar to the picturesque Llewelyn Park in New Jersey and Riverside near Chicago, Hurt created a neighborhood with curving streets, ample building lots, a park, a lake, and native trees, plants, and exotic plant materials that continue to thrive today.

Hurt based this plan on the ideas of Andrew Jackson Downing and Frederick Law Olmsted, and, with the success and appeal of Inman Park, soon other planned suburbs were being built about the city. Using similar respect for the natural amenities, creative promoters developed Ansley Park, Druid Hills, and northwest neighborhoods such as Tuxedo Park.

The Cator Woolford Memorial Garden at the Cerebral Palsy Center on Ponce de Leon Avenue is one of the oldest and most beautiful public gardens in Atlanta. Called Jacqueland from 1918 until 1944, the estate was the home of Cator Woolford. The grounds and gardens were designed in 1920 by Robert B. Cridwell of Philadelphia and renovated in 1959 by the landscaping company of William Monroe.

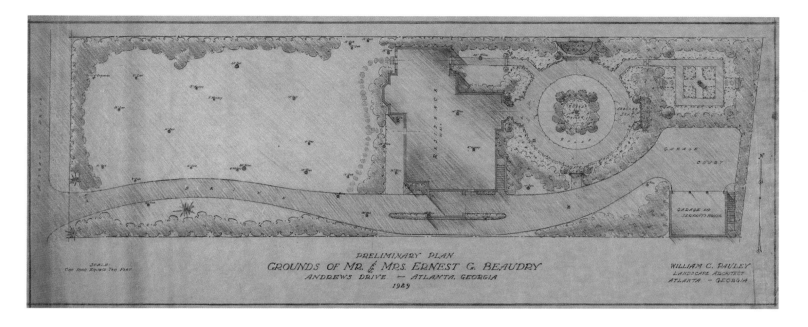

PRELIMINARY PLAN
GROUNDS OF MR. & MRS. ERNEST G. BEAUDRY
ANDREWS DRIVE — ATLANTA, GEORGIA
1929

WILLIAM C. PAULEY
LANDSCAPE ARCHITECT
ATLANTA — GEORGIA

Druid Hills was also begun by Joel Hurt, but in 1908, a group of men led by Asa Griggs Candler, the founding father of the Coca-Cola Company, purchased the unfinished 1,500-acre subdivision. Using an 1892 Olmsted design for the area, the Candlers turned the gently rolling wooded land into a beautifully landscaped residential park centering on Ponce de Leon Avenue. In 1914 Asa Candler gave seventy-five acres and a large sum of money to encourage the location of Emory University in the midst of the lush Druid Hills development. In 1977 Alistair Cooke, of the British Broadcasting Company, visited the campus and admired the "plunging hills and gardens and little lakes, all set off with towering trees." In an observation similar to those of other English visitors centuries before, he enthused, "Visiting Emory was like walking into the Garden of Eden."

Also in the early part of the century, the architectural firm of Hentz, Reid, and Adler began to leave its imprint on the style of Atlanta. With the additional genius of Philip Trammell Shutze, the firm designed many of the homes and gardens that give the northwest area of the city the distinction of being one of the loveliest garden suburbs in the nation.

In addition to the architects who presented integrated schemes of houses, appurtenances, and gardens, several landscape architects, a few innately talented designers, and some notable landscape companies have significantly influenced garden design in Atlanta.

It would be safe to say that Atlantans, as individual gardeners, clients, and designers (at least in the residential areas) have appreciated and tried to protect the sense of that wondrous environment Dr. Smith observed in 1848. A springtime drive down park-like Peachtree Battle, along winding Habersham, or up placid Lullwater reveals a modern paradise of flowering trees and shrubs, carefully tended beds, and manicured lawns.

The gardens of Atlanta and its environs featured herein represent not only the realized dreams of the early planners, but also the reverence for nature displayed by the contemporary Atlantans who maintain their own Edens today.

Landscape architect William C. Pauley's 1929 color sketch of a proposed garden on Andrews Drive. For many years the Howard Hailey Garden, it remains much as it was drawn.

Bellmere, North Fulton County

SMITH GARDEN

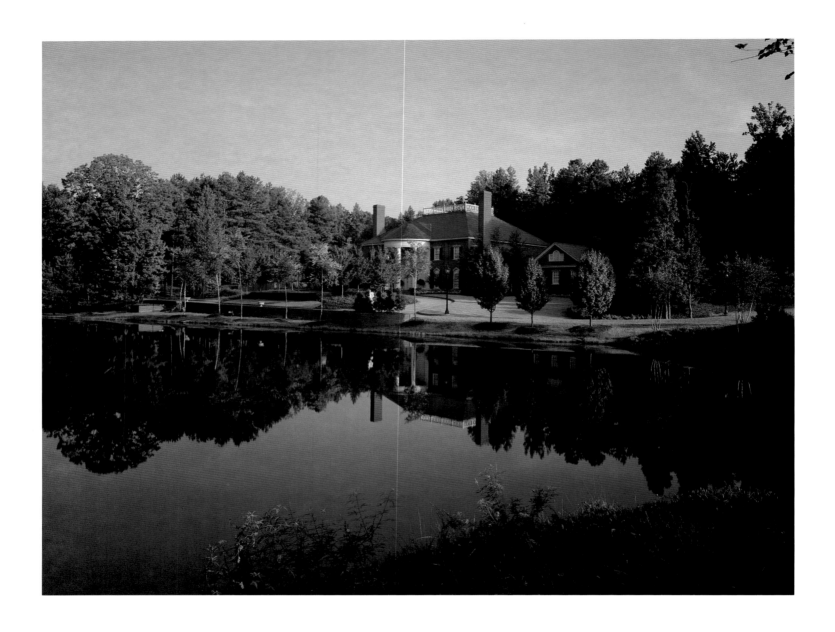

Fulton, the home county of the city of Atlanta, is the most heavily populated of the eighteen counties in the metropolitan Atlanta statistical area, because the city is within its bounds. Yet on the north, where the county extends far into the foothills of the Blue Ridge, there are still unspoiled acres that are attracting those who would escape more crowded suburbs nearer town. North of the Chattahoochee River near the Fulton-Forsyth county line is Bellmere, the 325-acre estate of Mr. and Mrs. Charles O. Smith, Jr. Far from a main highway and deep within the wooded acreage, which the Smiths treat as an arboretum, is this classical house of the 1980s, designed by Jack Wilson, AIA, of Moultrie.

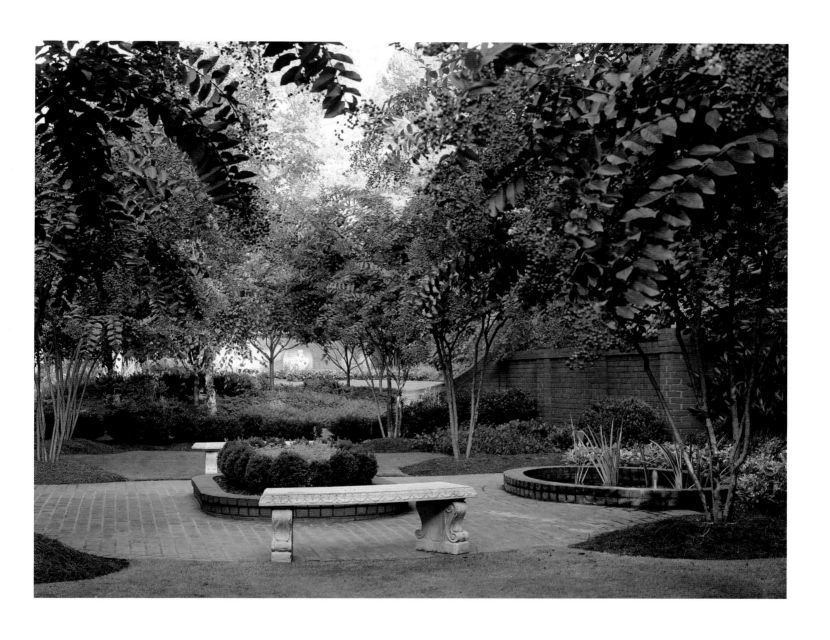

Jim Gibbs of Atlanta laid out, planted, and largely maintains the grounds and gardens, for which he has received a national landscaping award. The rear gardens are partly walled, yet embrace the woodlands that surround the more formal aspects of the grounds. Deen Day Smith expressed her philosophy on gardens, writing:

"When I am in a garden, I feel a closeness to God, and my spirits are lifted. Seeing His creation helps me trust Him more, because I see in each season that He is faithful to that which He has created. The seasons come on a regular basis, and the flowers sprout from an insignificant seed. Only God could create such a magnificent experience."

Lyle Avenue, College Park
JONES GARDEN

College Park was incorporated as Manchester, Georgia, in 1891. In 1895, after the removal of Cox College from LaGrange to Manchester, the name of the town was officially changed to College Park. The <u>Atlanta Constitution</u> reported at that time: "The town is a beautifully wooded grove of about 200 acres and undulating just enough to give an excellent natural system of drainage. The site is a magnificent one. It will be just beyond East Point, and will be one of the prettiest and most attractive suburbs in the neighborhood of Atlanta." That this prediction almost a century ago has been realized is well represented by the garden of Paige and Dana Jones, who built this house nearly half that time ago, reared their daughters there, and now are grandparents. Through the years they have made their grounds into a beautiful and useful garden— "an outdoor living space." Atlanta landscape gardener Jim Gibbs has helped them make this possible by providing a master plan. Dana Jones, a retired Delta Airlines pilot whose residence near Hartsfield Airport made his life easier, writes: "The garden is a release from stress and anxiety where one can recapture the thrill of God's great creation."

Brown's Mill Road
DAVIS GARDEN

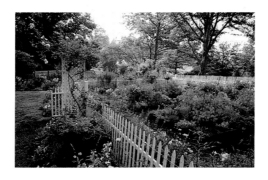

"Eve's Garden" is what Eve Davis calls the dream garden she has created on the heights above the South River. She visualized such a place in a dream. A week later, through friends, she found it for sale not far from the southeastern limits of Atlanta in Lakewood Heights, an area she had never visited before. She and her husband found an acre with a century-old farm house, old apple trees, hemlocks, tall oaks, and a spring. Here, Eve Davis has made "a Southern cottage garden—a cutting and display garden—filled with extremely wide varieties of annuals, perennials, and herbs, with vegetables interspersed, over 300 varieties." She continues, "I have been gardening since I could walk. It is the essence of my soul and passion. I am an organic gardener, because I believe we must begin to protect and help balance the earth again."

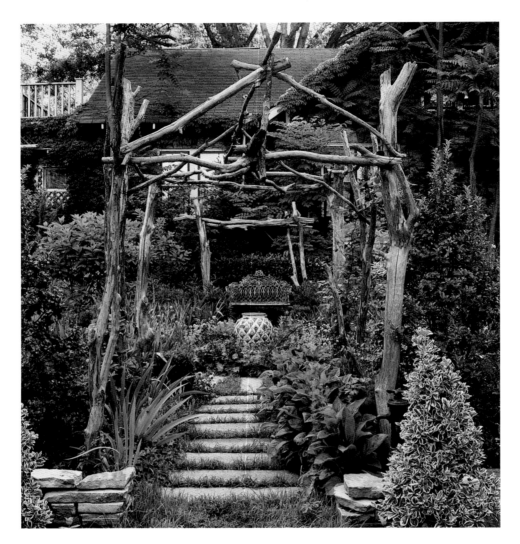

Decatur is a quiet, conservative town of homeowners which has become a suburb of Atlanta—although it is actually older, having been incorporated in 1823, twenty-five years before the incorporation of Atlanta. "Le Jardin des Fleurs" is the private Decatur garden of a professional gardener, the ornamental horticulturist and garden designer Ryan Gainey. Gainey has several garden shops in Atlanta, and his residence is on a Decatur side street, just off of Ponce de Leon Avenue. In 1981 Gainey bought this house and its three lots where a flower business had once existed. He has divided the property into several gardens, and each turn in the landscape presents a different charming vignette. Gainey combines formal and informal elements in a personal manner, such as in his border garden (top), where a rustic pergola, constructed of crape myrtle wood, frames a Majolica jar and a cast-iron settee.

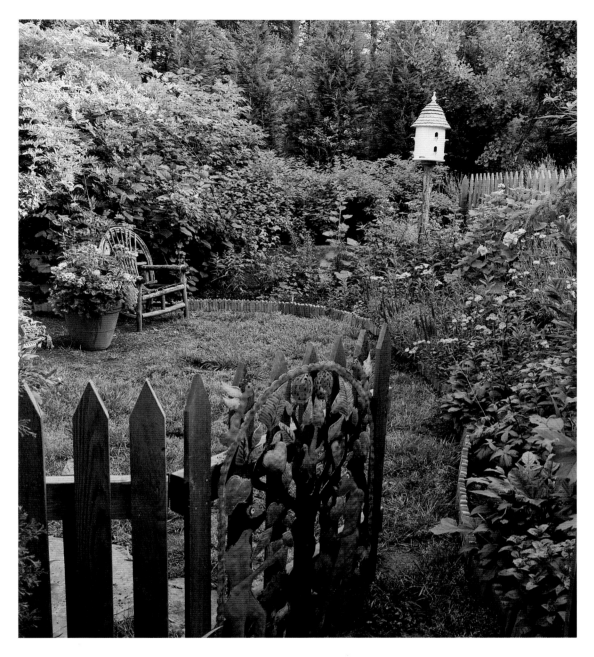

In the barn garden (top), entered through an artistic Haitian-made gate, is a fanciful dovecote. Gainey has continued to use the original three greenhouses on the premises; the ivy greenhouse (above right) sits next to the vegetable garden. Memories of his great-grandmother's house in the country have been an inspiration to Gainey, who calls his intriguing creation a "Southern cottage garden" *and credits several people with their help, among them Randy Alexander, Smith Hanes III, and Mark Smith.* "Le Jardin des Fleurs" *has been featured in a number of fine magazines and books and has been visited by many notable gardeners, including the three graces of British gardening, Peter Coats, Penelope Hobhouse, and Rosemary Verey.*

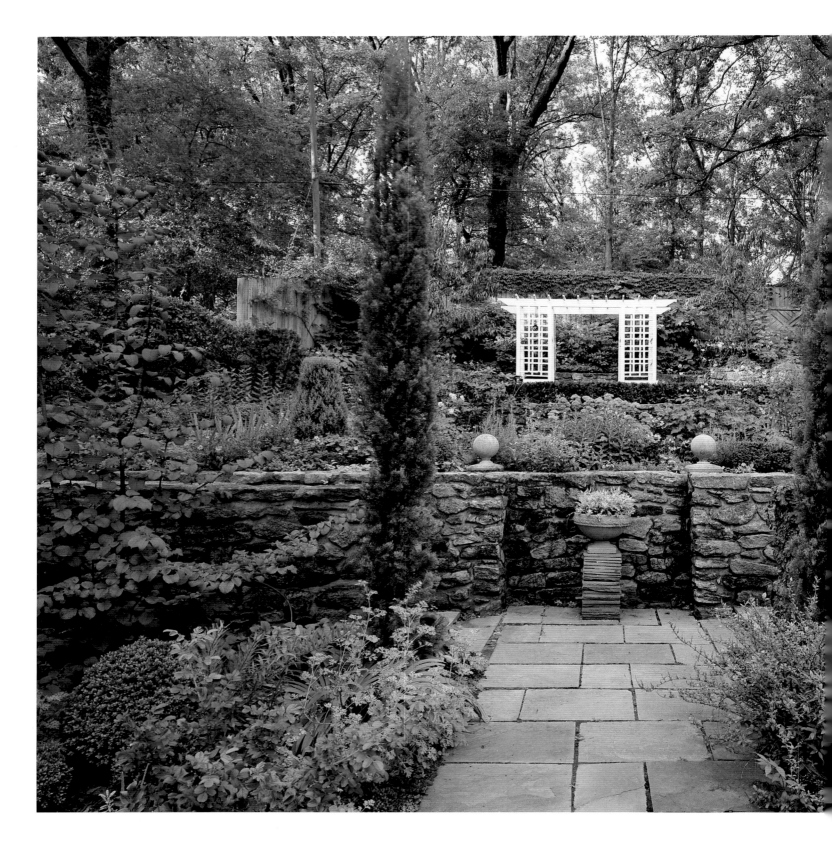

Originally called Peachtree Garden, Ansley Park
was developed by Edwin P. Ansley, beginning in 1904 on the 202 acres
George W. Collier had farmed since the 1840s. Under the influence of
Frederick Law Olmsted's neighborhood designs, an Atlanta civil engineer
named Solon Ruff laid out the garden suburbs with parks, streets,
and alleys that follow the rolling contours of the piedmont terrain.
During 1904 Ansley staged a street-naming contest; among the winners

was The Prado, site of the Hendricks's terraced backyard garden.
Kathy Hendricks, with the help of landscape architect
Philip Hauswirth, ASLA, designed and planted her backyard,
which descends north from a rear alley to The Prado. Intensely interested
in garden design and plants, Mrs. Hendricks writes: "I try to get
the right plant for the right place. I use Southern plants, but order
special ones from England, and will risk anything!"

The Prado, Ansley Park
HENDRICKS GARDEN

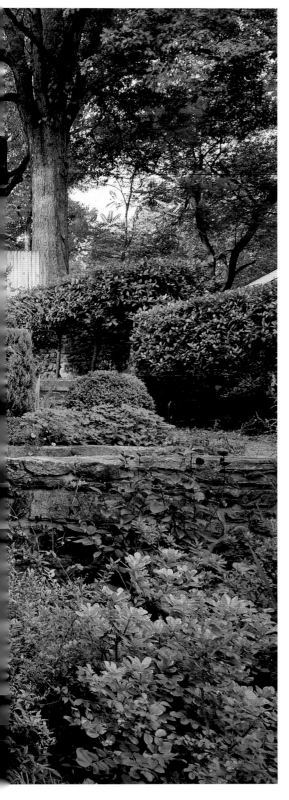

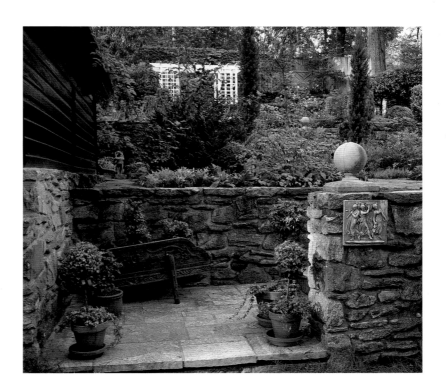

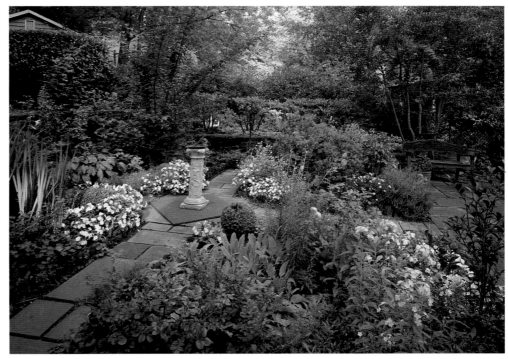

To create this terraced and walled rear garden on their Ansley Park hillside, the Hendricks
had 100 truck loads of dirt removed. Now, Mrs. Hendricks states: "The children play in and I revel
in this English-Southern hybrid backyard." Kathy Hendricks designed for her children
"a Yuppie swing set" (opposite), an arbor look-alike on an axis with the walkway on the second terrace.
The parterre garden (bottom), dressed in late-summer white, is on the first terrace.

The Prado, Ansley Park

PRITCHETT GARDEN

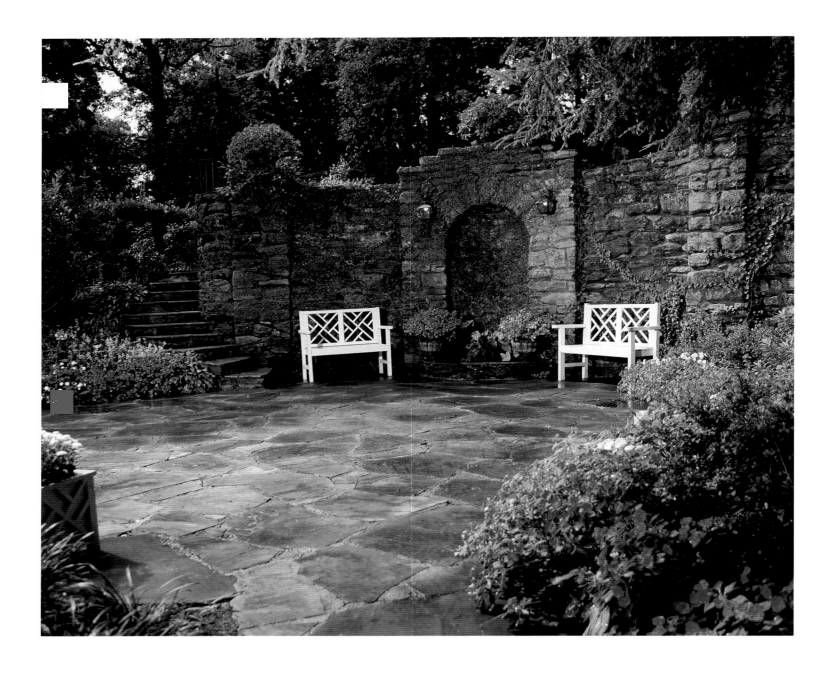

In 1904-5 when Ansley Park was created, it was a garden suburb, practically in the country, and has been called "Atlanta's first automobile suburb." Today the neighborhood is part of Midtown, a new designation dating from the late 1960s, and it is now considered quite urban. The Harry Pritchetts' house was built in 1909 by Mr. and Mrs. Philip Alston. The original garden was designed for the Alstons in 1926 by landscape architect William C. Pauley. Those plans have survived in blueprint form and were used in 1987 to restore and replant the garden. Spencer Tunnell, ASLA, of Edward Daugherty and Associates, discovered the copy and directed the restoration for the Pritchetts, who bought the property as their home in 1985. The beautifully curved descending fieldstone wall, stairs, and a small pool with a fountain are now just as Pauley designed them. The wall is partially covered with ivy and fig vine, and the round stone terrace is surrounded by an English border garden of tree-form Photinia, pink azaleas, hosta, liriope, laurel, and a mixture of different shades of pink and white annuals and perennials, with an abundance of pink sultana along the top of the wall and beside the pool. The Alston's suburban garden has become Harry and Allison Pritchett's "walled city garden."

Westminster Drive, Ansley Park
DEADY GARDEN

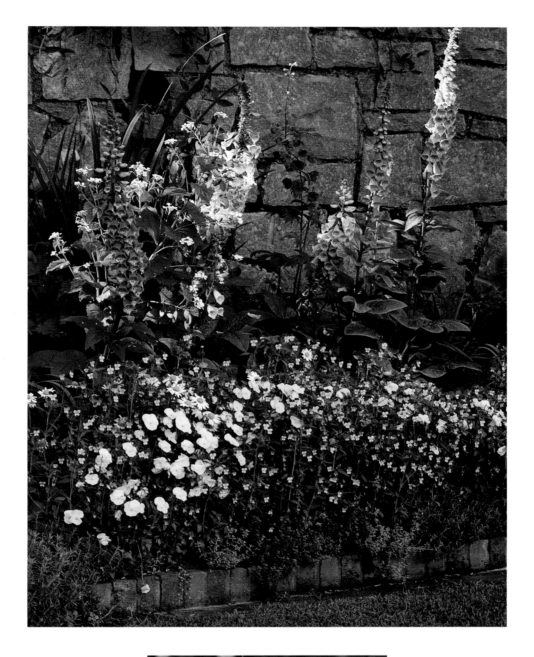

Westminster Drive borders the north side of Winn Park, one of the original woodlands E. P. Ansley planned as landscape elements of turn-of-the-century Ansley Park. In the 1930s the Iris Garden Club formed the wooded ravine into a public garden with paths, pools, irises, bulbs, and perennials. The first floor of the Jack Deadys' big, bold, stucco house is well screened by careful terracing and planting so that the house and garden meld into one conception on their hillside overlooking Winn Park. The

Deadys have incorporated ideas from many well-known landscape architects, including Edward Daugherty, Dan Franklin, and Edith Henderson. Granite from Stone Mountain forms a strong backdrop to a bed of Mrs. Deady's "happy plants" (top). Carol Deady writes: "Cooperate with nature. Don't grow any plant that is unhappy in our climate, or that is unhappy in a particular spot. As I gain experience, I more and more lean toward native plants and old-fashioned flowers."

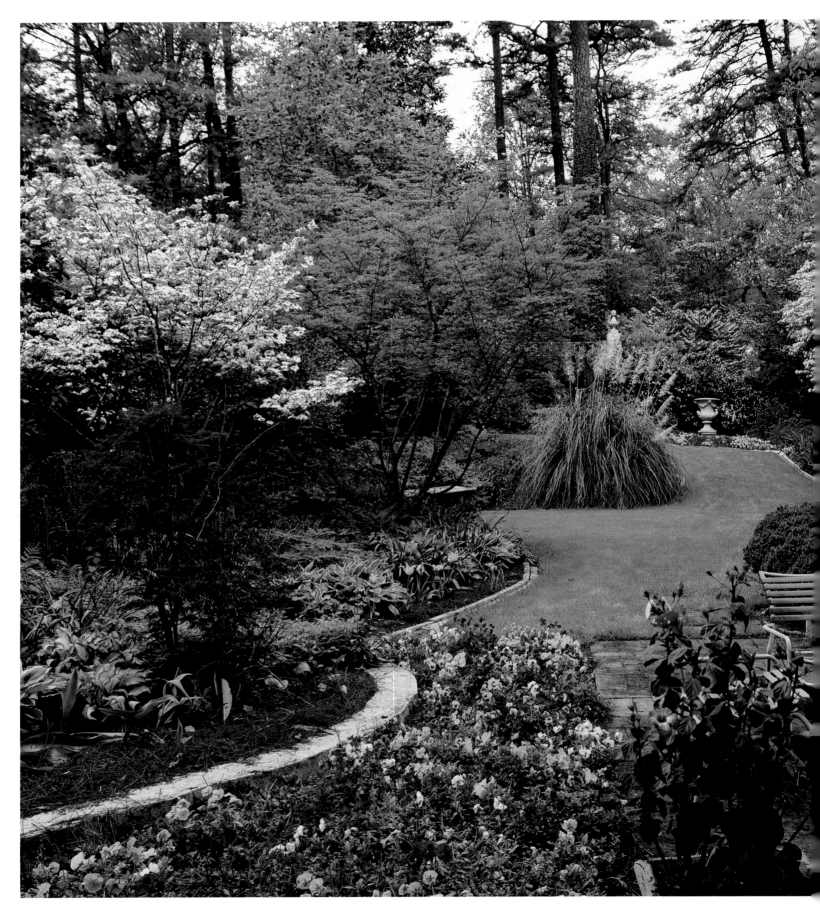

Lullwater Road, Druid Hills
DOROUGH GARDEN

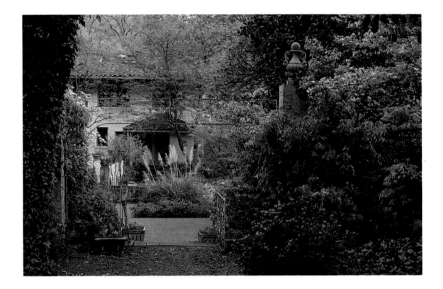

Asa Griggs Candler (1851-1929), founder of the Coca-Cola Company, and several of his friends paid Joel Hurt one-half million dollars in 1908 for Hurt's unfinished suburb on the northeastern edge of Atlanta. In 1892 Hurt had engaged Frederick Law Olmsted to plan Druid Hills, and Candler used Olmsted's ideas to make the rolling terrain into a large landscaped park centering on Ponce de Leon Avenue, a wide residential boulevard built east from Peachtree Street toward Decatur. From Ponce de Leon, following the bed of the meandering Lullwater Creek, dogwood-lined Lullwater Road winds north through the hills to North Decatur Road at Emory University. The Dorough garden, like several that follow, sits above the road on land that slopes gently to the creek. The late William Monroe, of the much-admired Monroe Landscaping Company, planned this garden in 1920, and the current owner, Doug Dorough, also a landscape professional, has continued the evolution of the garden since the property became his home in 1970. Dorough combines formal and informal ideas of landscape design— formal to complement the period architecture of his tile-edged Mediterranean-style house, and informal to enhance the sylvan, sloping, naturalistic Druid Hills setting.

Lullwater Road, Druid Hills
ROBINSON GARDEN

In one of his "Letters from America," Alistair Cooke, who visited the campus of Emory University in 1977,
described Druid Hills as "Olmsted's masterpiece." Cooke said, "To my mind, the little-known but exquisite setting
of trees, lakes, lawns, and rolling hills that houses Emory University was like walking into the Garden of Eden."
William C. Pauley, who designed Doris Robinson's Druid Hills garden in 1930, specialized in naturalistic gardens
with exceptional rock work, for which he received many national awards. Almost sixty years later his influence
on this garden is obviously still appreciated—few gardens exemplify the beauty of a Druid Hills
boxwood-embowered and azalea-lavished spring as well as this Lullwater Road design. Doris Robinson writes:
"A garden should be a place for quiet reflection, a retreat for birds and small animals."

Druid Hills
HATCHER AND MYERS GARDENS

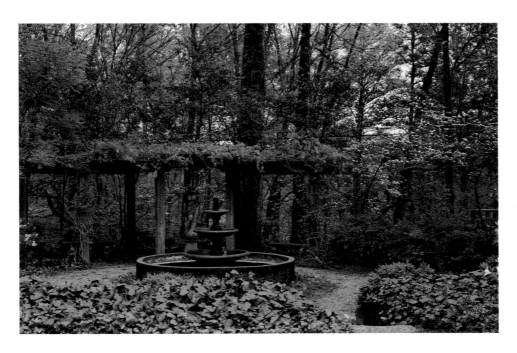

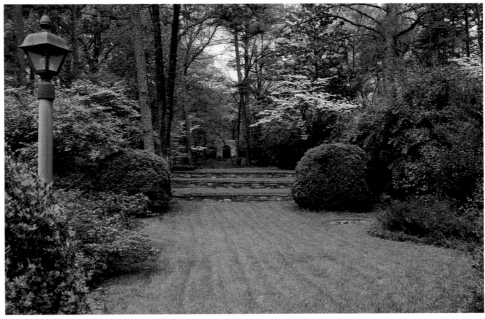

Dr. and Mrs. Charles Hatcher's classic old Druid Hills garden (top) backs up to the woods bordering the course at the Druid Hills Golf Club. In the sunken garden, a wisteria-covered curving pergola shelters a classical garden figure with a background fountain and basin—formal elements in an informal natural setting. The Dorough Landscape Company has carefully preserved the original character of the garden during renovation. In 1980 Mr. and Mrs. John Myers bought the John Howard Candler house on Lullwater Road (terrace, above). Mr. Candler had commissioned the Atlanta architectural firm of Ivey and Crook in 1929 to design the house and grounds for this wedge-shaped lot. The plan has survived and shows how carefully Ivey and Crook sited the house and garage, indicating the topography and the terracing, which is still in place. Ivey and Crook, as had their mentor, Neel Reid, often designed the basics of an integrated house and garden scheme. Mrs. Myers writes: "When we purchased the property the garden was restored by the Dorough Landscape Company with as few changes as possible. The back garden is terraced in several levels and something is blooming most of the time from early spring to late fall."

Yorkshire Road, Morningside
WOODHAM GARDEN

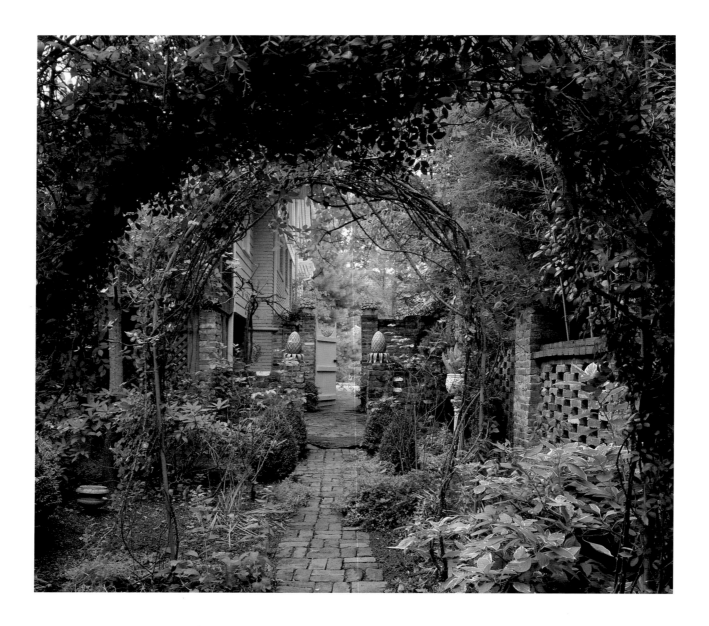

East of Monroe Drive in Morningside Park is the house and garden of gardening professional Tom Woodham, who writes: "I wanted to show what could be done on a small city lot. My garden is small, but seems larger, and completely surrounds my house, cottage-style." Tom Woodham is Ryan Gainey's colleague and business partner in a number of endeavors related to gardens. Woodham and Gainey have been leaders in a revived interest in gardens and gardening in the South, and they have practiced what they have preached — as their gardens show. Woodham's clever design contrives a number of vignettes within his small garden, using arbors, screens, and gates to create the illusion of greater, extended space. The cast pineapple finials on the garden gate (top) are by the late Karl Dance (1911-1985) of Rome, Georgia.

In another part of the garden is this old-fashioned rose arbor (opposite top) with Betty Prior roses in the foreground. Looking from Woodham's deck, it is obvious he is a master illusionist, using bamboo (opposite bottom) to screen his neighbors' yards and spin the impression of an exotic hideaway, even though it is near the heart of a major modern city.

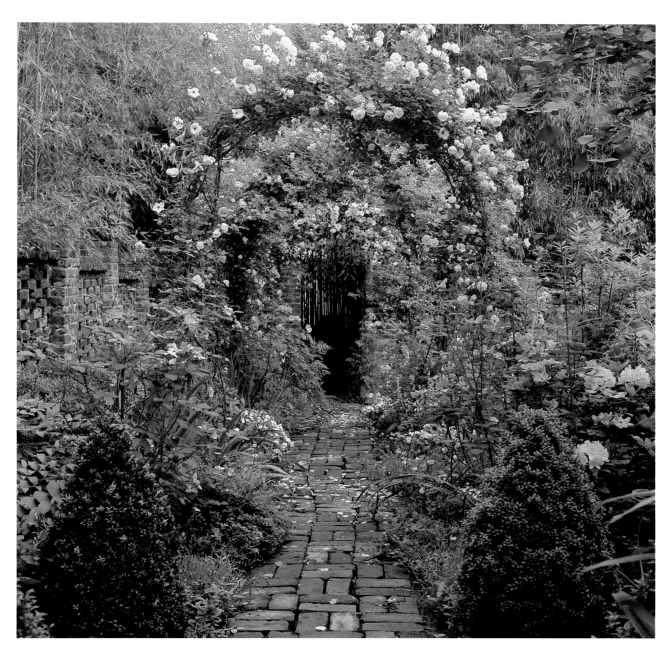

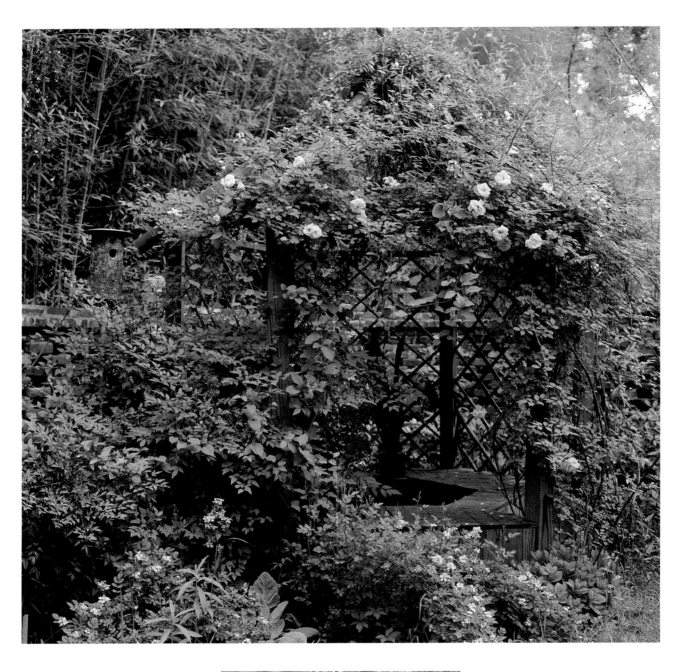

Woodham, a quietly jovial, modest South Carolina native who is not given to didactic exhortations, sometimes writes articles about his subject which are always expressed as graciously as his garden grows. He gardens in the spirit of Alexander Smith, who wrote in his essay "Books and Gardens" in 1863: "Around my house there is an old-fashioned rambling garden, and I know the genealogy of every tree and plant in it. I watch their growth as a father watches the growth of his children." As a garden professional, Woodham might privately agree with the essayist, who continued: "I like my garden better than any other, for it is my own." Among his favorite details are a "gazebo-wellhead-arbor" (top) covered with a Duchess of Albany rose and a pink clematis, and a dry-laid wall dressed with wild ageratum (lower photograph).

Morningside Drive, Morningside Park
COTTON GARDEN

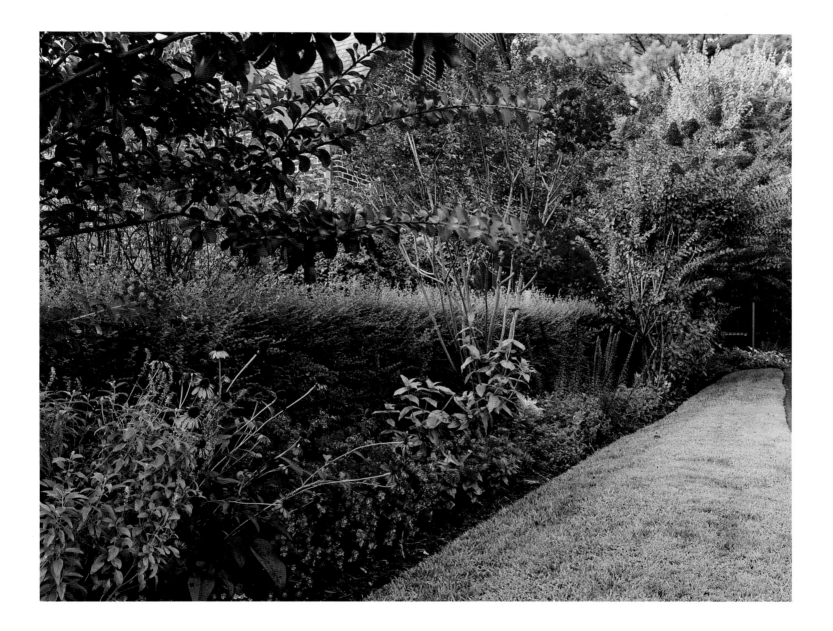

Morningside Park, now shortened to Morningside, was developed and annexed to the city in the early 1920s.
Lying between Ansley Park and Druid Hills, and east of Piedmont Avenue, Morningside is quite similar in layout
to those garden suburbs, also noted for their curving, tree-shaded streets and parks. In recent years, Morningside
has enjoyed a renaissance among those seeking a convenient location and the 1920s-period charm of medium-sized
Tudor Revival brick houses. Garden settings often complement the gable-roofed cottage character of the houses.
Randy Cotton writes: "We enjoy our garden most as an escape to the outdoors while living in the 'Intown' area."
The Cotton garden side yard shows a hedge and perennial border surrounding a neat strip of green lawn.
Crape myrtles blossom above purple coneflowers, petunias, begonias, phlox, and other bright summer colors.

Cottage Lane, Collier Hills
Franklin's "Privy Garden"

Collier Hills lies along either side of Collier Road on lands originally settled by Andrew J. Collier (1827-1887), a pioneer resident of Fulton County who operated a gristmill on Tanyard Branch before the Civil War. In July 1864 the Battle of Peachtree Creek raged there. Now it is a peaceful neighborhood of modest, stylish homes. Cottage Lane sits on a ridge running north off of Collier Road just above Tanyard Branch. Here resides one of the leading landscape architects in the South, Daniel B. Franklin, FASLA, whose family, like the Colliers, has lived in Atlanta since the antebellum period. Dan Franklin has dubbed his backyard "The Privy Garden" (as in "privy": belonging to a person in his individual rather than his official capacity; private; secret). This is indeed the landscape architect's private garden, his own creation for himself rather than for a client.

Yet there's more to it. Franklin's famous sense of fun is definitely at work. He intends a pun, one might say a private joke, for he calls his summer-house "The Franklin Outhouse." Some privy! Some garden to which one is fortunate to be "admitted as one sharing in a secret." It is a beautiful secret that he clearly enjoys sharing.

Southern Living featured Dan Franklin's garden in April 1987. The article began: "Ask Dan Franklin for an opinion, and you're sure to get one. Especially about gardening. For if ever a person loved and understood gardens, it's Dan." Franklin's garden interprets eighteenth-century formal gardens of the South. Large pots hold bright geraniums at the corners of the lawn and are part of the formal framework, as is the white lattice fence with bold, pointed corner posts.

*Glorious flower borders contribute to, yet soften, the geometry, as does the central lawn,
which would have been rare in the eighteenth century, especially in Georgia. "The Franklin Outhouse,"
reminiscent of an eighteenth-century plantation outbuilding, is elevated above the level of the rear lawn and borders.
It offers a panorama of the house, formal rear garden, and fish pond, as well as the opportunity
for Franklin to "borrow" views from his neighbors in the surrounding Collier Hills forest.*

Moore's Mill Road, N.W.
GEORGIAN-SHORES HILLSIDE GARDEN

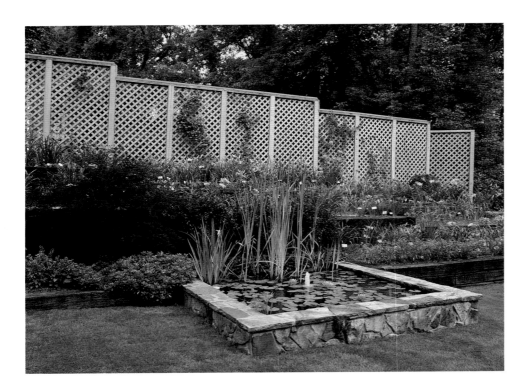

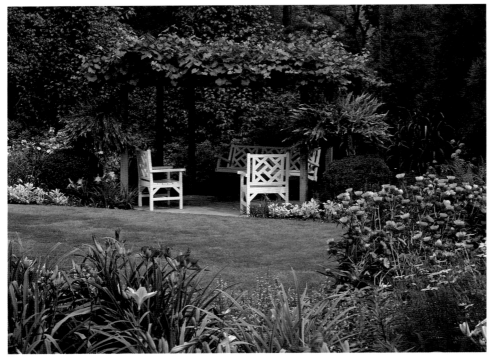

The intersection of Moores Mill Road and Howell Mill Road was once called Cox's Cross Roads for Carr Cox, who was the postmaster for the old Howell's Mill Post Office that stood there. At that intersection today, Robert George and Owen Shores (Georgian-Shores) have renovated an eighty-five-year-old house and transformed its surrounding gravel parking lot into a one-half-acre hillside garden.

The beauty of the garden is partly due to old oak trees that have stood there since it was Cox's Cross Roads. They laid out the grounds in 1975 using a series of connected water hoses to outline the design. A grape arbor and a seven-foot waterfall were two of the first elements completed.

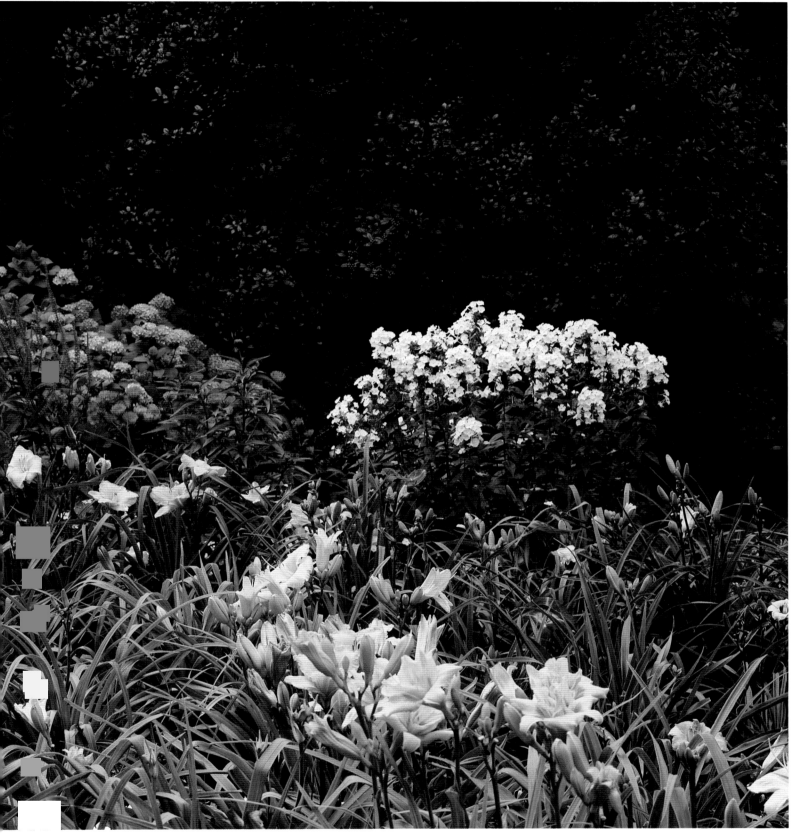

Later, landscape architect Daniel Franklin began to help with suggestions to complete the presentation. Among Franklin's suggestions were a water-lily pond, numerous perennials and annuals, Indiana limestone walkways, terraces, and borders for the formal beds. In 1986 the garden, which has more than 400 hybrid varieties of daylilies, was one of the features of the national convention of the American Hemerocallis Society. One of the finest daylily presentations in Georgia, the hemerocallis at Hillside Garden have been color coordinated and inventoried by cultivar, color, bloom size, and height, with computer assistance. There are also forty varieties of hybrid hosta accompanied by ferns, hydrangeas, hollies, flowering peach and cherry trees, Bradford pears, dogwoods, and large cryptomeria.

"Hydrangea Hill"
Peachtree Battle Avenue, N.W.

HOWELL-MCDOWELL GARDEN

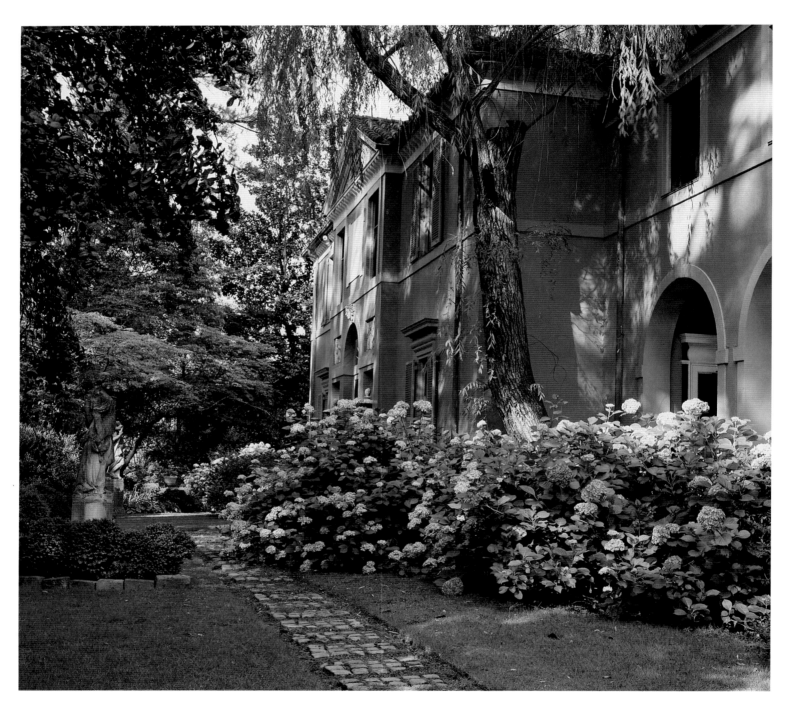

In 1852 Judge Clark Howell (1822-1882) established a gristmill and a sawmill on the north bank of Peachtree Creek near the present intersection of Howell Mill Road and Peachtree Battle Avenue. When Clark Howell died in 1882, he owned 4,000 acres of land in Fulton County. In 1931-32, on seven of these acres on an elevation above Peachtree Creek near the old Howell Mills, his great-grandson, Albert Howell, Jr., built an Italian Renaissance-style villa (above) with surrounding gardens. An architect who loved Italian architecture and gardens, he designed this villa as his residence and for his bride, Caro du Bignon Henry, who still resides there. Mrs. Howell, now Mrs. Michael McDowell, writes: "The garden has always been planned as a suitable setting for the house my late husband designed." The house sits atop a hill that slopes dramatically away on all sides. The rear of the house opens onto a terrace, which looks out on a lawn and balustrade of muses (opposite), before the land descends in terraces down to a classical garden pavilion.

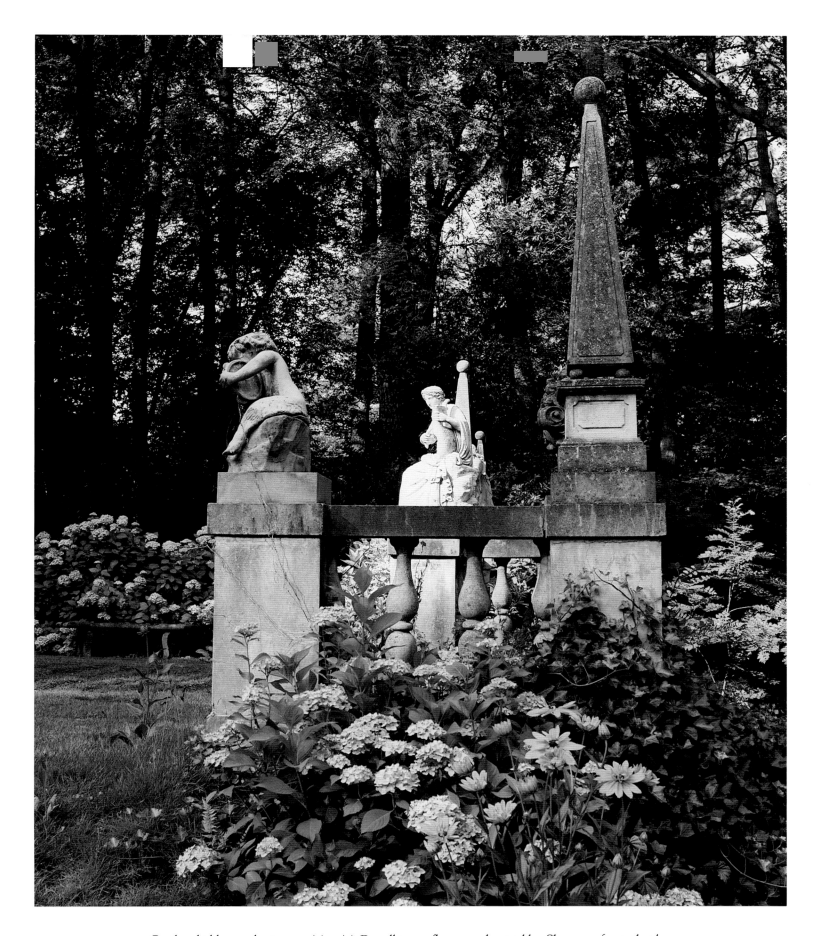

On these hidden garden terraces Mrs. McDowell grows flowers and vegetables. She now refers to the place
as "Hydrangea Hill," although it is sometimes called Villa Caro. Hydrangeas were introduced to the garden in the
1930s by William Hunter, a landscape architect who assisted the Howells in laying out the grounds, advising them
to use native plants and simple varieties. Offspring from the original plants cover "Hydrangea Hill"
with blossoms, usually during the first week in June. Mrs. McDowell is her own gardener, with one paid helper.

"Bride's Bower"
Peachtree Battle Avenue
EPSTEIN GARDEN

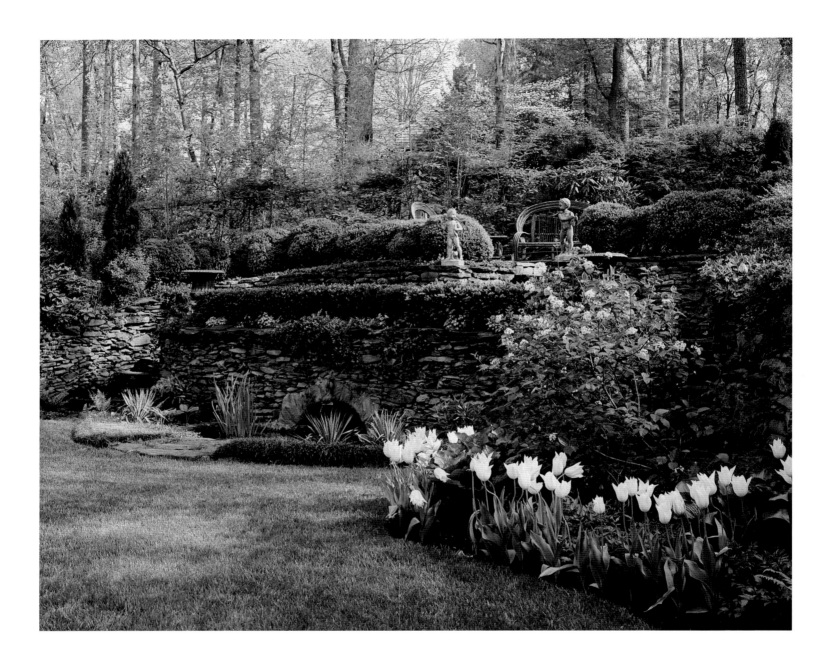

The formation of Peachtree Heights Park was just underway on land formerly owned by a member of the pioneer Collier family when the <u>Atlanta Journal</u> commented in May 1911: "The Collier property . . . will be changed; where there are now but natural groves . . . broad drives will cut their way, restful stretches of green park will be laid out, and Atlanta will boast of a residence section excelled nowhere in beauty and desirability." Peachtree Battle Avenue had already been built west to Howell Mill Road, but not until the 1920s would the prediction come true along Peachtree Battle, Habersham Road, Muscogee Avenue, Andrews Drive, Woodward Way, Cherokee Road,

and other handsome streets in Peachtree Heights Park. In 1928, near the corner of Peachtree Battle and Woodward Way, the Kenyon B. Zahners built their house and gardens, owned and loved since 1968 by the William W. Epsteins. The <u>Garden History of Georgia, 1733-1933</u> included the Zahners' gardens and reported: "An atmosphere of age has been achieved in the gardens by the use of weathered rock, old brick, boxwood, and antique wrought iron gates and grill work. The garden walls are dry-laid and moss and woods plants have settled comfortably in the crevices of the rock steps and paths." Virginia Kennedy Epstein writes: "The basic bones of the gardens have remained unchanged."

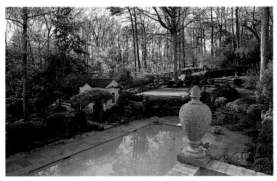

The Epsteins uncovered and conservatively renewed the Zahners' conception, embellishing it with native plants, placing emphasis on a full spectrum of white and fragrant varieties. In 1974 the Epsteins removed some parts of the rear walls and built a swimming pool, storing the original stones and using them again when the walls were rebuilt. In 1985 they placed five lead sculptures by American artist Wheeler Williams in prominent places throughout the gardens. "Pegasus" graces the boxwood parterre garden (above). For their latest project, Mrs. Epstein intends "to introduce plants with golden foliage—variegated yucca, golden leaf spirea, yellow berried nandina, and yellow stem dogwood. The garden expert Ryan Gainey has collaborated with us in this and other matters vital to the quality and evolution of these beautiful old gardens."

Montview Drive, Haynes Manor
COKER GARDEN

Just west of Peachtree Heights Park, along and on either side of Peachtree Battle Avenue, Haynes Manor was developed by E. V. Haynes in the late 1920s. On the southern edge of the area is Peachtree Creek and Bobby Jones Golf Course, and on the north is West Wesley Road; Montview Drive is in the middle, running perpendicular to Peachtree Battle Avenue. The David L. Cokers developed their rear garden around a big existing sugar maple. To blend with their two-story, gray-shingled Colonial Revival house, they had the designer John Baxter create a garage that connects to the house as though it were a detached kitchen building. It serves to increase the informal, early American character of their backyard. A pergola attached to the garage supports a sweet autumn clematis; the walkways are of old brick. Several years ago the Cokers had Edward L. Daugherty and Associates design an unobtrusive swimming pool for the far rear of the garden. Seeming like a woodland pool tucked away amidst ferns, maples, and dogwoods, it is screened from the house by crape myrtle trees. Beverly Coker is "the family gardener" and had Daugherty's firm design the grounds for low maintenance.

Muscogee Avenue, Peachtree Heights Park
MORRISON GARDEN

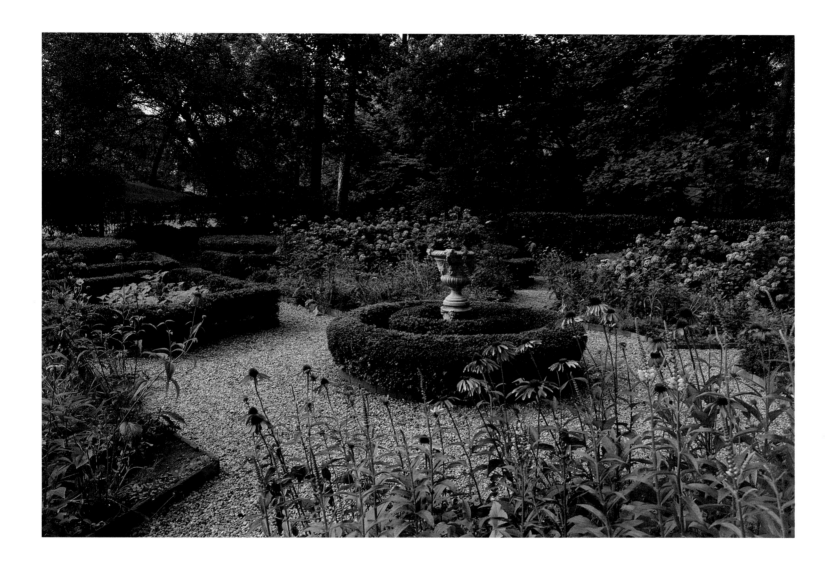

An exceptional Atlanta architectural firm, Hentz, Reid, and Adler (later Hentz, Adler, and Shutze),
designed many of the houses and gardens in Peachtree Heights Park. This was Hal Hentz's home. As was its
practice, the firm designed the house and the garden to complement each other, and it would be difficult to say
exactly which partner actually designed the ensemble. When the house was completed in 1937, Neel Reid,
the founding designer of the firm, had died. Perhaps Hal Hentz called on Philip Shutze for suggestions. Hentz himself
was a capable designer, but there survives in Shutze's own hand a colored sketch of the formal boxwood parterre,
with the house on the hill in the background. Mills and Anne Lane later owned Hentz's classical cottage
and its formal garden, turning it over in the 1970s to Lane's nephew, Howard J. Morrison, Jr.,
and his bride, Mary Reynolds Morrison, who is "chief gardener." The Hentz-Lane-Morrison parterre
garden keeps alive a classic and historic Georgia tradition, but in the true vernacular, for Mary Morrison
uses the simplicity of hydrangeas and purple coneflowers, and in some of the beds, summer squash.

"The Garden at Birchwood"
Birchwood Drive, Garden Hills
LAUFER GARDEN

East of Peachtree Road in the Buckhead area are several neighborhoods developed before World War II, among them Garden Hills and Peachtree Heights East. Birchwood Drive came into being after the war, just south of East Wesley Road, and is considered part of Garden Hills.

Here Geraldine and David Laufer have created *"an arrangement of gardens within a garden which demonstrates,"* Mrs. Laufer writes, *"that in only one-fifth of an acre, a tremendous variety of plants may be grown."* She has *"a Shakespeare theme garden, a traditional kind of garden, an arbor, a color-designed perennial border, a bee and butterfly garden, a lemon garden, a vegetable garden-berry patch, and a fine viburnum*

collection." The Laufers began their backyard garden in 1982, soon after purchasing the 1950s house. Mrs. Laufer continues: *"Before we started there were only four species here, Bermuda grass, privet, holly, and poison ivy. The garden now features over 1,000 species, all growing vigorously, due to the extensive soil preparation at the start of the project."*

Philip M. Hauswirth, ASLA, did a basic layout and a drainage plan, and they began planting in March 1984. Mrs. Laufer selected, purchased, and installed plants using her own sense of design and color and knowledge of horticulture. She *"shifts plants around"* to improve their relationship and their contributions to the garden as a whole.

Mrs. Laufer says with authority: "This garden has been entirely planted and maintained by Geri Laufer, without help!" But she loves the work: "I grew up with gardening. I live, breathe, eat, sleep plants; I'm eager to teach and I delight to share!" She selects the vast majority of plants for their fragrance. The lemon garden, for example, is redolent of lemons: lemon balm, lemon crispun geranium, lemon verbena, lemon grass, lemon basil, lemon eucalyptus, lemon catnip, lemon thyme, golden lemon thyme, lemon bee balm, and lemon mint. The knot garden (opposite) is made up of red barberry, variegated privet, grey santolina, and germander. Of her Shakespeare garden (this page, lower picture),

Mrs. Laufer writes: "Shakespeare mentioned over 200 trees, shrubs, flowers, and herbs in his plays and sonnets, and half of these have been chosen for their ornamental characteristics and their ability to thrive in the Atlanta climate. Informally arranged in a formal garden dominated by an armillary sphere, each plant is accompanied by the appropriate quotation standing next to the plant it describes." Among the plants shown are wormwood, heartsease, white-clove pinks, prostrate rosemary, creeping thyme, flax, feverfew, lily, and Queen Anne's lace. Needless to say, the Laufers' garden has had many visitors and has been included in newspapers, magazines, and other books.

West Wesley Road, Peachtree Heights Park
GILBERT GARDEN

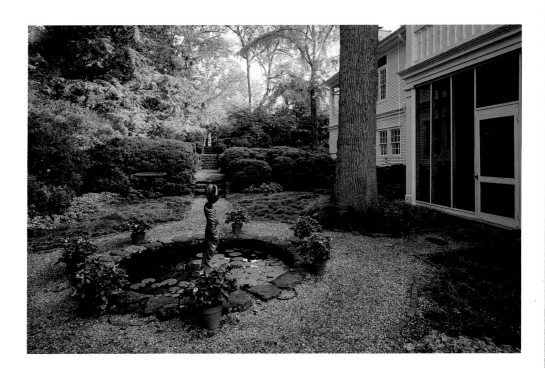

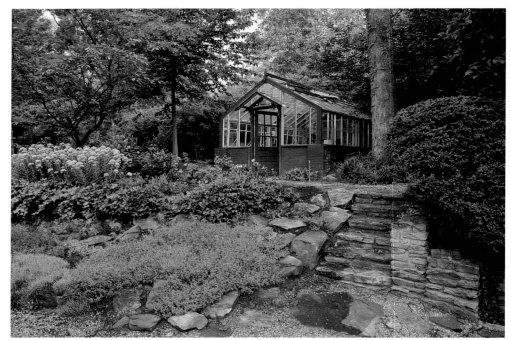

Several fine designers and appreciative owners over the years have created this setting on an elevation above West Wesley Road, within walking distance of Peachtree Road. Atlanta architect Philip Thornton Marye, FAIA, designed the house in 1916. Marye did the drawings for the <u>Garden History of Georgia, 1733-1933</u>, and this garden was included as Mrs. Richard Johnstone's. In 1928 Robert Cridland of Philadelphia prepared the basic layout for the grounds. Cridland was a pioneering landscape architect who designed several fine Atlanta gardens.

In his book <u>Practical Landscape Gardening</u>, published in 1918, Cridland outlined an approach already prevailing among the best Atlanta designers, which decreed that the house and garden together constituted the home—an "unbroken unity." If the grade were steep, the garden should be separated into terraced levels, as he did here. He also recommended enclosing the garden with walls or plants to create a sense of seclusion, employing architectural features, garden ornaments, and sculpture to complete the home grounds.

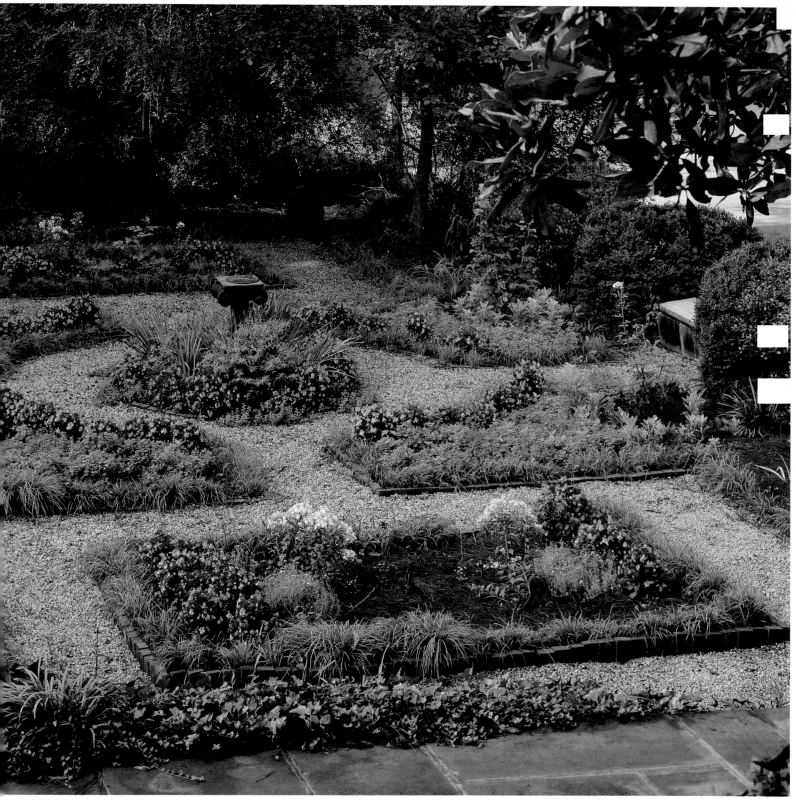

In 1930 a local landscape designer, W. C. Hunter, designed the upper terrace garden along the lines Cridland had established. In 1985 Dr. and Mrs. Robert W. Gilbert, Jr., acquired the property, largely because of what Dr. Gilbert calls "the intrigue of garden possibilities," and they have instigated a "restoration of the plan and plantings." The Johnstone-Gilbert garden is built on a hillside in a series of terraces. The first terrace is a formal green garden adjoining the house; it is surrounded with boxwoods of several varieties and in the center is a round pool. From here the garden ascends through three levels to a figure of Diana standing against dark evergreens. This same view (opposite, top), with few changes, appears in Garden History of Georgia, 1733-1933. The Gilberts retained the old greenhouse on the upper terrace (opposite, lower picture). The woodlands that surround and screen the gardens, including the Gilberts' parterre addition (above), give the illusion that this is a country house, but it is only about a block off of Peachtree Road.

Habersham Road, Peachtree Heights Park

GODDARD GARDEN

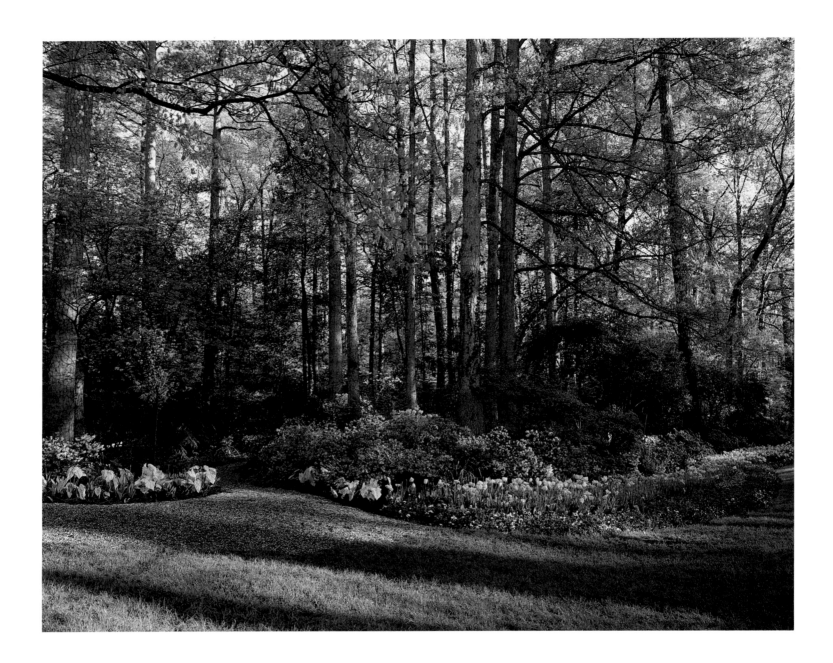

"The Garden of the Flower House" is what the current owners of this property call the wide border, long flower beds, and winding garden path at their woodlands garden on Habersham Road. An old hand-painted sign saying "Welcome Flower Lovers" went with the house when the Robert L. Goddards bought the place in 1986 from the estate of Mr. and Mrs. Charles Younts. Mrs. Younts began the tradition of seasonal plantings for the public to enjoy at the edge of her yard on a Habersham Road curve. Each spring for more than forty years she opened up the winding gravel path by putting out her sign. The Goddards continue the ritual and have expanded the garden with additional flower beds and thirty more flowering trees, while maintaining Mrs. Younts's basic landscape plan. The Goddards write: "The garden has hundreds of ferns, thousands of daffodils, several varieties of rhododendrons, a large old Japanese maple, a century-old pine tree, a water oak also over a century old, mature hemlocks, and several varieties of magnolias. Each year approximately 7,000 tulips and 2,000 pansies are planted. In the spring, when pink and white dogwoods bloom softly behind the collection of azaleas, several thousand people accept the invitation extended on the sign and walk the winding path. Later, many people write notes addressed to 'The Flower House.' It is through sharing that we enjoy our garden to the fullest."

Habersham Road, Peachtree Heights Park
McRae-Jones Garden

In the late 1920s, Philip Trammell Shutze (1890-1982) of Hentz, Adler, and Shutze designed this home on Habersham Road for Dr. and Mrs. Floyd W. McRae, who called it Boxwood House. The *Garden History of Georgia, 1733-1933* commented: "The garden is so keenly in keeping with the atmosphere of the house it seems an integral part of it." Generally this characterized the work of Hentz, Adler, and Shutze, but Boxwood House was one of the most superb examples of Philip Shutze's genius for coordinating architecture and gardens (and interior decoration) into a creative unity that transformed the style of the chosen historical period — in this case the Tudor — into an original conception. Shutze's work compares with that of Sir Edwin Lutyens (1869-1944), who also used period styles to create country houses for his time. This house and its grounds could even be said to be an essay on the houses and gardens Lutyens, with the gardening genius of Gertrude Jekyll, produced in England thirty years earlier. The Ellis Joneses have had Atlanta landscape architect Daniel B. Franklin, FASLA, simplify the gardens, yet preserve the spirit and many of the details of Philip Shutze's pre-World War II conception.

West Paces Ferry Road
CHERRY-SIMS GARDEN

In the 1830s Hardy Pace established a ferry on the Chattahoochee River. The road from Pace's Ferry to the Buckhead crossroads, where Peachtree Road and Roswell Road intersect, is now called West Paces Ferry and is one of the traditional centers of fashionable residential life in Atlanta. When the Tuxedo Park Company in May 1911 began selling a large section of land west of the present Governor's Mansion, along and adjacent to the road, the Atlanta Journal called it "a splendid rolling tract in which cool woods and the fragrant scent of pines

invite home-builders to tarry." And tarry they did, creating some of the most elegant houses and gardens in the city along this "splendid rolling tract" between the Chattahoochee and Peachtree Road. (This and Peachtree Heights Park merge into one large suburb called Buckhead.) The Cherry-Sims garden on a West Paces Ferry hillside of nearly four acres makes especially fine use of the rolling wooded terrain, the "borrowed scenery" (shakkei), in which this Japanese-style house and garden is sited.

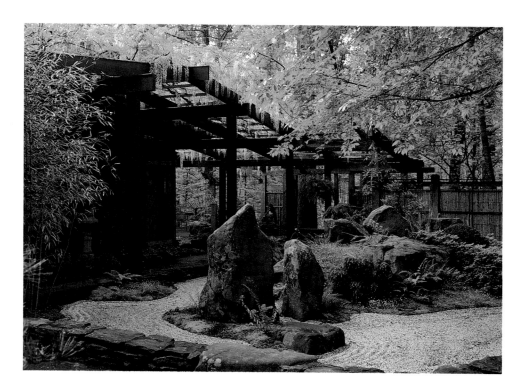

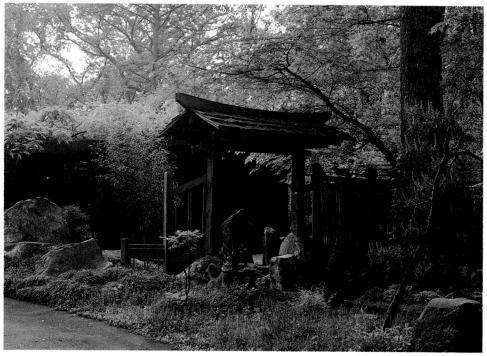

In the Japanese tradition, landscape and architecture are intimately related parts, a perfect union of outdoors and indoors, and this garden is possibly the most important private garden in that style in Atlanta.

Begun in 1964 by Mr. and Mrs. John Wesley Cherry, it was continued by Rebecca Wight Cherry (1921-1989) after John Cherry's death in 1981 and after her marriage to Benjamin Wilson Sims in 1987. John Cherry was an architect, and together he and Rebecca began the evolution of the house and garden into a complementary aesthetic whole—a Japanese ideal. In the beginning, they had the help of Edward L. Daugherty, who provided the initial plan. Later E. Felton Jones designed Japanese aspects, and in the 1980s Rodney Clemons and Thomas Rice made some major refinements. For Gardens of Georgia,

Beck Cherry Sims, president of The Garden Club of Georgia, Inc., from 1973 to 1975, wrote: "My interest in Japanese gardens developed naturally since my first husband was a modern architect, and we had a modern house and furnishings. Oriental arts seemed to complement and combine with our modern taste. With my study of Japanese flower arranging (Ikenobo School) and the art of bonsai, Japanese gardens seemed to complete the relationships of the indoors to the outdoors, bringing our house and garden together as one." Today, the tranquil beauty of the Moss and Koi Pond garden (opposite, top), the Qwan Yen garden (opposite, below), the Sand and Hill garden (top), and the Gatehouse garden (above) is testimony to Beck Cherry Sims's love of nature and gardening.

Cherokee Road, Peachtree Heights Park
GLENN GARDEN

The final two gardens in the Peachtree Heights Park neighborhood of Buckhead emphasize the woodland-naturalistic quality of the residential area. Designed by the New York architectural firm of Carrere and Hastings, the Peachtree Heights landscape plan respected the natural upper piedmont topography, leaving untouched great stands of trees, including small parks with streams, and specified curving streets like mountain roads through the wooded terrain. H. Stafford Bryant of the Classical America Society wrote in 1977: "Atlanta did not have the first or even the largest of the great leafy suburbs with each dwelling in its own large park, but in northwest Atlanta may well be the culmination of that entire landscape movement." A 1915 survey of Peachtree Heights Park recorded at the Fulton County Courthouse shows the neighborhood bounded on the east by Peachtree Road, on the south by Peachtree Creek, and including all of Cherokee Road, parts of Andrews Drive, and a number of other streets. Views of the rear garden terrace of Mr. and Mrs. Jack Glenn on Cherokee Road (above), emphasize the woodland character of the Buckhead area, a naturalistic private "piedmont park" now approaching seventy-five years of tender loving care.

Andrews Drive, Peachtree Heights Park
HAILEY GARDEN

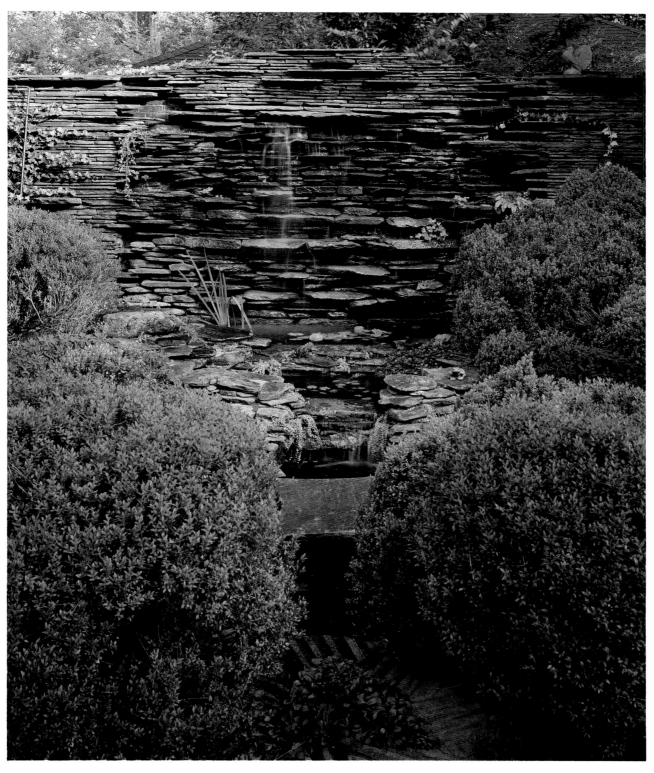

Designed in 1929 for the Beaudry family by landscape architect William C. Pauley, FASLA,
this dry-laid rock waterfall and boxwood-surrounded pool are part of one of Pauley's best naturalistic landscapes.
For many years the Howard Hailey family has owned the property and appreciatively
maintained the park-like grounds and extensive garden areas, essentially as Pauley designed them.

Buckingham Circle
INMAN VILLA

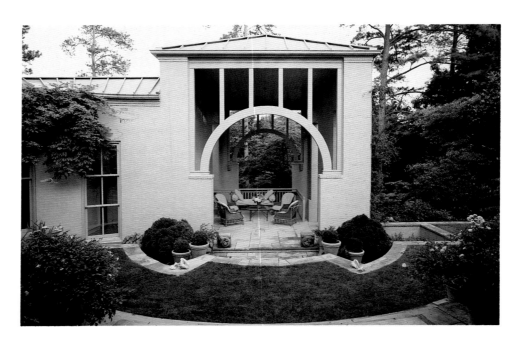

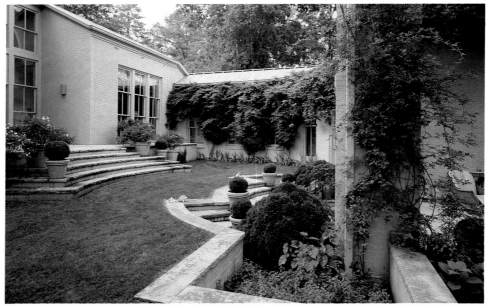

Off of Randall Mill Road, which runs north of West Paces Ferry Road, on part of a garden of an older house, a young couple has created a post-Modern classical villa. Charles W. Moore (1925-), one of the best-known American architects of the seventies and eighties, has helped

Mr. and Mrs. Edward H. Inman produce a house designed as an harmonious unit with its grounds and gardens, thus making it a villa. Moore is a professor of architecture at the University of Texas and co-author of a fascinating book, The Poetics of Gardens (MIT Press, 1988). In the book he examines great gardens from the past, in various climates, to understand basic principles and traditions that can be applied to the creation of

American gardens. Moore is well known for that point of view as it applies to architecture. That is why he is sometimes called a post-Modernist: unlike the Modernists, he is willing to include ideas from history in his designs. Edward and Suzanne Inman built their home in 1986. They collaborated with Charles Moore and Daniel B. Franklin, FASLA, of Atlanta in the final design for the grounds to coordinate them with the design of the house. One wing is a courtyard pavilion, a sort of classical loggia — an outside room that integrates house and garden (above). The harmonious geometry of the Inman villa is an Atlanta tribute to Palladio — a classical villa for the 1980s.

Tuxedo Road
SANDERS GARDEN

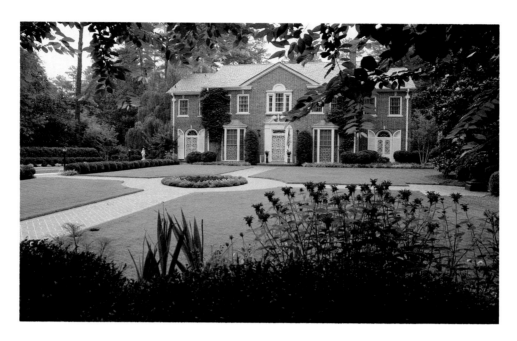

Tuxedo Park lies on, and north of, West Paces Ferry Road, roughly between Northside Drive and Nancy Creek. Charles H. Black formed the Tuxedo Park Company in May 1911, and his son, Charles H. Black, Jr., built many of the houses in the neighborhood. The home of former governor Carl E. Sanders and his wife, Betty Foy Sanders, was the last residence of world-renowned golfer Bobby Jones. The property originally fronted on Northside Drive, and the gardens stretched back to Tuxedo Road. When the Sanderses purchased the property in 1971, the house had already assumed a Tuxedo Road address and the original front on Northside had become the garden side, seen here. Mrs. Sanders writes: "As an artist and gardener, I have never liked to approach my subject with set rules of design. I mix my flower beds into a palette of wildflowers, bulbs, and annuals like my mother and grandmother grew, for sentimental reasons. I order some of my plants and seeds from Georgia's *Market Bulletin*. I also like to exchange flower seeds and plants with friends. This makes my flower garden special and personal for me."

Northside Drive
CARR GARDEN

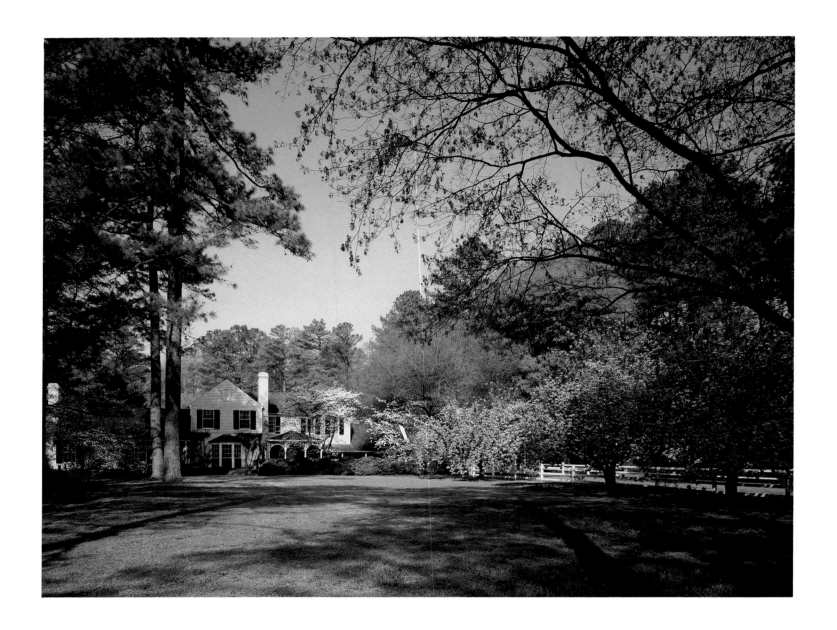

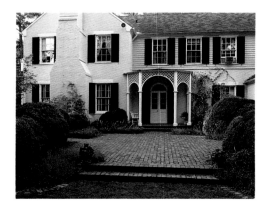

On a level elevation above Nancy Creek, on property formerly part of the Richardson estate, Philip Trammell Shutze, FAIA, built for Mr. and Mrs. Fred W. Patterson a yellow-and-white early American farmhouse in the late 1930s. For twenty-five years, this has been the home of Mr. and Mrs. Julian S. Carr. Mrs. Carr is one of the creators of the Cherokee Garden Library of the Atlanta Historical Society and a leader in the work of the Garden

Club of America, Inc. Philip Shutze's scheme for the property is a sophisticated farmhouse amidst an informal garden landscape, reached from Northside Drive down a white-fenced avenue of twelve Kwanzan cherry trees (above). He designed two formal, walled courtyard gardens next to the house, which are private outdoor rooms. It is a picturesque, indoors/outdoors house with a garden vista or garden access for all principal rooms.

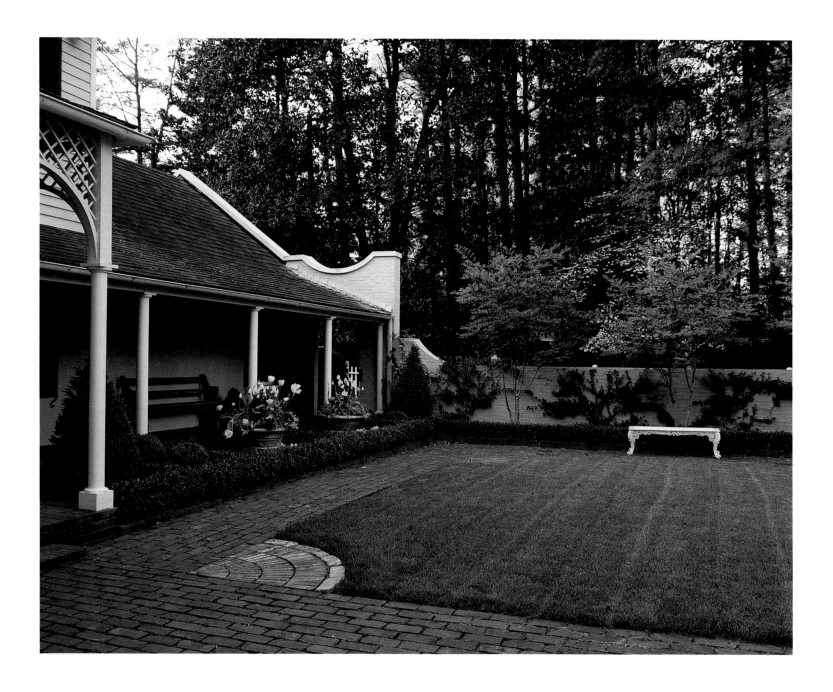

Mrs. Carr's entrance courtyard (above) is a green-and-white garden with white crape myrtle trees, white hydrangeas, white oak leaf hydrangeas, white tulips, white clematis, white geraniums, and white phlox. Retaining Shutze's basic design, she had Ryan Gainey rework the garden in this fashion after a large live oak tree that shaded the area died in 1987. On the south side of this house, another walled garden (opposite, lower photograph) opens off of the central L-shaped hallway. Anne Beauchamp Carr writes: "This garden is shaded and includes six varieties of hosta, strawberry begonia, white bleeding heart, foxglove, hellebores (Lenten rose), astilbe, and tulips in the spring. There are many fine old English boxwoods surrounding the house, and two Chinese koùsa dogwoods, Córnus koùsa chinénsis, the first two planted in Atlanta, back in 1939-40. There are twenty-four magnolia grandifloras as a background for many areas of the grounds, as well as many varieties of azaleas. I maintain the garden myself with the help of a gardener."

"Meadowlark," Northside Drive
ALLEN GARDEN

From West Paces Ferry Road north along the west side of Northside Drive up to Nancy Creek is a large estate that
was part of the area the Tuxedo Park Company opened for residential development. Hugh Richardson, who dealt in
real estate, purchased this land and built a weekend cottage in 1915. He liked it here so well that in 1923 he built a large
house called Broadlands, which was in <u>Garden History of Georgia, 1733-1933</u>. His son lives in the house today.
The 250-acre estate is still largely intact, and, on a segment of it, between Nancy and Wolf creeks, live Ivan Allen, Jr.,
a former mayor of Atlanta, and Mrs. Allen, who is Louise Richardson, Hugh Richardson's daughter.
Mrs. Allen calls their part of the tract "Meadowlark," the part kept by her and a seventy-seven-year-old gardener.
Just keeping the meadow mowed is part of the "hard work and pleasure of the place for
nine months a year," Louise Allen says. But it is "wonderful therapy."

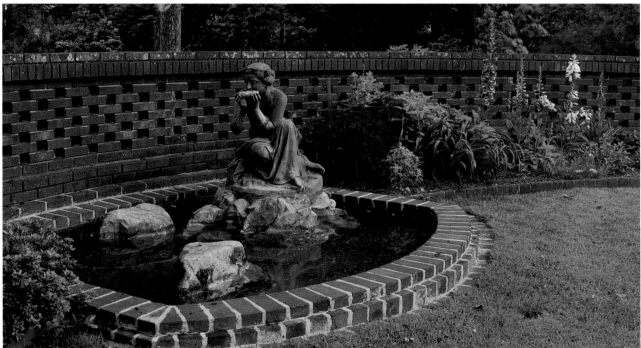

Mrs. Allen states: "I am a great advocate of native plant materials (as shown in her rock garden,
opposite page), which are not only beautiful but withstand heat, drought, and cold better than the ornamentals.
I have been planting unusual native trees and shrubs for twenty-five years. I continue to plant, when
interesting material, native or ornamental, becomes available, and I can find a spot to plant it!" The Allens
added a pierced brick wall (above) in recent years to extend their rear terrace, as well as the perennial border and
pool, which Mrs. Allen wanted after visits to English gardens and a landscape course with John Brooks,
renowned landscape designer and author of numerous books on the subject of garden design. From time to time
she has had help from Edith Henderson, Edward Daugherty, the late Frank Smith, Doug Dorough,
and Eugene Cline, but she has "never had a complete plan." "Meadowlark" is truly home for
Louise Richardson Allen—she has lived near Nancy Creek all of her life.

West Paces Ferry Road
FRANKLIN GARDEN

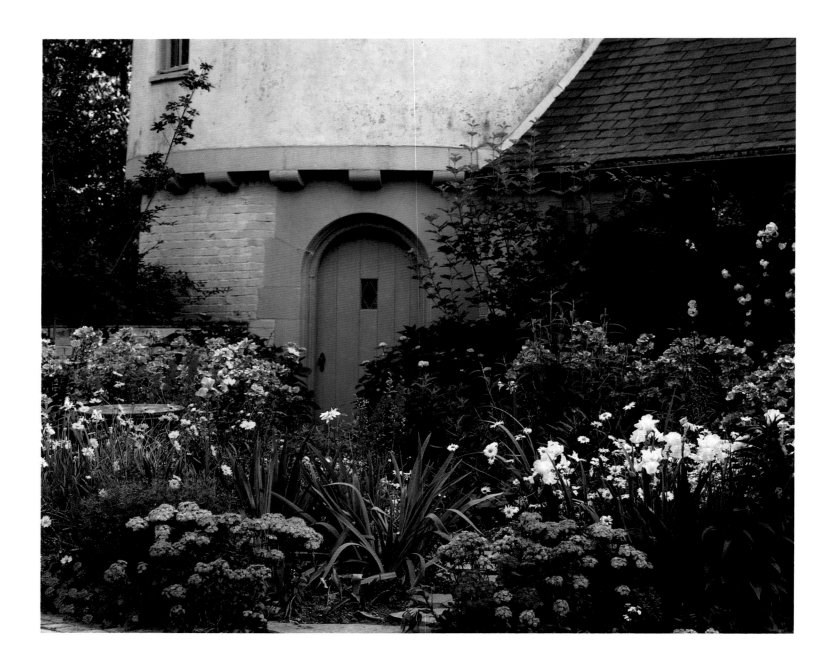

The Richardson family estate is large enough for several generations of relations to enjoy residing near the streams and meadows, among the hills and dales of its spacious beauty. Frances Richardson Franklin's portion of the acreage is on the West Paces Ferry part of the property. Her father built this house in the 1930s. It is an evocation of Normandy designed by architect Ayman Embury II of New York, who also designed Broadlands, the main house on the estate. Embury intended the walled courtyard garden for roses, to go with the house. But, as the tall trees of the place grew taller and shaded the court, Frances's mother, and later she, tried other plants, and so a cottage flower-garden evolved for the dooryard (above). Old-fashioned Betty Prior roses tolerate the semishade and retain a flavor of the original pastel rose yard by the Norman "keep." Ryan Gainey helped with the new plantings. Frances Franklin has "something blooming from early April to the first frost." She has a gardener for the heavy work, and she handles the "pruning and deadheading." She writes: "I adore flowers and love caring for them. After my children grew up and scattered, I turned to gardening. I think I needed something to nurture."

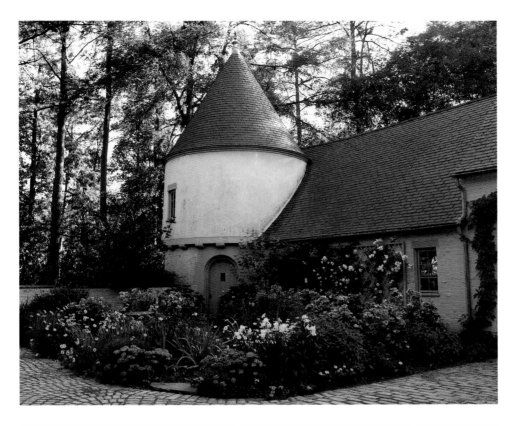

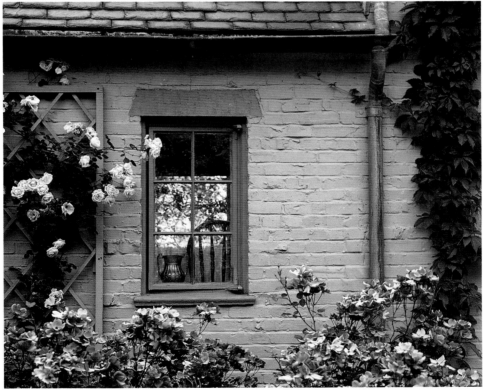

Fairfield Road
Martin Garden

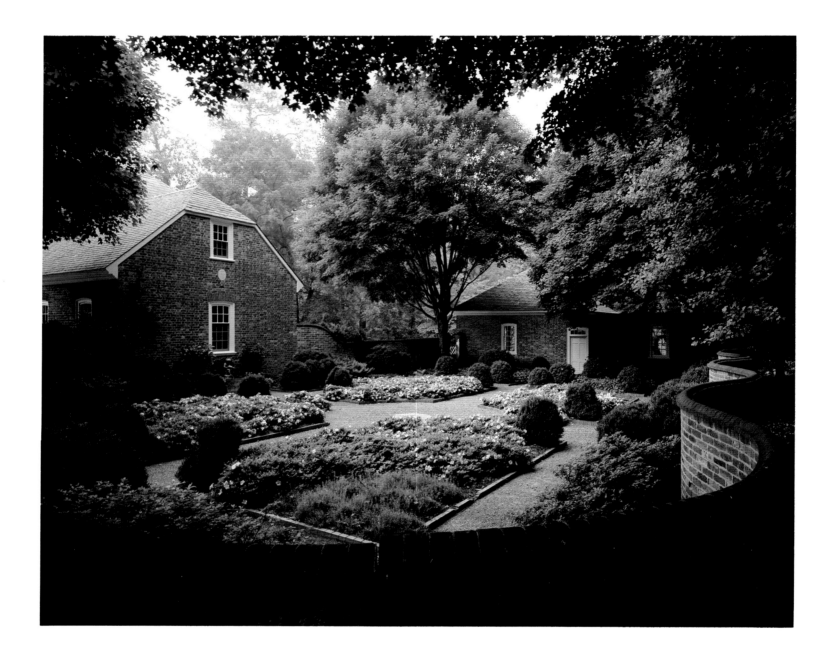

In a curve of Nancy Creek, on some of the former meadowlands of the old Richardson estate, Mr. and Mrs. Thomas E. Martin, Jr., had the Atlanta architect James Means (1904-1979) build them a tidewater Virginia style manor house in 1965. The house faces east, with acres of pasture between the front door and Northside Drive. It is a country house in a suburban setting. Peggy Sheffield Martin rode horseback over these fields and meadows when she was growing up in northwest Atlanta. Following the bridle paths, she often crossed the old bridge over Nancy Creek near where she and Tom Martin have built their home. The formal walled parterre garden (above) with white gumpo azaleas dates from 1966-67 and was designed by the Martins in collaboration with architect Means, the late Frank Smith, a leading landscape gardener and nurseryman, and Edith Henderson, FASLA, the dean of Atlanta landscape architects. Peggy Martin writes: "The serpentine garden was laid according to the actual plans of Thomas Jefferson for the walls on the grounds of the University of Virginia." Edith Henderson's design for the garden, showing the pattern of the beds and walls with a planting scheme for the four Atlanta seasons, was illustrated in Gardens of the South (Simon and Schuster, 1985). Subtle whimsical details, such as the terra-cotta rabbits guarding the garden gate (opposite), have been added through the years.

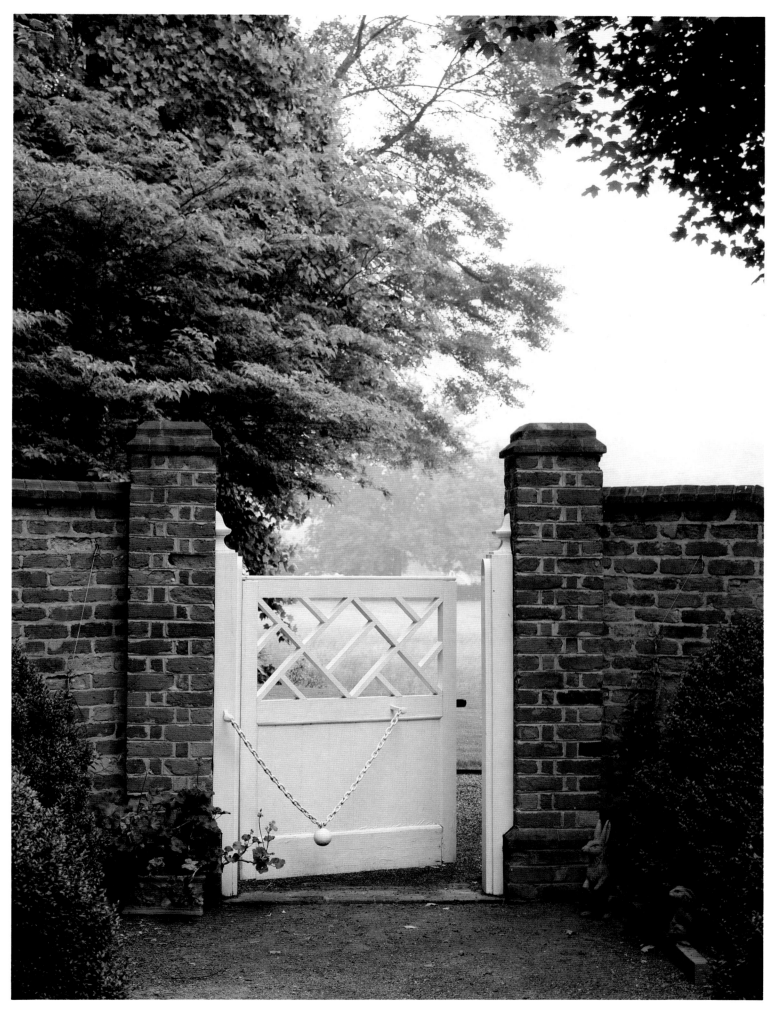

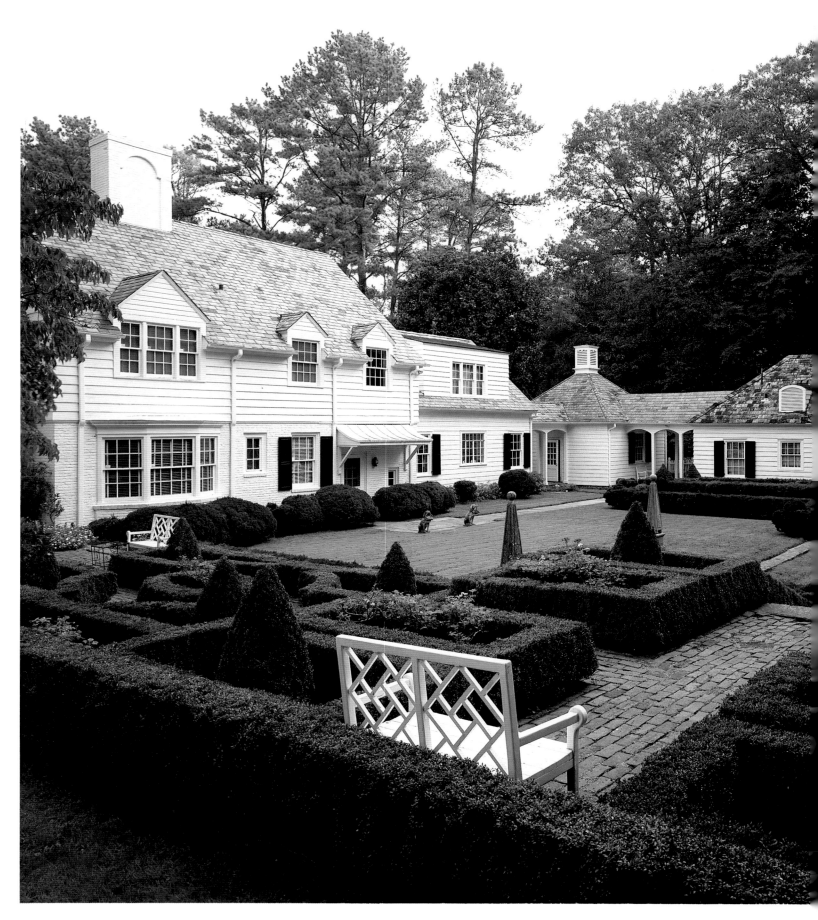

Blackland Road, Tuxedo Park
CANNON GARDEN

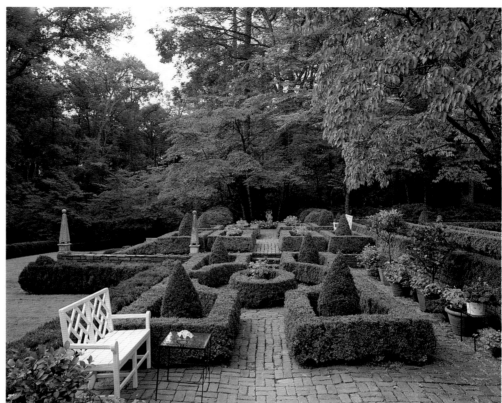

Blackland Road is named for the developer of Tuxedo Park, Charles H. Black. By the 1930s he
had formed the Valley Road Company to continue building Tuxedo Park in the area of
Mrs. Richard A. Cannon's house, which sits on a several-acre lot extending south of Blackland
Road toward Tuxedo Road. There she has developed the finest private boxwood topiary garden in
Atlanta. It is easily one of the most appealing formal boxwood gardens in Georgia, and very much
in the tradition of Hills and Dales in LaGrange, Boxwood in Madison, and the boxwood parterres
in Savannah. The Cannon garden, however, is relatively new. Edna Cannon, with the help of one
gardener, oversees and keeps up this very maintenance-intensive garden. Her crisp white Colonial
Revival house is well complemented by the boxwood topiary terrace, designed in formal geometric
patterns with obelisks punctuating dry-laid walls. Her green backyard garden is a model of
symmetry and balance, with garden figures and Chippendale-style white garden benches used as
focal points at the end of brick walkways. Pots of bright, friendly flowers are placed for
counterpoint. Surrounding three sides are woodlands filled with native dogwoods and hardwoods.
On axis with the garden entrance to the house is a green lawn, lined with box hedges, which sweeps
away to the woods. An informal wing encloses the east side of the garden and balances the
topiary terrace on the west. In the Age of Reason, beauty was derived from order and repetition,
repeated patterns, symmetrical balance, and repeated themes. Nature is put into elegant order in the
formal patterns of Mrs. Cannon's boxwood geometry; but just beyond, and in delightful
contrast, is the informality of nature's woodlands. This lovely and restful scene could be a
late-seventeenth-century William and Mary period garden, under Dutch influence,
as captured in one of Kip's early eighteenth-century bird's-eye views of English country houses.

Valley Road, Tuxedo Park
COCKE GARDEN ROOM

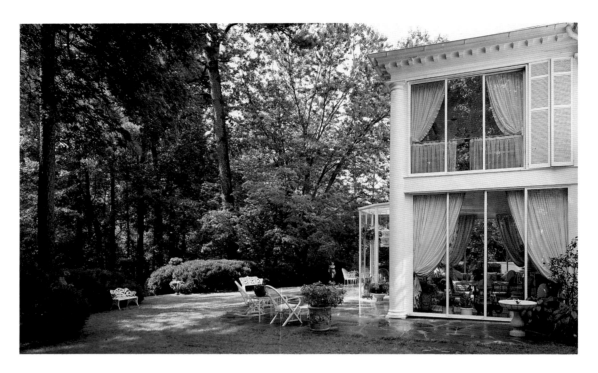

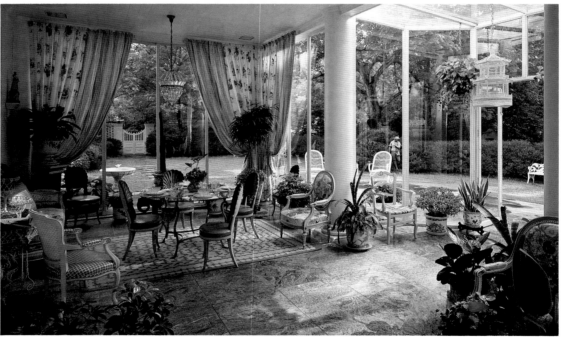

Valley Road follows the stream bed of Wolf Creek through the middle of Tuxedo Park. Large houses are sited on the elevations well back from the road, among woodlands of pine, dogwood, sourwood, oak, beech, tulip poplar, and hickory. Naturalistic or English landscaping is generally the norm, with broad lawns, large shade trees, and informal plantings of boxwood, rhododendron, azalea, and mountain laurel. The home of Frances and the late Emory Cocke takes great advantage of

this beautiful setting. Mrs. Cocke opened up the rear of the house a number of years ago with a glass-walled room that makes her established garden and the natural setting a part of her everyday experience, whatever the weather, and allows for container gardening year-round. Fanny Cocke expresses her taste and imagination and love of the decorative arts in a light-filled space that embraces the beautiful landscape of her home in northwest Atlanta.

Valley Road, Tuxedo Park
BACHMAN GARDEN

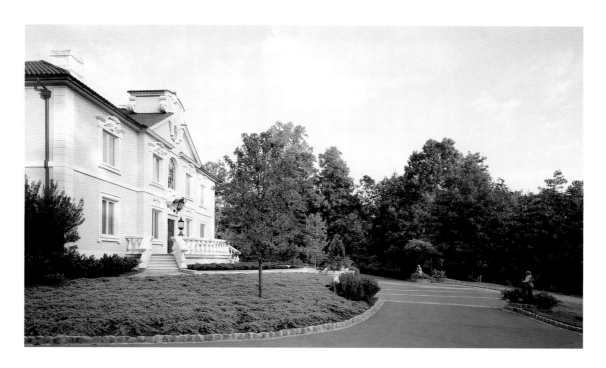

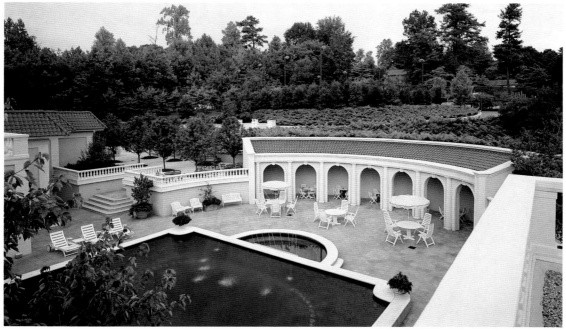

Italian Renaissance and baroque villas have long inspired Atlantans to create their own great stucco, tile-roofed houses set into specially designed hillside garden landscapes. Built in the mid-1970s, this attempt to capture the spirit and beauty of a Mediterranean villa almost failed. The Gilbert Bachmans purchased the property after a tornado had toppled many of its great oaks, and the house, despite its youth, had practically been given up. Only then did the place have a chance to fulfill its promise. Using the basic shell of the house (entrance facade, top) and some aspects of the grounds, the Bachmans started over. Mrs. Bachman writes: "Our garden is approximately six acres, with many architectural features and statuary, and makes wide use of native as well as exotic plants. The original overall design was done for us by Rick Anderson, with revisions and changes by Eugene C. Cline." Family pleasure is the main purpose for the garden and courtyard (above)—truly a Mediterranean "revival" story set on a hillside in Atlanta.

"Dogwood Hill," Tuxedo Road
Fuqua Garden

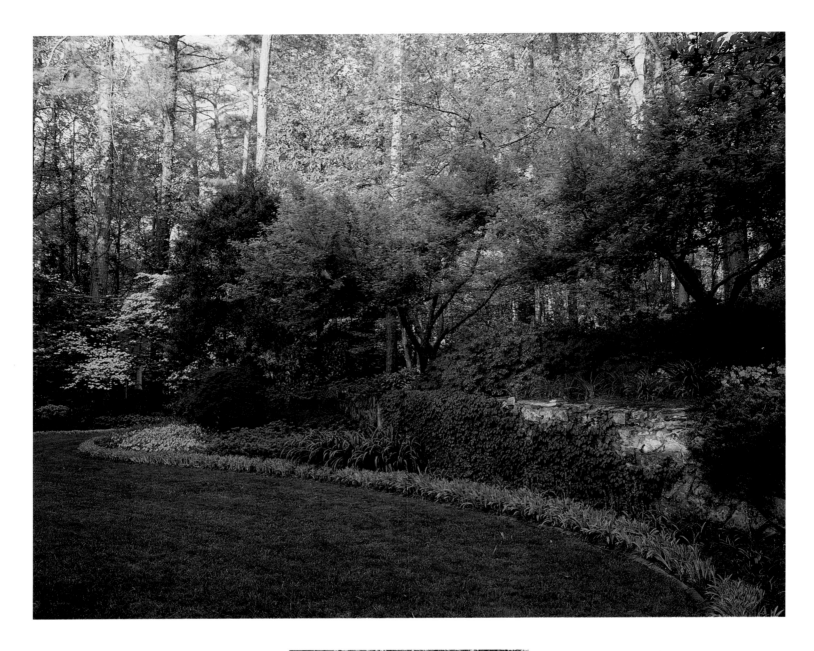

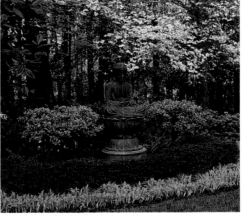

Tuxedo Road from West Paces Ferry Road to Northside Drive—the stretch in which the Fuqua garden is located—is one of the most beautiful drives in Atlanta and compares to Lullwater Road in northeast Atlanta. Indeed, Tuxedo Park and Druid Hills fulfill Frederick Law Olmsted's garden suburb ideal, and the grounds of Mr. and Mrs. J. B. Fuqua partake of it. They call their place "Dogwood Hill." The original master plan for their property was drawn and planted by Jim Gibbs more than twenty years ago, and Mrs. Fuqua says they had the same gardener even longer than that, but recently they have had to change to a garden service, which she supervises when she can.

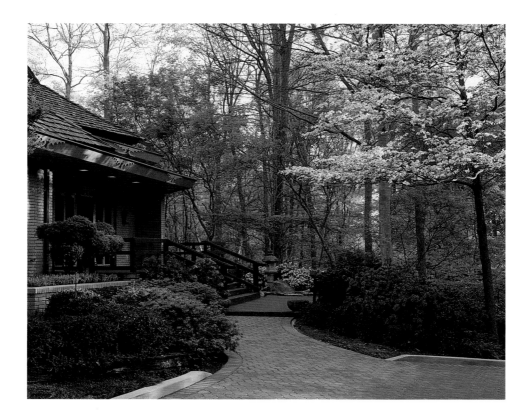

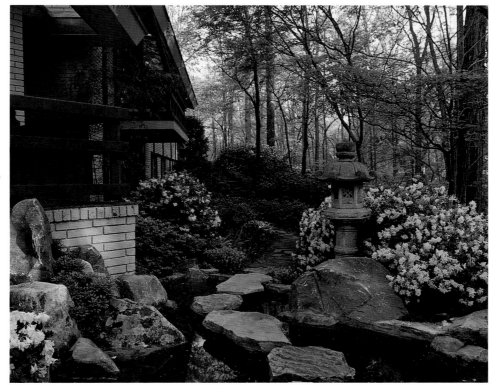

The house and the garden immediately around it share an Oriental influence, as well as aspects of the informal landscape, which features azaleas. Garden details such as the Buddha statue (opposite, below) and the Kasuga-type stone lantern (this page, lower photograph) complement plants such as the azalea and dogwood, which are so much a part of the landscape in Georgia. Mrs. Fuqua writes: "Gardening is very special to me, it is therapeutic, almost a religious experience. I just have to have the beauty of flowers and birds singing around me."

West Paces Ferry Road
GOVERNOR'S MANSION GARDENS

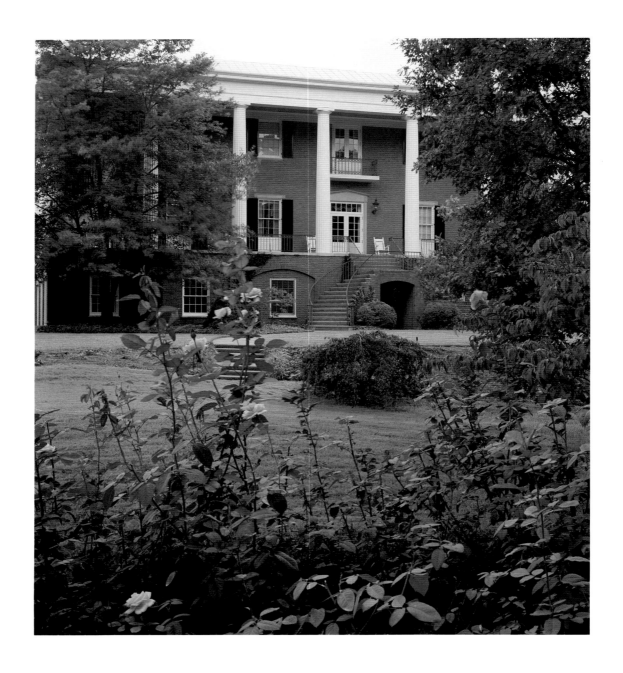

Woodhaven, the estate of Robert Foster Maddox (1870-1965), consisted of seventy-five acres of lawns, gardens, and woodlands with a large, rambling, English Tudor-style mansion that the Maddoxes built in 1911-12. It was the first great estate built on West Paces Ferry Road. After World War II, Maddox subdivided the property and kept twenty-five acres. In 1966 the state purchased eighteen acres for the grounds of the Georgia Governor's Mansion, a classical revival house that was completed two years later. Thomas Bradbury designed the house, and Edward Daugherty planned the landscape. Important aspects of the Maddox gardens were preserved, especially "The Garden of Terraces" (opposite page). The Maddoxes built this formal Italianate garden, it is said, "with the help of a man and a mule" in a ravine on the west side of the ridge on which their house, and now the Governor's Mansion, was built.

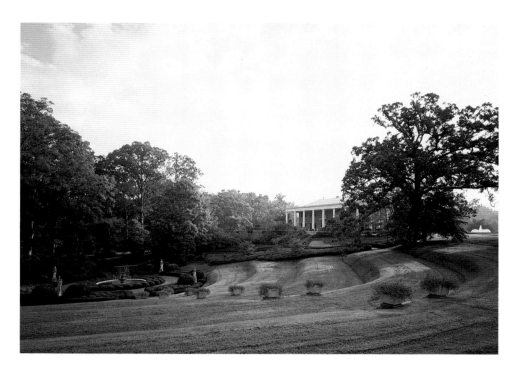

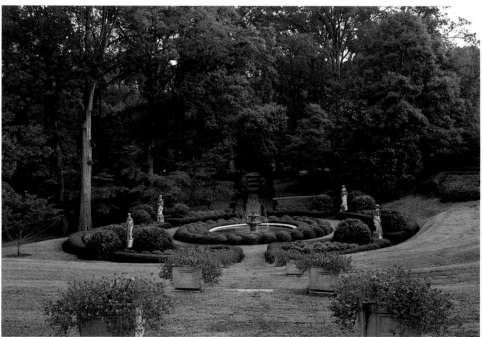

The Maddoxes's fountain and Italian marble figures of the four seasons still adorn the garden, which is sometimes called the "Sunken Garden." The Maddoxes's "Pergola Garden" (above, in the background) also remains, on axis north of the fountain. The present residents of the mansion, Governor and Mrs. Joe Frank Harris, have made major contributions. Elizabeth Carlock Harris's horticultural work has included almost 400 rose bushes; a fruit orchard with apple, peach, pear, cherry, and damson trees; a perennial garden; a vegetable and herb garden; and a woodland area for native Georgia plants. For Gardens of Georgia, *the first lady of Georgia wrote: "Gardens are cultivated to enhance knowledge of the Master Creator." In 1989, for her exemplary efforts on the mansion grounds, Elizabeth Harris received the Certificate of Merit of The Garden Club of Georgia, Inc.*

Piedmont Park at The Prado
ATLANTA BOTANICAL GARDEN

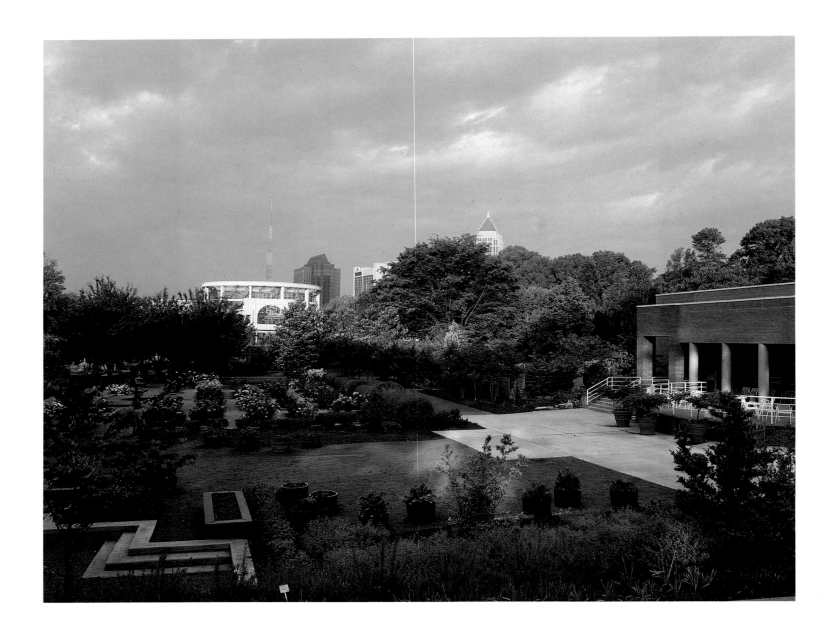

The Atlanta Botanical Garden is located in the northwest section of Piedmont Park, a 185-acre oasis in the Midtown Ansley Park area originally laid out for the Cotton States and International Exposition of 1895. The Atlanta Botanical Garden was incorporated in 1976, and in 1980 the city of Atlanta leased sixty acres to the garden for fifty years. The firm of Edward L. Daugherty, FASLA, prepared the master landscape plan for the extensive grounds. The Gardenhouse, a 24,000-square-foot complex designed by Atlanta architect Anthony Ames, was the first permanent building. Areas within the Gardenhouse include Cecil B. Day Hall (shown on the right side of the top and lower photographs of this page), Lanier Terrace, James B. Cox Courtyard (lower photograph), Sheffield Botanical Library, offices, meeting rooms, and a gift shop.

In March 1989 the Dorothy Chapman Fuqua Conservatory opened (opposite, top photograph, in the background). A 5.5 million dollar, 16,000-square-foot facility designed by Heery Architects and Engineers of Atlanta, it is the latest thing in conservatories, with three distinct climate zones. The Tropical Rotunda, a glass cylinder measuring fifty feet tall and eighty feet in diameter, can be seen from throughout the garden. It houses thirty-foot-high Madagascar palm trees and some of the rarest and most endangered plants in the world. Also on the grounds are formal gardens (such as the test area for the American Rose Society, top), a woodland trail with a paved pathway, and the Storza Woods, a mature hardwood forest with walking trails. In addition, there is an herb and knot garden, a vegetable garden, a dovecote, and areas for perennials, annuals, flowering bulbs, wild flowers, and native shrubs and trees of the piedmont region.

Spring Hill, Spring Street
Oglethorpe Hill, Peachtree Road
THE GARDENS OF H. M. PATTERSON AND SONS

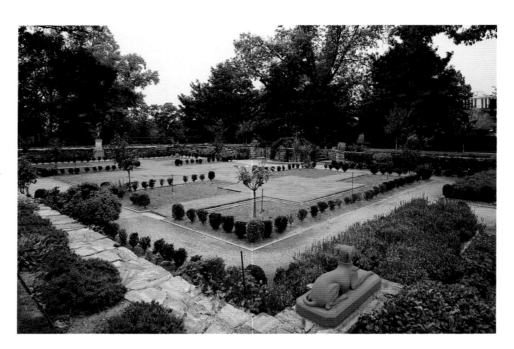

Without the gardens of H. M. Patterson and Sons at Spring Hill and Oglethorpe Hill, the spring season
in Atlanta would not be the same. These gardens have long been accessible to the public—very much on
public view—even though they are on private property. Garden History of Georgia, 1733-1933 included
Spring Hill under institutional gardens, showing the same two aspects of the Spring Hill grounds—
the formal north (top) and the informal south (lower photograph) gardens. In 1928 Mr. and Mrs. Fred Patterson
planned the original Spring Hill layout and had their architect, Philip Trammell Shutze,
include it in the overall scheme for their new funeral home on Spring Street.

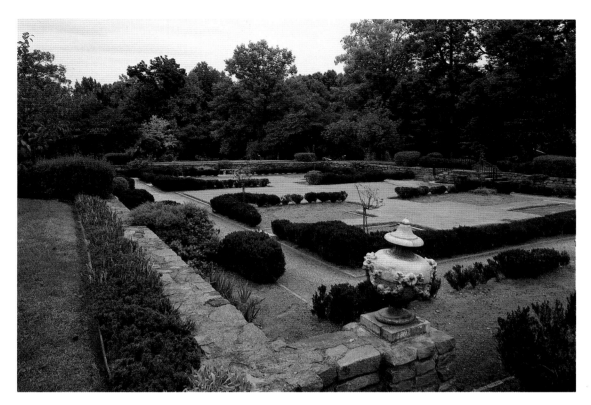

In 1957 the company began Oglethorpe Hill in the Oglethorpe College area of north Atlanta. The Atlanta architectural firm of Ivey and Crook, AIA, designed the handsome new facility in the Georgian Revival style, and the gardens are almost duplicates (north garden, top, and south garden, lower photograph). Except for minor details and some differences in the choice of flowers used in the formal north parterre garden, the gardens at both locations replicate the written description and photographs of Spring Hill in the 1933 Garden History. Such continuity in this day and time should not go unrecognized. For both funeral homes, Dan Allen, a Fred Patterson grandson, maintains the planting effects and color harmonies designed for the Pattersons by J. B. Shannon in 1928. Allen has sometimes had to replace old trees, shrubs, and perennials with new plantings of the exact same materials. At Spring Hill, and now at Oglethorpe Hill, Kwanzan cherry trees still bloom.

Atlanta Historical Society, Andrews Drive
SWAN HOUSE GARDENS

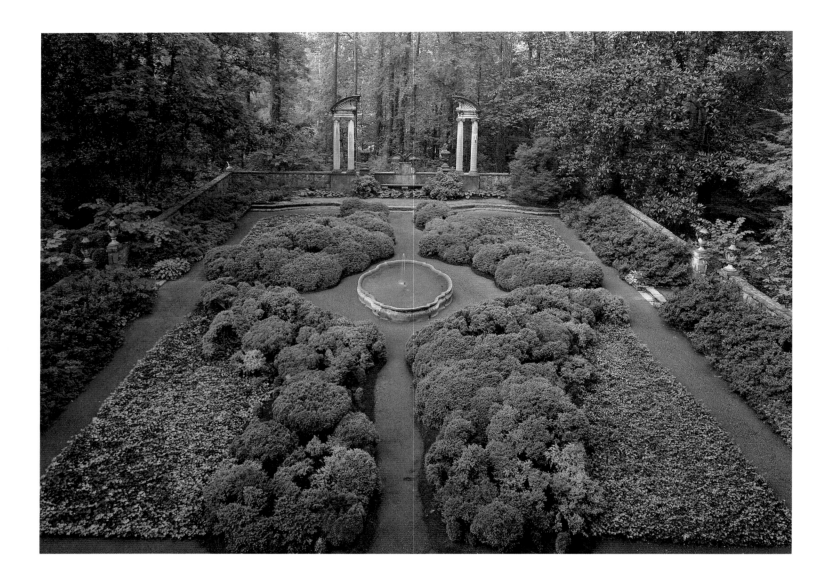

In 1966 the Atlanta Historical Society acquired the Edward H. Inman house (Swan House), its formal gardens, and twenty-two acres of surrounding woodlands from the heirs of Mr. and Mrs. Inman. The house, gardens, and grounds were opened to the public the following year. The society found this formerly private estate in Buckhead to be a superb place from which to carry out its objectives and added eight more acres to the grounds. On the accumulated thirty acres, the society has created a "history center" made up of numerous gardens, trails, buildings, and features that have been developed or restored since 1967. In addition to Swan House and its formal setting are McElreath Hall and the Frank A. Smith Rhododendron Garden; the Tullie Smith House and its gardens and outbuildings; the Quarry Garden; and Swan Woods Trail. The gardens and grounds have evolved from the formal features designed in the late 1920s by Philip Trammell Shutze, the architect of Swan House. Many new garden aspects have been created through the work of other professionals and the efforts of many garden club volunteers, led by Mrs. Ivan Allen, Jr., and Mrs. Arthur Booth. The staff gardener is R. Allen Sistrunk.

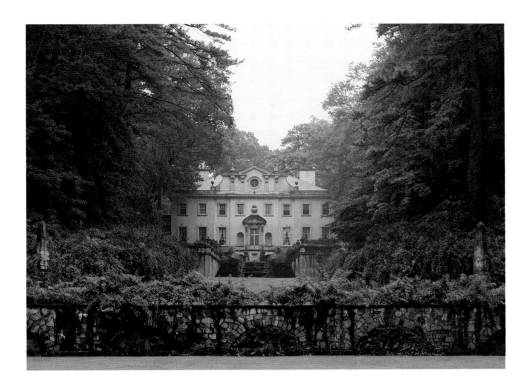

The Swan House garden facade and terraced lawn (top) face Andrews Drive. In his unedited notes at the Atlanta Historical Society, Philip Shutze explained his landscaping scheme: "Whatever has been done was with the Italian garden in England in mind before the advent of Capability Brown. As in the Italian vernacular, there are no perennial flower borders as such.

An architectural frame work with evergreen planting is the order—flowers are used in pots and tubs—a usage so common to the European arrangement in parterres." The Old Lamp Post Garden (opposite, lower photograph) at the former service entrance was created by the Camellia Garden Club of Atlanta and designed by landscape architect Daniel B. Franklin. The garden is named for the circa 1850 Atlanta gas lamp post

placed there by the club, and it features "The Boy with Swan," a lead English garden statue that in the 1880s had decorated the formal garden of a downtown Atlanta residence. The walled boxwood parterre (opposite, top) is on the south side of Swan House off of an arched porch. The lava encrusted urns are charming notes of Shutze's classicism. Shutze based the central fountain basin on several Italian precedents, as he did the architectural ornaments at the end of the garden. The twin columns with encrusted broken pediments are similar to those in the garden of La Pietra, a villa near Florence, Italy. From every view (west corner of north elevation, above), the Swan House grounds offer a sense of serenity and grace—a fitting tribute to the devoted efforts of many Atlantans.

INDEX OF GARDENS

The gardens illustrated in *Gardens of Georgia* are listed by region and alphabetized. Museum houses, public gardens, and other non-residential gardens are listed in italics.

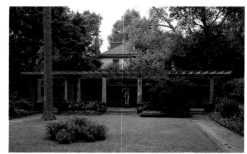

President's Home, Medical College of Georgia, Augusta

W. C. Bradley Library, Columbus

Crosby Garden, Athens

Cabaniss Garden, Athens

Fickling Garden, Macon

Graham Garden, Alpharetta

Highland Hills Baptist Church, Macon

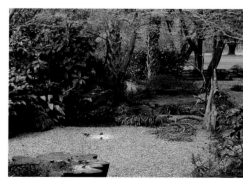

Birdsong Plantation, Thomasville

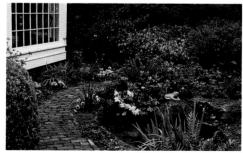

Jones Garden, Thomasville

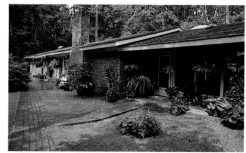

Bush Garden, Americus

Rich Garden, Thomsaville

Johnson Garden, Rome

Felton Garden, Macon

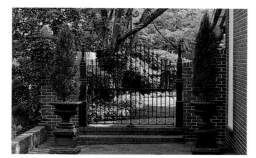

Ledbetter Garden, Rome

Wyatt Garden, Rome

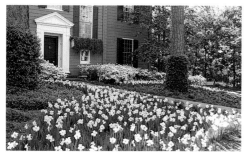

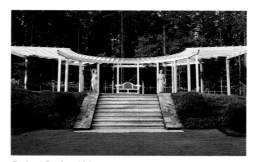

Dowden Garden, Atlanta

Graham Garden, Alpharetta

Stephens Garden, Morrow

Canterbury Court, Atlanta

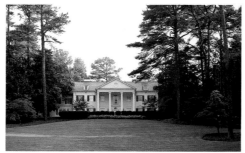

Carter Presidential Center, Atlanta

Faisel Garden, Atlanta

Sources For Quoted Material

Sources are listed by *Gardens of Georgia* page numbers in the order the quoted material appears in the text. Referenced by author and year of publication, complete bibliographical information on each source may be easily found in the accompanying bibliography. Quotes from garden owners were taken from information forms filled out for each garden.

Page	
vii	Page, 1983, p. 49
3	Haile, 1897, p. 28
6	Owens, 1983, p. 39
6	Owens, 1983, p. 42
7	Gray (Bartlett, ed.), 1968, p. 440
9	Oglethorpe (Reese ed.), 1972, p. 125
9	Montgomery (Reese ed.), 1972, p. 5
9	Montgomery (Reese ed.), 1972, p. 3
9	Montgomery (Reese ed.), 1972, p. 8
9	Ribault (Jones ed.), 1883, p. 35
10	Montgomery (Reese ed.), 1972, p. 8
11	Oglethorpe (Reese ed.), 1972, pp. 123-24
11	Oglethorpe (Reese ed.), 1972, p. 126
12	Moore (Jones ed.), 1883, pp. 223-24
13	Coulter, 1960, p. 17
36	Herrick (Cooney ed.), (1933) 1976, p. 38
36	*Itinerant*, 1878, pp. 9-11
37	Kemble, 1863, pp. 19-20
38	Loudon, 1949, p. 174
38	Lowe, 1949, p. 179
39	Bartram, 1973, pp. 465-66
39	Bartram, 1973, p. 465
40	Coulter, 1960, p. 267
40	Coulter, 1960, p. 269
49	Hall (Lane ed.), 1973, p. 78
49	Bartram, 1973, pp. 32-34
50	Bartram, 1973, pp. 34-35
50	Bartram, 1973, p. 32
50	Hodgson (Lane ed.), 1973, p. 53
51	Hodgson (Lane ed.), 1973, p. 53
52	Roberts, 1976, p. 17
53	Buckingham (Lane ed.), 1973, p. 168
53	Buckingham (Lane ed.), 1973, p. 166
54	Sears, 1979, p. 171
55	Buckingham (Lane ed.), 1973, p. 150
55	Owens, 1945, p. 21
56	Owens, 1945, p. 51
56	Sears, 1979, p. 177
56	Hall (Lane ed.), 1973, pp. 81-82
56	Hall (Lane ed.), 1973, p. 82
57	Lennox, 1868, p. 2
66	Sears, 1979, p. 27

Page	
76	Mitchell, 1982, p. 103
76	Verey, 1984, p. 28
76	McDougald, 1983, p. 91
84	Power (Lane ed.), 1973, p. 117
93	Mitchell, 1982, p. 167
99	Harley, 1866, pp. 182, 191
99	DeVorsey, Jr., 1971, p. 141
100	Haile, 1897, p. 5
100	Andrews, 1971, p. 288
101	*Newsweek*, July 6, 1981, p. 32
101	*Harper's Weekly*, Oct. 10, 1903, p. 1645
102	Cooney, (1933) 1976, p. 405
103	Herring, 1918, p. 158
123	Sherwood, (1827) 1937, p. 11
124-25	Bartram, (1792) 1973, pp. 333-36
125	White, (1855) 1969, p. 453
125	Perdue, Fall 1986, p. 459
125	Featherstonhaugh (Lane ed.), 1973, p. 123
126	Featherstonhaugh (Lane ed.), 1973, p. 135
126	Harley, 1886, pp. 162-63
126	Crawford, Summer 1988, p. 223
144	Smith (Garrett ed.), 1969, vol. 1, p. 291
145	Andrews, (1866) 1971, p. 340
145	Andrews, (1866) 1971, p. 341
145	Allen, 1948
145-46	Smith (Garrett ed.), 1969, vol. 1, p. 291
147	Mitchell, 1982, p. 173
147	Mitchell, 1982, p. 173
150	Garrett, 1969, vol. 2, p. 222
160	Mitchell, 1982, p. 173
164	Smith, 1951, p. 107
164	Smith, 1951, p. 108
166	Askey, April 1987, p. 124
172	Garrett, 1969, vol. 2, p. 563
172	Cooney, (1933) 1976, p. 278
178	Argintar, Summer 1983, p. 26
181	Cooney, (1933) 1976, p. 250
182	Garrett, 1969, vol. 2, p. 575
184	Mitchell, 1982, p. 211
209	Shutze's notes to docents, Atlanta Historical Society

BIBLIOGRAPHY

PRIMARY SOURCES

The gardens themselves, as visited in 1988 and 1989, were primary sources used in preparing the text for *Gardens of Georgia*. The questionnaires filled out by the garden owners were also major sources of information and quotes. (These valuable forms are filed with The Garden Club of Georgia, Inc.) The author's interviews with garden owners and with others familiar with individual gardens, and his prior knowledge of some of the gardens, gave perspective on their background and evolution. More than a half-century after its publication, *Garden History of Georgia, 1733-1833* has become a primary source of information, especially for gardens that have survived to the present day. The superb pen-and-ink bird's-eye garden views Philip Thornton Marye, FAIA, drew for that valuable book are carefully preserved at the Georgia Department of Archives and History. Unpublished National Register nomination forms, available from the state historic preservation section, are important sources of information on some of the older gardens.

PUBLISHED MATERIALS

Allen, Ivan. *The Atlanta Spirit: Altitude and Attitude.* Atlanta: 1948.

Andrews, Sidney. *The South Since the War . . . Georgia and the Carolinas.* Boston: Ticknor and Fields, 1866. Reprint, Boston: Houghton Mifflin Company, 1971.

Bartram, William. *Travels Through North and South Carolina, Georgia, East and West Florida.* London: 1792. Reprint, Savannah: Beehive Press, 1973.

Boney, F. N. *A Walking Tour of the University of Georgia.* Athens: University of Georgia Press, 1989.

Bruce, Harold. *The Gardens of Winterthur.* New York: Viking Press, 1968.

Buckingham, James Silk. *The Slave States of America.* 1839. In *The Rambler in Georgia.* Edited by Mills Lane. Savannah: Beehive Press, 1973.

Calkins, Carroll C., ed. *Great Gardens of America.* New York: Coward-McCann, Inc., 1969.

Cate, Margaret Davis. *Our Todays and Yesterdays.* Brunswick, Ga.: Glover Bros., 1930. Reprint, Spartanburg, S.C.: The Reprint Co., 1979.

Clifford, Derek. *A History of Garden Design.* New York: Frederick A. Praeger, 1966.

Coleman, Kenneth, and Charles Gurr, eds. *Dictionary of Georgia Biography,* vols. 1 and 2. Athens: University of Georgia Press, 1983.

Cooney, Loraine M., et al. *Garden History of Georgia, 1733-1933.* Atlanta: The Peachtree Garden Club, 1933. Reprint, Athens: The Garden Club of Georgia, Inc., 1976.

Coulter, E. Merton. *Georgia: A Short History.* Chapel Hill: University of North Carolina Press, 1960.

DeVorsey, Louis, Jr., ed. *De Brahm's Report of the General Survey in the Southern District of North America.* Columbia, S.C.: University of South Carolina Press, 1971.

Downing, Andrew Jackson. *A Treatise on Landscape Gardening,* 1841.

Duncan, Wilbur H., and Leonard E. Foote. *Wildflowers of the Southeastern United States.* Athens: University of Georgia Press, 1975.

Edwards, Paul. *English Garden Ornament.* New York: A. S. Barnes and Co., 1965.

Fairbrother, Nan. *Men and Gardens.* New York: Alfred A. Knopf, 1956.

Fendig, Gladys, and Esther Stewart. *Native Flora of the Golden Isles.* Jesup, Ga.: Sentinel Print, 1970.

Featherstonhaugh, George. *A Canoe Voyage Up the Minnay Sotor.* London: 1847. In *The Rambler in Georgia.* Edited by Mills Lane. Savannah: Beehive Press, 1973.

Gardens of the South. New York: Simon and Schuster, 1985.

Garrett, Franklin M. *Atlanta and Environs,* vols. 1 and 2. Athens: University of Georgia Press, 1969.

Gordon, Alexander. *Gardener's Magazine,* vol. 8. London, 1832. In "Notes on Georgia Camelliana," by James Stokes. In *American Camellia Yearbook, 1949.* Gainesville, Fla.: American Camellia Society, 1949.

Grady, James H. *The Architecture of Neel Reid in Georgia.* Athens: University of Georgia Press, 1973.

Gray, Thomas. "Elegy Written in a Country Churchyard." 1750. In *Familiar Quotations.* Edited by John Bartlett. Boston: Little, Brown, and Co., 1968.

Greenaway, Kate, illus. *Language of Flowers.* London: Frederick Warne and Co., Ltd., 1925.

Hall, Basil. *Travels in North America.* Edinburgh: 1829. In *The Rambler in Georgia.* Edited by Mills Lane. Savannah: Beehive Press, 1973.

Haile, J. C. *Southern Scenes . . . Points and Pictures Along the Central of Georgia Railway.* Savannah: Central of Georgia Railway Company, 1897.

Harley, Rev. Timothy. *Southward Ho!* London: Sampson, Low, Marston, Searle, and Rivington, 1886.

Hastings, Donald M., Jr. *Gardening in the South.* Dallas, Texas: Taylor Publishing Co., 1987.

Herrick, Francis Hobart. *Audubon: The Naturalist,* vol. 2. In *Garden History of Georgia, 1733-1933.* Atlanta: Peachtree Garden Club, 1933. Reprint, Athens: The Garden Club of Georgia, Inc., 1976.

Herring, J. L. *Saturday Night Sketches: Stories of Old Wiregrass Georgia.* Boston: Gorham Press, 1918.

Hobhouse, Penelope. *Garden Style.* Boston: Little, Brown and Co., 1988.

Hodgson, Adam. *Remarks During a Journey Through North America.* 1820. In *The Rambler in Georgia.* Edited by Mills Lane. Savannah: Beehive Press, 1973.

Hodler, Thomas W., and Howard A. Schretter. *The Atlas of Georgia.* Athens: University of Georgia Press, 1986.

Hortus Third. New York: MacMillan Publishing Company, 1976.

Itinerant Observations in America. Reprinted from *The London Magazine,* 1745-46. In *Collections of the Georgia Historical Society,* vol. 4. Savannah: Morning News Steam Printing House, 1878.

Jackson, John Brinckerhoff. *Discovering the Vernacular Landscape.* New Haven: Yale University Press, 1984.

Jones, Charles C., Jr., ed. *The History of Georgia,* vols. 1 and 2. Boston: Houghton, Mifflin and Company, 1883.

Keeler, Harriet L. *Our Native Trees.* New York: Charles Scribner's Sons, 1912.

Kemble, Frances Anne. *Journal of a Residence on a Georgia Plantation in 1838-1839.* New York: Harper and Brothers, Publishers, 1863.

Lane, Mills, ed. *The Rambler in Georgia.* Savannah: Beehive Press, 1973.

————. *General Oglethorpe's Georgia: Colonial Letters, 1733-1743,* vols. 1 and 2. Savannah: Beehive Press, 1975.

Lawrence, Elizabeth. *A Southern Garden.* Chapel Hill: University of North Carolina Press, 1984.

LeConte, Joseph. *Autobiography of Joseph LeConte.* 1903. In *American Camellia Yearbook, 1949.* Gainesville, Fla.: American Camellia Society, 1949.

Lennox, Mary. *Ante Bellum: Southern Life As It Was.* Philadelphia: J. B. Lippincott and Co., 1868.

Lockwood, Alice G. B., ed. *Gardens of Colony and State.* The Garden Club of America, 1931, 1934.

Loudon, J. C. *An Encyclopaedia of Gardening.* London, 1850. In *American Camellia Yearbook, 1949.* Gainesville, Fla. American Camellia Society, 1949.

Lowe, George D. "Horticultural History of the Georgia Coast." 54th Annual Meeting Georgia State Horticultural Society, 1930. In *American Camellia Yearbook, 1949.* Gainesville, Fla.: American Camellia Society, 1949.

Meadows, John C. *Modern Georgia.* Athens: University of Georgia Press, 1951.

Mitchell, William R., Jr. *Landmarks: The Architecture of Thomasville and Thomas County, Georgia.* Thomasville: Thomasville Landmarks Inc., 1980

————. *Lewis Edmund Crook, Jr., Architect, 1897-1967.* Atlanta: The History Business, Inc., 1984.

Mitchell, William R., Jr., and Van Jones Martin. *Classic Savannah: History, Homes, and Gardens.* Savannah: Golden Coast Publishing Co., 1987.

————. *Landmark Homes of Georgia, 1733-1983.* Savannah: Golden Coast Publishing Co., 1982.

————. *The Architecture of Wm. Frank McCall, Jr., FAIA.* Savannah: Golden Coast Publishing Co., 1985.

Montgomery, Sir Robert. "A Discourse Concerning the Designed Establishment of a New Colony to the South of Carolina, In The Most Delightful Country of the Universe." 1717. In *The Most Delightful Country of the Universe: Promotional Literature of the Colony of Georgia, 1717-1734.* Edited by Trevor Reese. Savannah: Beehive Press, 1972.

_____. "A Description of the Golden Islands." 1720. In *The Most Delightful Country of the Universe: Promotional Literature of the Colony of Georgia, 1717-1734*. Edited by Trevor Reese. Savannah: Beehive Press, 1972.

Moore, Charles W. *The Poetics of Gardens*. Cambridge, Mass.: MIT Press, 1988.

Moore, Francis. *Voyage to Georgia*. London, 1744. In *The History of Georgia*. Edited by Charles C. Jones, Jr. Boston: Houghton, Mifflin and Co., 1883.

Oglethorpe, James Edward. "A New and Accurate Account of the Provinces of South Carolina and Georgia." 1732. In *The Most Delightful Country of the Universe: Promotional Literature of the Colony of Georgia, 1717-1734*. Edited by Trevor Reese. Savannah: Beehive Press, 1972.

Owens, Hubert B. *Georgia's Planting Prelate*. Athens: University of Georgia Press, 1945.

_____. *Personal History of Landscape Architecture, 1922-1982*. Athens: University of Georgia Alumni Society, 1983.

Page, Russell. *The Education of a Gardener*. New York: Random House, 1983.

Peabody, Charles, ed. *The Soil of the South*, vol. 3, 1853. In *American Camellia Yearbook, 1949*. Gainesville, Fla.: American Camellia Society, 1949.

Pirtle, Caleb, III. *Callaway Gardens: The Unending Season*. Birmingham, Ala.: Southern Living Books, 1973.

Power, Tyrone. *Impressions of America*. 1834. In *The Rambler in Georgia*. Edited by Mills Lane. Savannah: Beehive Press, 1973.

Ray, Mary Helen, and Robert P. Nicholls, eds. *The Traveler's Guide to American Gardens*. Chapel Hill: University of North Carolina Press, 1988.

Reese, Trevor, ed. *The Most Delightful Country in the Universe*. Savannah: Beehive Press, 1972.

Reiter, Beth Lattimore, and Van Jones Martin. *Coastal Georgia*. Brunswick, Ga.: Coastal Area Planning and Development Commission, 1985.

Roberts, Clifford. *The Story of the Augusta National Golf Club*. New York: Doubleday and Co., Inc., 1976.

Ribault, Jean. "The True and Last Discoverie of Florida made by Captain John Ribault in the yeere 1562." In *The History of Georgia*. Edited by Charles C. Jones, Jr. Boston: Houghton, Mifflin and Co., 1883.

Sears, Joan Miles. *The First One Hundred Years of Town Planning in Georgia*. Atlanta: Cherokee Publishing Co., 1979.

Sells, Edward S. *Geography of Georgia*. Norman, Oklahoma: Harlow Publishing Corp., 1961.

Sherwood, Rev. Adiel. *A Gazetteer of the State of Georgia*. 1827. Reprint, Athens: The University of Georgia Press, 1937.

Smith, Alexander. *Eight Essays*. Mount Vernon, N.Y.: Peter Pauper Press, 1951.

Taylor, Raymond L. *Plants of Colonial Days*. Williamsburg: Colonial Williamsburg, Inc., 1952.

Thacker, Christopher. *The History of Gardens*. Berkeley: University of California Press, 1979.

Verey, Rosemary, and Ellen Samuels. *The American Woman's Garden*. Boston: Little, Brown and Co., 1984.

Wedda, John. *Gardens of the South*. New York: Galahad Books, 1971.

Wharton, Edith. *Italian Villas and Their Gardens*. New York: The Century Company, 1904.

White, Mrs. E. Carl, ed. *Sixty-Year History*. Athens: The Garden Club of Georgia, Inc., 1988.

White, Rev. George. *Historical Collections of Georgia*. New York: Pudney and Russell, 1855. Reprint, Baltimore: Genealogical Publishing Company, 1969.

Williams, Dorothy Hunt. *Historic Virginia Gardens*. Charlottesville: University of Virginia Press, 1975.

Wood, Louisa Farrand, et al. *Behind Those Garden Walls in Historic Savannah*. Savannah: Historic Savannah Foundation, Inc., 1982.

Wyman, Donald. *Wyman's Garden Encyclopedia*. New York: MacMillan Company, 1972.

ARTICLES

Argintar, Sybil H. "Robert Cridland Gardens in Atlanta." *Atlanta Historical Journal*. 27 (Summer 1983): 25-38.

Askey, Linda C. "Dan's Garden: A Journal in Flowers." *Southern Living*. 22 (April 1987): 124-27.

Bell, Laura Palmer. "The Vanishing Gardens of Savannah." *Georgia Historical Quarterly*. 28 (September 1944): 196-208.

Cherry, Rebecca Wight. "Atlanta's Japanese Gardens." *Atlanta Impressions*. 3 (Fall 1981): 48-53.

Crawford, George B. "Cotton, Land, and Sustenance: Toward the Limits of Abundance in Late Antebellum Georgia." *The Georgia Historical Quarterly*. 72 (Summer 1988): 223.

Daugherty, Edward L. "Landscaping McElreath Hall: A Vision of Land Use." *Atlanta Historical Bulletin*. 19 (Winter 1975): 13-17.

Griffin, Florence P. "Gardens in Early Georgia." *New Directions in Preservation*. Collected Papers, The Georgia Trust for Historic Preservation, Sixth Annual Conference. (May 1974): 13-20.

Harper's Weekly. "Georgia Number." (October 10, 1903): 1645.

Hewett, Susan. "Gardens of Little Bird Mountain." *Atlanta Impressions*. 2 (Spring 1982): 42-47.

Jones, Randy. "Preserving Georgia's Heritage." *Southern Accents*. 4 (Spring 1984): 94-101.

Laufer, Geraldine A. "Shakespeare's Herbs." *Southern Accents*. 11 (July-August 1988): 20-26.

Lee, Clermont H. "The Squares of Savannah." *Planning and Civic Comment*. 17 (March 1951): 24.

McDougald, Bill. "A Gardener Captures the 1800s." *Southern Living*. 18 (September 1983): 90-93.

Mitchell, William R., Jr. "Pebble Hill Plantation." *Southern Accents*. 10 (July-August 1987): 96-105.

_____. "The Anne Morgan Home." *Southern Homes*. 7 (July-August 1989): 56-63.

Morrison, Mary Lane. "On Savannah Squares." *Nineteenth Century*. 2 (Spring 1976): 6-13.

Owens, Hubert B. "Plantings." *A Plan for Barnsley Gardens*. Rome Area Heritage Foundation. (1979).

Perdue, Theda. "John Ross and the Cherokees," Review Essay of *The Papers of Chief John Ross. The Georgia Historical Quarterly*. 70 (Fall 1986): 459.

Sinnes, A. Cort. "The Domain of Ryan Gainey." *Flower and Garden*. 33 (January-February 1988): 34-40.

Woodham, Tom. "An Evolving Southern Cottage Garden." *Southern Accents*. 9 (May-June 1986): 108-15.

To all the children who have become new friends with Bear.

Thank you for reading my books!

—K. W.

For Boo—I love you.

—J. C.

Margaret K. McElderry Books
An imprint of Simon & Schuster Children's Publishing Division
1230 Avenue of the Americas
New York, New York 10020

The text of this book is set in Adobe Caslon.
The illustrations are rendered in acrylic paint.

Manufactured in Mexico

ISBN-13: 978-0-689-85984-7
ISBN-10: 0-689-85984-8 (hardcover)

Bear's New Friend

Karma Wilson

illustrations by Jane Chapman

MARGARET K. MCELDERRY BOOKS

New York London Toronto Sydney

*I*n the woods, in the sun,
on a hot summer day,
Bear feels an itching
to head out and play.

He goes to find Mouse,
his littlest friend.
But just as big Bear
heads round the bend . . .

. . . there's a clatter in the tree!
Oh, what could it be?
And the bear
asks,
"Who?"

Bear calls, "Is that Mouse
who hides in the tree?"
But Mouse scurries up
and squeaks, "It's not me!"

Bear scratches his head.
"Who's hiding up there?"
Mouse shrugs his shoulders.
"Perhaps it is Hare?"

Mouse starts to shout, "Come out, friend, come out!"
And the bear
asks,
"Who?"

Nobody answers.
"Who is it?" asks Bear.
They peek in the tree,
but nobody's there!

Bear cries, "No one's here!
But where did they go?"
Then Hare hops along
and says, "Howdy-ho!"

"Something sped past, going fast, fast, fast!"

And the bear asks, "Who?"

Hare says, "Let's go follow,
to see what we see."
Bear says, "Is it Badger?
Who else could it be?"

But there by a log
with Gopher and Mole,
Badger is peering
into a deep hole.

"Come look if you dare! There's someone down there!"

And the bear asks, "Who?"

Bear says, "It's not us!
But who is it then?"
"I know!" says Badger.
"It's Raven or Wren."

But Raven and Wren
flap down from the sky.
"We saw all our friends
and thought we'd fly by."

Up from the ground comes a rustling sound.

And the bear asks,

"WHO???"

"Who are you down there?
Who is it, I say?
Why stay in that hole?
Why hide the whole day?

"Why don't you like us?
WHY, WHY, WHY, WHY???"

Then a trembling voice says,

"Because—I am shy."

Two eyes peek-a-boo and the voice says, "Who?"
And the bear
says,
"Hi!"

"I'm Bear. Howdy-ho!
That's Mouse and that's Hare.
And Gopher and Mole
are standing right there.

Next to those bushes
sit Raven and Wren.
Come swimming with us
in the pool by the glen!

"Please do not hide. Come on outside."

Then . . .

. . . an owl says,

"Hoo . . . hoo . . . hoo . . . hoo?"

"Hello, I'm Owl.
And I'm sorry I hid.
I'm just a bit bashful,
and that's why I did."

Bear says, "Hello, friend!"
"Come on," cries Mole.
And they all scamper off
to the old swimming hole.

They splash and have fun in the hot summer sun . . .
with Bear's new friend.